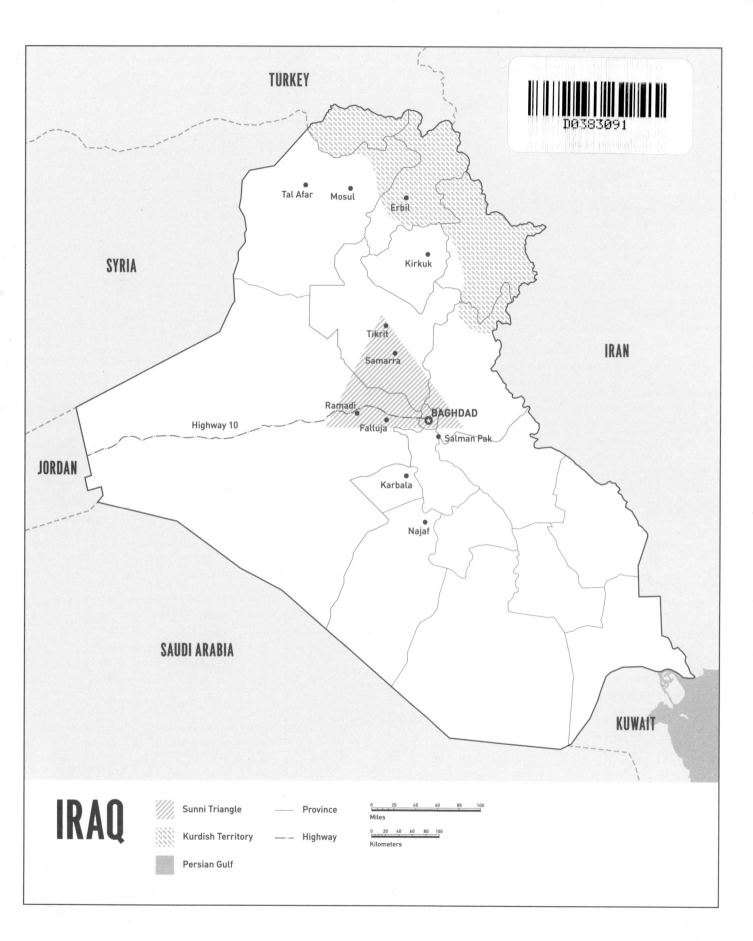

TURKEY

SYRIA

IRAN

D0383091

Tal Afar • • Mosul
 • Erbil

 • Kirkuk

 Tikrit •
 Samarra •

Ramadi •
 Falluja • ★ BAGHDAD
 • Salman Pak

JORDAN

 • Karbala

 • Najaf

Highway 10

SAUDI ARABIA

KUWAIT

IRAQ

▨ Sunni Triangle — Province
▨ Kurdish Territory —·— Highway
▨ Persian Gulf

0 20 40 60 80 100
Miles

0 20 40 60 80 100
Kilometers

WHISKEY TANGO FOXTROT

ASHLEY GILBERTSON

WITH AN INTRODUCTION BY DEXTER FILKINS

The University of Chicago Press
Chicago and London

WHISKEY TANGO FOXTROT

A PHOTOGRAPHER'S CHRONICLE OF THE IRAQ WAR

ASHLEY GILBERTSON was born in Australia and lives in New York City. His photographs have appeared in *Time*, *Newsweek*, the *New York Times*, the *Boston Globe*, *U.S. News and World Report*, and other publications. Among numerous honors, Gilbertson won the prestigious Robert Capa Gold Medal for his photographs of the battle of Falluja and was named the National Photographer of the Year by the National Photo Awards in 2005.

DEXTER FILKINS was a Baghdad correspondent for the *New York Times* from 2003 to 2006. He is a Nieman Fellow at Harvard University.

The University of Chicago Press, Chicago 60637
The University of Chicago Press, Ltd., London
Commentaries, photographs, captions © 2007 by Ashley Gilbertson
Introduction © 2007 by Dexter Filkins
Compilation © 2007 by The University of Chicago
All rights reserved. Published 2007
Printed in Hong Kong

16 15 14 13 12 11 10 09 08 07 1 2 3 4 5

ISBN-13: 978-0-226-29325-7 (cloth)
ISBN-10: 0-226-29325-4 (cloth)

LIBRARY OF CONGRESS CATALOGING-IN-PUBLICATION DATA

Gilbertson, Ashley
 Whiskey tango foxtrot : a photographer's chronicle of the Iraq war / Ashley Gilbertson ; with an Introduction by Dexter Filkins.
 p. cm.
ISBN-13: 978-0-226-29325-7 (cloth : alk. paper)
ISBN-10: 0-226-29325-4 (cloth : alk. paper)
 1. Iraq War, 2003—Pictorial works.
 2. Iraq—Politics and government—2003–
 3. United States—Armed Forces—Iraq—Pictorial works.
 I. Title.
DS79.762.G55 2007
956.7044'3—dc22 2007010474

♾ The paper used in this publication meets the minimum requirements of the American National Standard for Information Sciences—Permanence of Paper for Printed Library Materials, ANSI z39.48-1992.

FOR JOANNA

CONTENTS

INTRODUCTION
BY DEXTER FILKINS

ONE

War, the old saying goes, is seven parts boredom and one part terror. A soldier mans a post for hours on end, with only the crickets to liven his night. Life in the village carries on, the distant armies no more troubling than the clouds on the horizon. Then, in a flash, all is changed: lives are upended, bodies wrecked, futures destroyed. This is war's way.

But the old formula, while true in a sense, misses war's most singular aspect: its ability to evoke a wider range of human experience than any other human endeavor. Hero-ism, cowardice, joy, deceit, brotherhood, violent death. A nineteen-year-old from upstate New York discovers an unknown capacity for courage as he pulls a fallen com-rade from a mosque. A young Iraqi woman feels her life dissolve as she cradles her blinded son. All in an after-noon, all in a flash. War may be a peculiar mix of boredom and terror, but within those horrifying moments lies the whole galaxy of the human condition.

The photographs displayed here depict the full range of human experience called up by the war in Iraq. Ashley

Gilbertson, a gifted and fearless photographer, has plunged into this darkest and most ferocious of battle-grounds and found beauty and horror and honor and truth. Scan the faces captured in these pages, of Iraqis and Americans, and of the predicaments they have found themselves in, and see and feel—in your gut—what it really means to be a human being in the middle of a place as tormented and dynamic as Iraq is today.

As you focus on the individual scenes, you will notice, too, the arc of a much larger story. In March 2003, the Americans went into Iraq as conquerors and redeemers, or so they saw themselves. No small number of Iraqis saw them that way, too. And now, in the war's fifth year, many if not most of those hopes have fallen away. A nation has imploded, and a conqueror is bloody and humbled. With thousands of Americans and hundreds of thousands of Iraqis dead and maimed, the worst we can imagine seems to outdo itself each day. The Americans grope for a way out, while the Iraqis, fighting over irreconcilable visions of the future, drag their country toward an abyss. The arc has turned sharply downward, and it has not yet run its course. The end we can only imagine.

TWO

It's remarkable to recall just how high the hopes were then, before it all went bad. Despite the war's public premise—Saddam's presumed weapons of mass destruction—for most Iraqis, and for many Americans, too, this war was about ridding the world of an evil dictator, one who had wrung untold suffering from the bones of his own people. This was nowhere more true than among the Kurds, who, over the past thirty years, had borne the full measure of Saddam's furies. Linguistically and ethnically, the Kurds are a people apart. For years, in Iran and Turkey and Syria as well as in Iraq, they had sought greater

freedom for themselves and, if the opportunity ever came, independence. Culturally they stand apart, too: where the Arabs of Iraq till the alluvial plains around the Tigris and Euphrates rivers, the Kurds are a mountain people; the villages and sweeping vistas of the area they call Kurdistan stand for a different vision of their place in the world. Geography is destiny.

The pride and distinctiveness of the Kurdish people have drawn the ire of Iraqi leaders since the country was formed after the First World War, but never so much as Saddam Hussein. Before the war began, we didn't know the numbers—we could only guess—but over the past four years we've seen the mass graves and the sprawling cemeteries and have a clearer picture now: as many as 180,000 Iraqi Kurds—in other words, nearly one in every twenty Kurds in Iraq—perished in the campaigns against them beginning in the 1970s. Not surprisingly, the Kurds were virtually unanimous in their support of the American invasion, and not just because they wanted to see their tormenter brought low. For more than a decade following the end of the first Gulf War, the Americans had guaranteed the Kurds a safe haven in the north, denying Saddam's armies and air force the access they wanted. That allowed the Kurds to build a virtual state, with schools, highways, and democratic elections. "Welcome to Kurdistan" the sign says as you cross over from the northern border with Turkey, reading like an insult to anyone who refuses to believe. And so when the American invasion finally came, the Kurds reacted with enthusiasm for the operation and gratitude for the men and women who brought it. You can see that exhilaration in these photos here; you can see it in their eyes. If, four years after the invasion, the democratic experiment in Iraq appears doomed, there is little basis for such doubts in the Kurdish north. Indeed, most Kurds saw the American invasion

as an opportunity to gain formal autonomy—and, as soon as possible, independence. When Saddam's regime in Baghdad fell, it was not the Iraqi flag the Kurds were waving; it was their own, with the sun in the middle. These days, the Kurdish flag flies ever higher, and snaps more brightly in the breeze.

THREE

In the rest of Iraq, the cheers that greeted the American soldiers never reached the peaks they did in the Kurdish north. And they died away faster. The liberation quickly became, in the eyes of many Iraqis, an occupation. The suspicion cut both ways. For the Americans' part, the country they discovered was not a normal one in any respect. After decades of tyranny and war, Iraq was a deeply traumatized place, broken and atomized at its very core. Every Iraqi, it seemed, had a story that would chill the bones: of brothers killed, of fathers taken away, of torture, of humiliation, of sadism unbound. By the time the Americans arrived, Iraq had become a place where most of the ordinary bonds that hold a society together— honesty, self-restraint, a sense of the common good—had disappeared. It was as if, for the past several years, Iraq had been held together by a steel frame—the steel frame of a dictatorship. When the Americans came and smashed that frame, the country dissolved in their hands.

There are photos in these pages that show ledgers, and the ledgers with names. Long lists of names. These are the lists of the dead: shot, tortured, burned. After the fall of Saddam Hussein, Iraqis like Kanan Makiya, an intellectual living in exile in America, came home to gather the names. No one really knows how many bodies lie underneath Saddam's Iraq. Many, many thousands. That pain became the Americans' pain; it was something that had to be dealt with, measured, accounted for.

From these wounds rose a terrible dynamic, one that gripped the country for many months following the fall of the regime, and one that ultimately crushed any American hopes of a quick and graceful exit. The first insurgents began striking American soldiers, with rifles and homemade bombs, then slipping back quietly into civilian life. The Americans—strangers in a strange land, without much knowledge of the place or its language—would strike back, often by raiding entire city blocks. Door-to-door searches became the norm. Given the growing violence, those searches seemed necessary. But they were horrifying to witness. Not for the violence, which was relatively rare, but for the way those searches often destroyed the trust between ordinary Iraqis and American soldiers. Sometimes the Americans would get the young Iraqi men they were looking for, and sometimes they would not. But it was these latter raids that proved decisive. In a tribal society like Iraq, where bloodlines matter most, there is no such thing as an isolated incident. For every house that American soldiers smashed their way into, and for every innocent man they led away, for every insurgent they killed, a hundred more enemies stepped to the fore. It was not long before the insurgency was exploding, in numbers and scale and intensity, forcing onto the Americans something for which they had not planned. The real war had begun.

In any insurgency, the goal of the guerrillas is to demonstrate to ordinary people that the regular army or the government cannot protect them. In Iraq, the suicide bombers took that idea to its pathological frontier. These men—sweaty, shaven, with hands cuffed to the steering wheels of their cars—would not merely demonstrate that the Americans were powerless. They would murder and maim Iraqis—babies, old ladies, young men—by the dozens, by the thousands, to drive that point home. Large

parts of the insurgency became a death cult, a fevered order that seemed to feed off the misery it wrought. Give me more, it seemed to say, and the cars would career and the bombs would explode and the bodies would fly. On those days, amid the severed limbs and the broken lives, the world seemed to come to a terrible end.

While most of the violence was being generated by members of Iraq's Sunni minority, who had been disenfranchised by Saddam's fall, the Americans soon found themselves confronting another foe. In the spring of 2004, it was not just Sunni guerrillas who were attacking American troops but Shi'ite ones as well. Insurgents loyal to a young cleric, Muqtada al-Sadr, rose up in Shi'ite cities across Baghdad and southern Iraq, occupying two Shi'ite shrines in the holy cities of Najaf and Karbala. The Mahdi Army, as the young and bedraggled fighters called themselves, presented a difficult challenge for the Americans. It was not just because of al-Sadr's immense popularity among Iraq's Shi'ites, but also because, having seized the shrines, the guerrillas portrayed themselves as the holy sites' defenders. While the mainstream Shi'ite religious establishment detested al-Sadr and quietly urged the Americans to flush his men from the shrines, they did so with the admonition that neither shrine could be damaged. That, all sides agreed, could have sparked a potentially wider conflagration and made the Americans' stay in Iraq untenable. Hence, for the next several months, American soldiers fought their way into the centers of Najaf and Karbala, fighting at very close quarters, often firing just past the shrines, and occasionally even hitting them. The fighting was heavy, with hundreds dead and wounded, particularly among the Mahdi guerrillas. The combat had a surreal aspect to it: uniformed American troops advanced through the ancient warrens and back alleys of Najaf and Karbala against an untrained foe that wore no uniform. The holy shrines—of Hussein in Karbala, of Ali in Najaf—acted as backdrops, beautiful and untouchable.

The Americans were victorious in Najaf and Karbala, at least for a time. Muqtada al-Sadr agreed to vacate both temples, but he was allowed to stay free himself, and the surviving members of his Mahdi Army were allowed to walk away unharmed. That was the long-term price the Americans paid to buy peace. And for a time, the American strategy seemed to work: Muqtada called off his uprising and made his first steps into the just-emerging democratic process. The renegade cleric seemed to have been tamed.

FOUR

For all the chaos that has buffeted Iraq since the invasion, the American strategy there has been about more than just killing insurgents. Since the autumn of 2003, the vision has had two goals: contain the insurgency and build a democratic state, one stable and strong enough to allow the Americans to leave. As 2005 approached, American and Iraqi leaders laid out a three-step plan to do that: a nationwide election in January to choose a government that would write the country's constitution; a nationwide vote to ratify or reject that new constitution; and then, in December, a final round of voting to choose a four-year parliament. The central idea underlying the American plan was that voting, elections, and writing a new constitution—the give and take of democratic politics—would co-opt the insurgency and set Iraq on a path toward stability and peace.

As the first round of elections approached, much of Iraq's Sunni region had slipped from the control of the Iraqi government and the American forces: Insurgents controlled

Samarra, parts of Ramadi, Tal Afar, and Mosul. The guerrillas' uncontested stronghold was Falluja, a city of about 250,000 thirty-five miles west of Baghdad. There, following the murder and burning of four American contractors in April—the charred remains of their bodies strung up on a bridge—guerrillas had taken control of the entire city, setting up what amounted to an Islamist emirate inside. Falluja represented a safe haven for the insurgents a half hour's drive from the capital of Iraq. In the fall of 2004, the Americans declared that they would retake all of the contested areas in time for the elections. On November 8, 6,500 American troops and 2,000 Iraqi soldiers moved into Falluja.

The battle for Falluja was the bloodiest of the war. The guerrillas, who had proved themselves the most elusive of enemies, chose in Falluja to hold their ground. Nearly all of the city's civilians had fled, setting the stage for a fight of unusual purity. The insurgents didn't have much choice. As the Marines swept in from the north, an Army unit had set up blocking positions across the southern rim: a hammer and an anvil.

The Marines moved in about 11:00 p.m., and the insurgents were waiting. From the mosques and minarets across the city, the insurgents began calling into the loudspeakers to call their comrades to the fight. Rocket-propelled grenades began sailing out of the city, their explosions illuminating the landscape. The battle had begun.

The fighting reached an intensity unseen by American fighting men since the Vietnam War. Every foot of the city was contested, literally: on the first evening of battle, the group of marines with whom Ashley and I traveled—Bravo Company of the First Battalion, Eighth Regiment—advanced just 100 yards into the city. The insurgents were

dug in, defending hardened positions whose approaches were often strewn with booby traps. The casualties were horrendous: 71 Americans were killed and 450 wounded. Seven of the young Americans pictured in these pages did not survive. Among the insurgents, no one knows for sure, but the dead probably number in the hundreds.

About twelve hours into the attack, on the morning of November 9, the 150 marines of Bravo Company moved under heavy fire to the northern edge of 40th Street. On the other side lay the city's cultural center, a three-story cement building that was one of the principal objectives of the assault. Insurgent machine gunfire came from several directions, interlocking in the middle of the street. The marines ran anyway, into the street and into the fire, whose sound was so piercing that it was impossible to hear. The marines fired, too: hundreds and hundreds of rounds; the casings of spent bullets reached to your shins.

By the time Bravo Company made it to the other side, five marines lay in the street. With the fire unremitting, the young marines dashed back into the street to haul in their fallen comrades. These were acts of extraordinary bravery; the road seemed to invite certain death.

The marines managed to pull all five of their brethren from the street, but for one of them it was too late. Sergeant Lonny Wells, a twenty-nine-year-old sergeant from Vandergrift, Pennsylvania, bled to death on the side of the road. He had been shot in the leg, and the bullet had hit his femoral artery. Wells was the first member of Bravo Company to die in the battle, and his passing was especially cruel. Wells, in charge of about fifteen younger marines, had written letters home to their families, assuring them that he would do whatever he could to keep them safe.

"He loved playing cards," Gentian Marku, a twenty-two-year-old corporal from Warren, Michigan, recalled. "He knew all the probabilities."

Sixteen days later, Corporal Marku was dead, too. He had come to the United States as a fourteen-year-old from Albania. He had enlisted, like so many of the marines who fought in Iraq, after the September 11 attacks. He had a wry sense of humor and a quick, knowing smile, and he was as lean and fit as a young man could be.

Marku was shot as he crouched behind a wall outside a house filled with guerrillas. It was Thanksgiving Day.

With the enemy so close, the fighting in Falluja sometimes seemed surreal. All through the night, the air vibrated with the buzz of the Dragon Eye, a pilotless airplane fitted with cameras that beamed real-time images back to the base. Guerrillas, some of them, moved through the city dressed in Iraqi Army uniforms. The insurgents used black flags to signal one another, often hanging them atop the minarets of mosques. At one point, a cat walked down a sidewalk during a firefight, its tail stuck in the air as if to signal disdain. In the same firefight, a canary landed on the helmet of a marine. Whiskey Tango Foxtrot, indeed.

On the eighth day, the marines reached the southern edge of the city; the hammer had struck the anvil. The insurgents were routed, their safe haven destroyed. Falluja, once known as a "no-go" zone, was again an open city. And it was in ruins, too. No block was unscathed; some blocks were entirely destroyed. It was too easy to say, as some people did, echoing the notorious line from Vietnam, that the village had been destroyed in order to save it. It was perhaps more accurate to say that the city

had been destroyed in order to save the country. Or so the feeling went.

FIVE

The victories in Falluja and Samarra cleared the way for the elections to go forward on January 28, 2005. What happened that day was a thing of wonder: in the face of unrelenting violence, eight and a half million Iraqis went to the polls to cast ballots. Iraqis of all stripes came out to vote that day. Husbands and wives walked to the voting centers with their children, often dressed in their finest clothes. Old men came in wheelchairs. Children and families broke into parties and football games.

All through the day, the bombs kept exploding, audible from inside the polling centers. Most of the time, the Iraqis did not even bother to look up, so inured were they to violence and so immersed in their democratic moment.

"Do you hear that, do you hear the bombs?" said Hassan Jawad, a thirty-three-year-old election worker at Lebanon High School in Baghdad, calling over the thud of an exploding shell. "We don't care. Do you understand? We don't care."

"We all have to die," Mr. Jawad said. "To die for this, well, at least I will be dying for something."

And then Mr. Jawad got back to work, guiding an Iraqi woman's hand to the ballot box.

The total represented 58 percent of eligible voters, who faced down mortal danger to exercise their new democratic rights. The insurgents had tried desperately to scuttle the voting; they launched 260 attacks that day, making it the single most violent day since the Ameri-

can invasion. They failed. In Najaf, Iraqis stepped over the corpses of suicide bombers to get inside the voting booths.

The election contained flaws, serious ones that returned to haunt the country. The most obvious one was that the majority of the Sunni population, the embittered minority that forms the backbone of the insurgency, sat out the election. But on that day, the election represented a moment more full of promise than any the country had known in many years. The day seemed to herald a better, if still difficult, future. No one could say, as people sometimes did, that Iraqis did not understand the first principles of democracy. Millions of Iraqis had risked their lives to cast ballots.

The country held two more nationwide votes. The first was in October 2005, a nationwide referendum on a new constitution. The second, for a four-year parliament, came on December 15. In these later elections, members of Iraq's Sunni community came out in great numbers, buoying hopes that the American-backed strategy would work—that the democratic process would ultimately begin to quell the violence.

But those hopes, like so many in America's venture in Iraq, proved to be an illusion. The Sunnis may have voted, but the insurgency grew stronger than ever. As the American project in Iraq entered its fourth year, the violence morphed into something far more serious: it was no longer just Sunnis killing Shi'ites, and Sunnis killing Americans, but Shi'ites killing Sunnis. Civil war had begun to unfold in the streets. The unofficial beginning of that war came in February 2006, when Sunni insurgents destroyed the al-Askariya shrine, a holy Shi'ite mosque in Samarra.

Since the fall of Saddam, Shi'ite leaders had exercised remarkable restraint in the face of unrelenting attacks by Sunni guerrillas. But after the Samarra bombing, that restraint fell away. The Shi'ite militias, led by al-Sadr and others, responded with ferocity. Most of the victims were civilians. By late 2006, 3,000 Iraqis a month were dying. The violence was spiraling out of control.

The Americans went into Iraq to topple a dictator, and they did that handily. But the larger challenge came later, when the country they invaded fell apart from within. As Leon Wieseltier wrote, "After we invaded Iraq, Iraq invaded itself." Suddenly, a fragmented land brimming with ancient hatreds and irreconcilable demands was an American responsibility, and one they did not fully comprehend. The Americans went about their task with energy and determination, but as the years dragged on, Iraq kept eluding their grasp. The way ahead seemed to herald only darkness.

ONE

PREOCCUPIED IN KURDISTAN

FIRST COMBAT

It was never my intention to become a war photographer.

I wasn't interested in covering combat—if people wanted to kill each other, so be it, not my problem. My concern lay with those left in combat's wake. I started covering people affected by war in 1998, when I met a large contingent of Kosovar refugees who had been granted temporary safe haven in Australia. Their situation was heartbreaking, and I made it my goal to tell the stories of innocent civilians whose lives were ruined by war.

I traveled continents documenting the plight of refugees. I photographed desperate Arabs trying to make the dangerous and illegal passage from Indonesia to Australia; I visited refugee camps in Pakistan and followed people home when they were repatriated to Afghanistan. Eventually my journey led me to Iraqi Kurdistan, where almost everyone had at some point in his or her life been a refugee.

I first traveled to Kurdistan in 2002. At the time, the Syrian authorities turned a blind eye to the little boats skipping

across the Euphrates as the Kurds smuggled in journalists like me. Those were a nerve-racking ten minutes on the river. Iraqi snipers watched through binoculars. Should the boat break down midway, the current would wash us south into territory controlled by Saddam Hussein and we would certainly be imprisoned. After getting across, I was greeted by a large hand-painted sign declaring "Welcome to Kurdistan." It didn't mention Iraq.

I found the Kurds inspiring people—tough and proud, intent on gaining independence and overthrowing Saddam. The modern history of the Kurds is rife with suffering. Most recently, tens of thousands perished during Saddam's 1988 al-Anfal campaign against the Kurds, some from chemical weapon attacks. The 1991 Gulf War sent over a million Kurds streaming into Turkish refugee camps to escape Iraqi forces. The American government imposed a no-fly zone, leaving the Kurds control of northern Iraq. They have effectively had autonomy from Baghdad, with their own militia and government, since then.

On that first trip, I photographed the Kurds for three months, filing stories for various Australian publications. I shot everything in black and white, and processed when I went home. But soon I switched to digital—black-and-white photographs from an unknown photographer were a tough sell, and I couldn't process my film from a war in a timely fashion. I returned to Iraqi Kurdistan in February 2003, several weeks before the U.S. invasion of Iraq. I wanted to photograph and report what kind of a deal would be cut for the Kurds in the coming war. I wasn't the only one: editors smuggled droves of reporters, photographers, and television crews across Kurdistan's mountainous borders, anticipating an American assault on Iraq from Turkey in the north. When Turkey blocked the use of its territory, both the American war planners and the

journalists in the north had to change tactics. The United States poised to invade from the south, and a few journalists left to embed with them. Many, including me, waited in Kurdistan.

The first fighting of the war in the north was between the Kurdish militia, backed by American Special Forces, and Ansar al-Islam, a terrorist group led by a then little-known jihadist named Zarqawi. The Kurdish fighters are known locally as Peshmerga, meaning "one who faces death." We nicknamed them the Pesh. I set out to visit the Peshmerga's front lines and ended up spending many nights atop a mountain with them, much of it in a decrepit bunker, waiting to be hit. Chechen and Afghan fighters, reputedly ferocious, were among Ansar's ranks. When Ansar al-Islam attacked Kurdish positions, their fighters would come within a hundred yards of the bunker and fire from every side. The bunker would shake violently, and the Kurds would run outside and start firing into the darkness.

Word spread to the press that I was seeing a lot of fighting. A German TV crew approached me, complaining they weren't allowed to go out after dark. I was running very short on money and offered my services. They sent me back for a night with a video camera, and I earned enough cash to stay another couple of weeks. Television networks can be great when you're included in their budget.

That was the first time I was exposed to combat. I realized during the cold nights atop the mountain that while I had covered dozens of issues around war, I had never looked inside it. I decided to expand my focus in Iraq, from the Kurds in the north to the war in its entirety. All of a sudden people killing each other was my problem. I had started out photographing the effects of war, now I wanted to look at its causes and the way it was fought. I didn't

know how deep into the fighting I would have to go, and what it would cost me.

COUNTDOWN

On March 17, George W. Bush told the world that if Saddam and his sons did not leave the country within forty-eight hours, America would invade Iraq. Our "four-star" hotel in Erbil, Kurdistan's regional capital, had only one English-language channel—Fox News—and when we weren't out working, we were watching their "countdown to war." Once Fox's little animated clock in the corner of the screen hit zero, our world, and that of twenty-five million Iraqis, would change forever.

I was sharing a room and working with an old friend, Timothy Grucza. Tim and I had known each other since we were kids in Melbourne and had worked together for years on stories in Australia, the Balkans, and the South Pacific. Tim was a freelance cameraman on assignment for the French television network Canal+, which was funny since back then he spoke hardly a lick of French. I was unaffiliated and hoped to pick up work in Kurdistan as the war developed.

The Kurds didn't need Fox's countdown to tell them to prepare for war. They bought out plastic sheeting to protect themselves from chemical attacks, covering their windows or building tent-like shelters between rock outcrops in farmland. The daily arms bazaar in a small darkened building in Erbil was awash with flak jackets that couldn't stop the kind of firepower headed their way, and homemade gas masks that were good for little more than subduing the stench from open sewers. As I covered the Kurds' preparations, I realized that I was no better equipped for an invasion than they were: I didn't have a flak jacket, a mask, or even a fixer I could trust.

Fixers are invaluable to journalists in foreign places, acting as guides, translators, and assistants. In Kurdistan, ours were repeatedly poached by larger outlets, some of whom offered serious money—usually about $300 per day. As Fox's clock ticked down to seventeen hours, Tim and I desperately searched for someone who could help us. The prospects were minimal. We interviewed a midget, a seventy-three-year-old tomato sauce expert, and a guy who could hardly string a sentence together in his native Kurdish let alone in English. While Tim went off to break the bad news to the midget, I went to the hotel bar and started drinking. A Kurdish friend spotted me there holding my head in dismay and offered to help.

His name was Warzer Jaff. We had met during my last trip to Erbil, and we had become friends over drinks he served when he managed the hotel's Internet café. I had not expected to see him there. Some months ago the café's owner had referred to Uday Hussein, Saddam's oldest son, as "Mr. Uday." Jaff beat him up and was fired.

Jaff tested me: "I will work for you Ashley, but my English is not so good." I told him that his English was great, and we talked money. Months later Jaff explained that if I had confirmed his assessment of his language skills, he wouldn't have worked for us. Jaff's English wasn't great, but it wasn't nearly as bad as the guy we had used to interview Kurds in a market about French opposition to the war—he had translated our simple questions as if we were spies: "These men are working for the French government, and they want to know what you think of Jacques Chirac."

With Jaff on our team, Tim and I were set. We celebrated on the lawn of the hotel over beers smuggled in from Turkey with journalists smuggled in from Syria. We woke

early the next day hungover and watched live coverage of Baghdad on television. The sun was rising over the city and just beginning to penetrate the smoke from the oil fires that Saddam had set to frustrate the expected air strikes. There was something very tranquil about the scene, even beautiful.

At 5:30 a.m., the television screen flashed. The first bomb had hit Baghdad. We went back to sleep.

FREEDOM AND THE PRESS

Stuck in Erbil, and later Suleimanya, we watched our embedded colleagues on TV. They breathlessly reported from sand storms and combat as Iraqi cities fell to the U.S. military in quick succession. The press in the north complained about missing the war, even though our windows rattled when 2,000-pound bombs fell on the nearby Saddam-controlled cities of Kirkuk and Mosul. Still, we hadn't done much reporting aside from covering the streams of Kurdish refugees.

Then suddenly we got our war. Paul Moran, an Australian cameraman freelancing for ABC, was killed by a suicide bomber in the northern town of Sayed Sadiq. I sat in a hotel room in Suleimanya with his heavily bandaged friend and colleague Eric Campbell, who survived the attack, as he swore never again to cover a war. Another night I sat alone in a restaurant where only days earlier I had shared a meal with Kaveh Golestan, a BBC cameraman who was trying to cover fighting near Kifri, in the southern part of Kurdish-controlled Iraq, when he stepped on a land mine and died.

On April 1, soldiers from the 173rd Airborne parachuted into Harir airstrip near Erbil. We had been expecting them for days, but the Kurdish authorities had declared the area off limits. I managed to sneak myself into a house near the airstrip and photograph contractors preparing for the 173rd's arrival before the Kurds found and arrested me for taking pictures. I was taken to a senior official who politely chastised me. I shouted back at him, citing freedom of the press. Angered by my insolence, he said that he could not allow the press to divulge the location of the American breech point in the northern front. "Saddam built the fucking airstrip," I yelled. "You don't think he knows where it is?" The following day, my photographs ran on the front page of the *Boston Globe*. It was the first time an American news outlet had given my photographs major play, and it felt good.

There had still been little fighting on the northern front when Baghdad fell on April 9. On television we watched images of U.S. troops preparing to pull down the Saddam statue in Firdos Square. We watched a marine climb atop the statue to put Old Glory over Saddam's head, then quickly replace it with an Iraqi flag. When the statue broke and toppled to the ground, leaving Saddam's feet firmly attached to the pedestal, excited correspondents reported the fall of Baghdad—the great American victory. Al Jazeera, the most influential Arabic news channel, noted with poetic foresight, "Saddam has fallen. His feet, however, remain."

The northern front opened up after the statue fell. Peshmerga and American Special Forces units fought their way through small towns until they were on the outskirts of the oil-rich cities of Kirkuk and Mosul, both still under Saddam's control. Covering the advance wasn't easy. The press was largely barred from the front, leaving us to sit behind the lines at the last checkpoint playing backgammon, hoping to be given a few minutes of access. Jaff, Tim, and I hid in a deserted village a kilometer behind the

Special Forces, where for several days we were shelled by the Iraqi army. We had gasoline tanks in the back of our car and could do nothing but cower as explosions rocked on all sides of us.

One day we heard the whine of a mortar coming in and scrambled to a wall for cover. The sound didn't climax in the usual boom—it got louder and louder until it sounded like a high school orchestra trying to hold its highest pitch right in our ears. I covered mine in terror, hoping that if I blocked out the sound, whatever was dropping out of the sky wouldn't hit us. The earth shook around us as a 1,000-pound bomb spewed an enormous cloud of dust and dirt from the next hill and onto nearby rooftops. That was too much. While we were on the front, we weren't getting pictures. The risk was too high, the payoff too low, so we marched up to the Special Forces to announce our presence.

They were amazed we had waited it out there. "If you guys have been taking the same shit we have, then you can hang around," their commander said. We asked about the 1,000-pound bomb. A soldier grudgingly admitted that the Air Force had bombed the wrong side. We were lucky to be alive.

We returned to the hotel in Erbil one evening to file pictures. I flicked on the television: still Fox-only. In the green night vision made famous during the invasion, a correspondent was crouching in front of sandbags, wearing a flak jacket and a helmet. He was supposedly on the front lines, reporting via a scratchy video phone. He had to whisper, he said. The enemy was so close. We examined the screen. Hadn't we seen that guy at dinner? Fox's bureau was upstairs, so it was possible. We took a closer look, and behind the sandbags Tim and I could make out

the distinctive architecture of our hotel. Fox News' front-line correspondent was reporting from his hotel room with his lights turned out.

He had to whisper? What an asshole. Tim and I decided to call him on it, then and there, on live television. I rang his cell phone, and then his satellite phone. Both were switched off. Kudos—he had paid attention to those little details. We remembered that the hotel's in-house phones sometimes worked. We tried him on that line. His phone rang. We hung up. My uncle swore he heard the phone ring on his TV in Melbourne.

That was an extreme example of the deceptive "front-line reporting" that is commonplace in network television. Television reporters rarely travel from their hotels. Often when a network cuts "live to Iraq," the reporting is from the network's permanent spot on a Baghdad hotel rooftop or from well behind the front lines. I have friends who are exceptions to the rule, people who take enormous risk to tell a story, but on the whole, television crews are too busy doing "live updates" to actually go out and report.

Tim was growing increasingly frustrated with his own network. He felt that they weren't taking his work seriously. They referred to him as a "traveler in Iraq" rather than a reporter; they used only his first name; they cut silly edits into his reports. One day under Iraqi fire, we bolted across an open field and threw ourselves against a pile of dirt. Tim pulled out a packet of smokes, turned to the video camera I was holding and said with a smirk, "I'm here on the front line, and what I'm most worried about is that I only have one cigarette left." Sarcasm and humor eased some of our more desperate situations, and footage like that was for us. It wasn't meant for viewers. But Canal+ used it.

The following morning, Tim, Jaff, and I returned to the front. Neighboring Kirkuk fell to the Kurds, and officials from the former Ba'athist regime were publicly executed. Looters immediately overran the city. While most journalists in the north descended on Kirkuk, a small group of us decided to stay in the front-row spots we had outside Mosul. Minefields stretched around us and shells dropped erratically. There was little we could do but wait. We set up a small table, drank French wine, and ate Danish Blue until the city opened up.

The following morning, we were the first journalists to enter Mosul. Driving into the city we found just a few armed men, looking mean. In a war zone, deserted streets are the first sign of danger. We weren't sure at first if the men were Saddam's Fedayeen or Kurdish Peshmerga. Only when they didn't shoot at us did we establish that they were Pesh. The center of the city was a different story—hundreds of people had gathered, cheering as they tore down the banners of Saddam that adorned every government building. A man threw gasoline over a huge painting of Saddam and another ran forward from the mob to set it alight. As I took pictures, I recognized the man igniting the painting. It was Jaff. He was giddy with joy. When he backed away from the flames, I grabbed him and said that as my fixer, he was a neutral observer—he could not be involved. Jaff instantly sobered. "Ashley," he said, "first I am an Iraqi. Second I am a journalist."

The throng ran out of banners and murals to destroy and turned on the central bank of Mosul. Its barred front doors had been cracked open by the Pesh, and the men who only hours earlier had been fighting side by side with Americans were now looting burlap sacks of money. They fired carelessly into droves of jubilant Iraqis attempting to get a piece of the pie. Then the deep bass of an explosion belched forth from the bank. Money started falling from the sky. The Pesh had blown the vault.

The madness wasn't confined to the bank. People ransacked military armories and set up arms bazaars outside them. Jaff desperately wanted to buy a gun—for safety, he said—but I wouldn't let him, believing as I do that it's unethical for journalists to carry weapons for any reason. When I came across a group of men trying to load an eighteen-foot rocket onto their truck, I thought I was hallucinating. If anyone wonders why that picture isn't in this book, here's the answer: we were driving pedal-to-the-metal in the other direction.

Looters were pillaging the United Nations' Oil-for-Food supply warehouses. From afar, the storage facilities looked as though they were being attacked by ants; people marched out in lines, carrying sacks of rice and boxes of oil. At Saddam's Mosul palace, entire families looked for something to steal—light switches, door frames—whatever they could get. A man fell to his death as he tried to jimmy a banister from its fittings. Another man took a stab at it, and managed to tear part of it off.

Photojournalists dream of shooting wild scenes like these, but I was so sickened I had to stop working. Was this the freedom America promised: frenzied men with armfuls of cash wrestling free from crowds trying to rob their booty? America's Kurdish allies shooting anyone who got in the way of their meticulously planned looting spree? The entire infrastructure of Iraqi cities looted and torched?

At the war's outset, I had supported it. Weapons of mass destruction seemed like a bullshit reason to invade, but I didn't care. Any reason the Americans could agree upon

to topple that monster Saddam was good enough for me. I'd seen victims of his purges, the birth defects of children born to mothers who had been exposed to Saddam's chemical weapons at Halabja. His thugs had tortured and nearly killed close friends of mine. I justified the American invasion as a means to an end.

I changed my mind, though, when I watched Mosul burn. I couldn't understand how the Americans let this occur. "Stuff happens," Donald Rumsfeld said in response to the mayhem.

In the following weeks, Arabs and Kurds, longtime enemies, sectioned off their neighborhoods with burning tires, bricks, and gangs of men with AK-47s. Turning down the wrong street meant death to many, though most locals knew what was out of bounds. One morning Tim and Jaff went out to conduct some interviews. I stayed at the airport to find some soldiers who might spare me a cup of coffee. Tim and Jaff returned a few hours later ghostly white and unable to speak. They had made a wrong turn—a simple mistake in Iraq's second largest city—and run into a gang of Arab men who had decided to kill them. They barely made it back.

Mosul deteriorated into further chaos to become one of the most dangerous cities in Iraq.

THE FALL OF TIKRIT

Tikrit, eighty miles north of Baghdad, was the last city to fall from Saddam's control. On the morning of April 14, the BBC reported that American tanks were clanking down the main street of Tikrit. We were skeptical—rumors of Tikrit's invasion had been flying around for two weeks. We hit the road and found a half dozen other press vehicles hammering south toward the city. Traveling in a pack one feels a lot safer: it dramatically lowers the odds of taking a bullet.

The press usually strapped long pieces of tape reading "TV" across their cars' hoods, roofs, and doors to prevent American helicopters from attacking. Tim, Jaff, and I had also marked our vehicle as "friendly" with a piece of fluorescent orange cloth we had been given by some Special Forces soldiers. Some colleagues without an orange rag of their own arrived in Tikrit only to be attacked by an Apache helicopter, narrowly escaping with their lives.

Tikrit was a strange place. The population didn't pour onto the streets to burn Saddam posters, or pull down his effigies. American marines milled about on the main drag, and the occasional resident rode by on a bike festooned with a white flag. Combat operations were taking place less than a mile away as helicopters and tanks blasted the Iraqi Army.

On our way to one of the palaces in town, we came upon a long line of humvees leading to the charred remains of what was once an ornate display of wealth and power. On a parallel road, and in clear sight, marched a line of Iraqis carrying away anything they could manage. There were men dragging toilets, wrestling with refrigerators, and pushing stoves. An American TV truck, weighed down by expensive carpets and other valuables from the palace, drove slowly through the procession.

At the palace, we were told firmly that only embedded reporters could speak with the troops or even photograph them. Struck by an obscenely overweight marine, I ignored the rules and started chatting with him. His stomach hung low over a pair of filthy fatigues. He looked like a mighty marine gone bad in every way. It turned out he

wasn't a marine at all, but one of the embedded reporters and had sat in a tank for the whole ride from Kuwait. I stumbled off, wondering why on earth a reporter would ever want to dress like a soldier.

"Embedding" is the formal term the military uses to describe reporters living with soldiers. Over the years I've embedded with skateboarders, graffiti artists, junkies, Kosovar refugees, and small guerilla outfits in the South Pacific and Asia. I never put a name to this: getting access to my subjects is simply my job. If I could, I'd embed with every one of them; living with subjects is the best way to take in their lives' most intimate moments, and the fastest way to gain someone's trust. Those moments and that trust give me the chance to get the bigger picture into my photographs, to get closer to the truth of the story.

At this early stage of the war, arguments were being made back in the States that embedding with the military would cloud reporters' objectivity—that journalists were being fed military propaganda and concealing the "real" story. But soldiers can't prevent embedded journalists from seeing them kill civilians. The higher-ups might try to manipulate the coverage, but I didn't question my colleagues' integrity or ability to get their stories out. I did, however, question why any journalist would want to spend three weeks sitting around in the back of a tank.

I bumped into a couple of marines exploring Saddam's palace and decided I was better off breaking the noninteraction rule than passing up the opportunity to take pictures. I definitely made the right choice: the marines photographed each other with ornate chandeliers in the background, they pretended to call family from disconnected elevator phones ("Hi! Mom? Yeah, it's me!"), and they slid down the palace's banisters as though they were horsing around back at home.

That night was one of the highlights of my time in Iraq. Tim, Jaff, and I took over one of the palace's guesthouses with some colleagues and drank what beer we hadn't used to bribe marines for access to the grounds. Jaff corralled a couple of black marines to practice slang he was quickly picking up from the Americans: "You wan' me to open this can of whoop ass, you trailer park trash?" A couple of correspondents stole away from the party to screw in a bedroom once reserved for Saddam's A-list guests. The rest of us listened to Hendrix and cracked jokes with marines stopping by for an illicit beer.

SIX HOURS IN BAGHDAD
We drove south to Baghdad the following morning.

There were crowds of press already there and little need for a couple of Australian freelancers breezing into town. We felt like tourists. Tim and I had only covered Iraq from the north. We had never been in Saddam's Iraq. Baghdad was then, as it is now, host to thousands of American soldiers. It was the only Baghdad we would ever know.

On the way into the city, Tim and I joked that getting directions to Baghdad should be easy: "Go straight down Saddam Avenue, take a left at Saddam Park, and then keep going until you hit Saddam Boulevard. You'll know you've arrived when you hit the third Saddam statue." But there was nothing funny about what we found when we arrived. Plumes of acrid smoke rose from all over the sprawling metropolis, looters were everywhere, and most of the streets we tried to negotiate were blocked by tanks and razor wire. A soldier stationed near the airport told us he'd been a hair's breadth from filling our car with bullets before noticing the small orange square of fabric atop our car. The Special Forces guys from up north who'd suggested using the material had saved our lives again, but this soldier told us to trade our orange rag for a larger

piece of fabric. Unfortunately, the only store in town that stocked U.S. military-issued orange fabric had closed for the day.

We eventually found the Palestine Hotel, host to most of Baghdad's press corps. Iraqis begged for food and water through the razor wire American soldiers had used to cordon off the area. Desperate Baghdadis grabbed journalists leaving the hotel, begging to use their satellite phones so they could tell their relatives that they'd survived.

The madness wasn't confined to outside the hotel. We managed to sneak past the American soldiers who were, incredibly, demanding to see Saddam-approved press cards to let people enter. The hotel had become notorious during the invasion because Saddam's thugs had routinely arrested and occasionally assaulted the journalists based there. The lobby was a pigsty, covered in litter and darkness. Still, it was the best hotel in town, and brimmed with people. Most of them were press, though there were some contractors, and one American soldier playing a grand piano on which he'd placed his M-16 to rest like a martini glass. I was so green back then that I didn't get the picture. I didn't think I was allowed to shoot photos of the Americans.

The only contact we had in Baghdad was a reporter from Canal+ who was supposed to be staying at the Palestine. Tim combed through the names in the hotel's registry. It read like a who's who of network television. We couldn't find the guy, and decided to check our e-mail while we thought we had the chance.

"Where's the Internet café?" we asked the receptionist. From behind us, an American voice answered for him: "You gotta be fucking joking. We haven't even got electric-ity here." It was some reporter whose ratty appearance and smell suggested that he had stuck it out in Baghdad during the invasion. I hadn't realized how bad the conditions were for those based in the city. I heard later that to prepare for a rumored "microwave bomb" attack, some of the reporters had hidden their satellite phones in microwave ovens in their hotel rooms. The bomb was supposed to disable all electrical devices in Baghdad. The reporters figured that if the oven wouldn't let waves get out, it would stop them from getting in. We'd had it good up north.

Jaff took us to a small hotel his uncle owned nearby. The man apologized for not being able to offer us tea, but there was no water or power, and hadn't been in weeks. He refused to rent us a room because of the condition the hotel was in. A gunfight erupted down the street, drowning out the small talk.

We had little money, no contacts, no hotel room. We decided to leave Baghdad and continue south to Karbala, where the Shia were gathering to mark the end of Ashura, a major religious holiday, for the first time since Saddam had taken power thirty years ago. We found Karbala, too, crawling with journalists. We spent the night there, then drove back to Kurdistan.

THE NEW YORK TIMES

Up north, many journalists who covered the war had either left the country or moved on to Baghdad datelines. The few who remained focused on the unfolding reversal of Saddam's Arabization program. Saddam instituted the program during the 1980s, aiming to shift Kirkuk's mixed population of Kurds and Arabs to one hundred percent Arabic. An ethnically cleansed city would allow Arabs to control the area's vast oil fields in perpetuity. For the past two decades, tens of thousands of Kurdish families were forced to live in refugee camps in Iraqi Kurdistan. Saddam

gave Arab families financial incentives to move north from southern and central Iraq, and occupy the Kurd's homes.

The postinvasion madness gave the Kurds a perfect opportunity to reclaim their homes, but the Arabs were not easily moved. After years of living in Kirkuk, they had no other homes to return to. Armed Kurds descended on Kirkuk and surrounding villages with a direct threat—get out or die.

At a Kurdish refugee camp in Erbil, we found thirty families preparing to return home. Their village, Ala-u-Mahmud, had been taken from them twenty years earlier. They were eager to get out of the run-down camp. On the day Kirkuk fell, the men of the families drove to the village and set down a deadline for the Arabs' departure. Should the Arabs decide to stay, the Kurds said, the disagreement would be resolved with a gunfight outside the mosque on Friday, high noon.

These tensions went on, and we covered them for close to a month until, finally, American soldiers entered the area. The Kurds who were trying to retake their land by force were arrested and loaded into the backs of five-ton trucks for their trip out of Kirkuk. The Kurds complained, "First Saddam throws us out, and now the Americans arrest us for trying to return."

Tim went home to Paris soon after the arrests. I stayed because I'd picked up some work from the *New York Times*. It was an important assignment, my first significant job for an American publication, and I wanted to prove myself to the paper. The *Times* correspondent assigned to the north, Sabrina Tavernise, was an incredibly thorough reporter, working every day from before dawn until late into the night. I was run down, and the long hours doing interviews and taking pictures started taking their toll.

Sleeping and eating became secondary to showing the paper that my work was to their high standards. I finally left when, malnourished and dehydrated, I reluctantly agreed to be medivaced to Turkey. I felt fine the minute I arrived in Istanbul.

I rested for a couple of months in Paris, where I had an apartment at the time. I spent most of my time at an expat bar in the Marais called the Lizard Lounge. Celebrating the eve of Bastille Day with other foreigners at the bar, I spied a young lady sitting nearby. My recklessness on the frontlines did not translate to approaching pretty strangers in bars, so I commissioned Tim for the job. That was just the beginning. I met Joanna. We fell madly in love, and I soon moved to New York with her. After a month of bliss, I went to see the *New York Times*. They immediately gave me a two-month contract in Baghdad. By this time, editors were finding it difficult to hire photographers to work the Iraq beat. Photographers complained the light was horrible, the country didn't look good in pictures, and it was too dangerous. I don't think I would have gotten the gig if so many other photographers didn't hate covering the war.

I arrived in Amman, Jordan, late at night and took a cab directly to where I could find an inexpensive ride to Baghdad—$300 for the twelve-hour journey. The route took us straight through the dangerous Sunni heartland of Anbar province, and my driver demanded we leave at midnight so we could pass through Falluja at dawn. Statistically, he told me, there were fewer attacks then. I was nervous—people had been robbed dozens of times on that road, and for the first time, Tim wasn't accompanying me to Iraq.

My trip was relatively uneventful. As we approached the most dangerous part of Anbar, my driver hid his cash behind the ashtray and hit the gas, speeding down High-

way 10 as fast as the old GMC would take us. I complained the whole time that I had no money, meanwhile scheming how I might hide my cameras should we be stopped. I was convinced that the drivers were in on the robberies, tipping off their counterparts in Iraq when they had a wealthy foreigner in their cars. A black BMW, then the insurgents' and gangsters' car of choice, pulled alongside us on the outskirts of Falluja, but my driver waved it away, and it obliged.

That drive was to be the first and last time I would enter Iraq by road. As the Sunni insurgency gained momentum, Highway 10 became more dangerous. Some contractors were gunned down at a roadside stand I had stopped at for a soda and a pack of smokes. Falluja became the unofficial capital of the resistance. Soon enough, Western hostages were being regularly paraded on websites before having their heads hacked off. The country was in the grip of a full-fledged terror campaign.

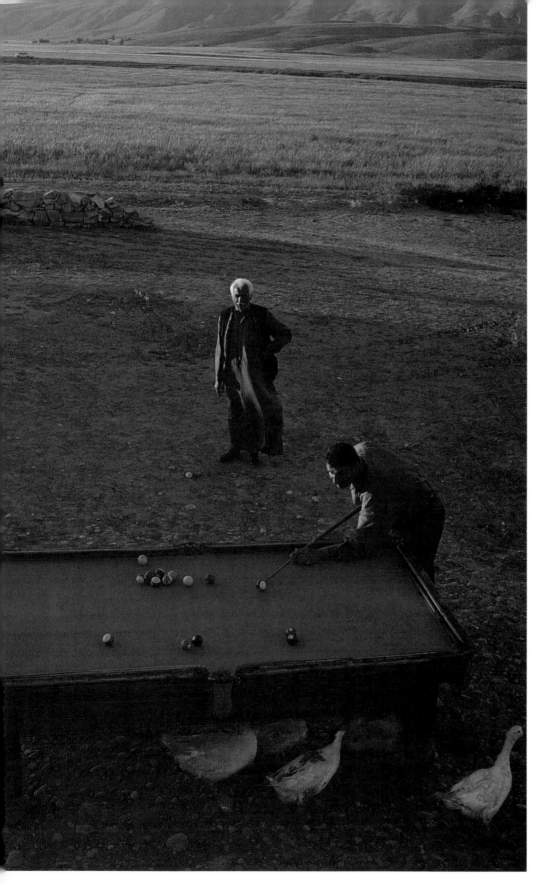

Arabs play billiards in front of a wheat field in their hamlet near Mosul.

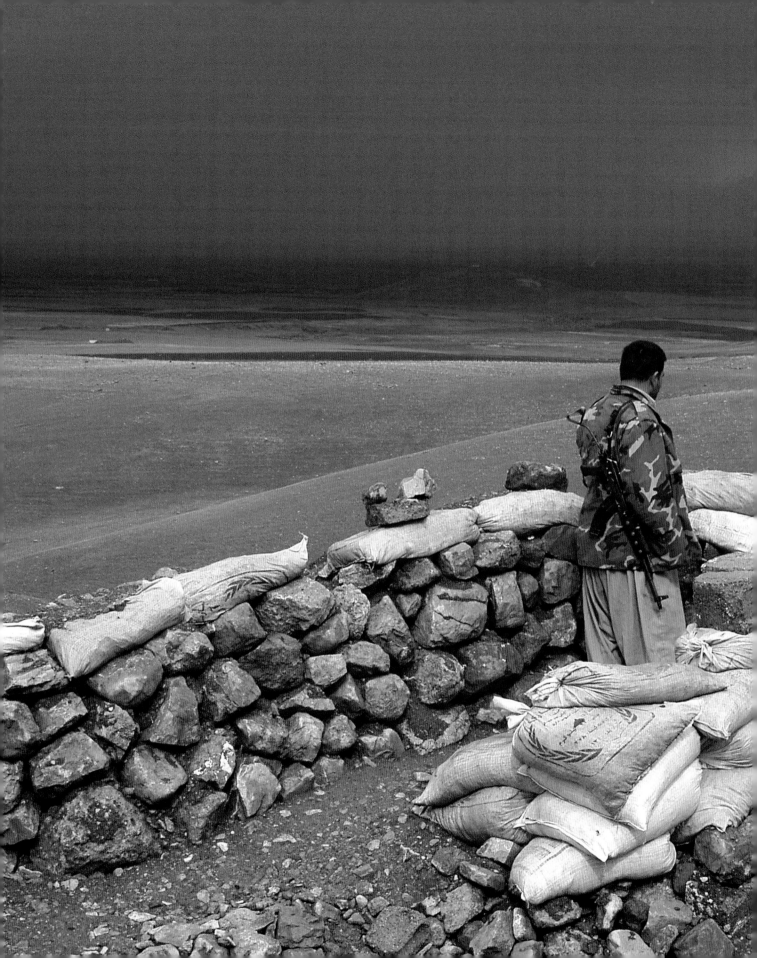

Five weeks before the U.S.-led invasion, a Kurdish fighter, or Peshmerga, stands guard on the front line near Halabja, facing Ansar al-Islam, a radical Kurdish group connected with al-Qaeda. At this outpost we learned by satellite phone that my colleague Paul Moran had been killed by a suicide bomber nearby.

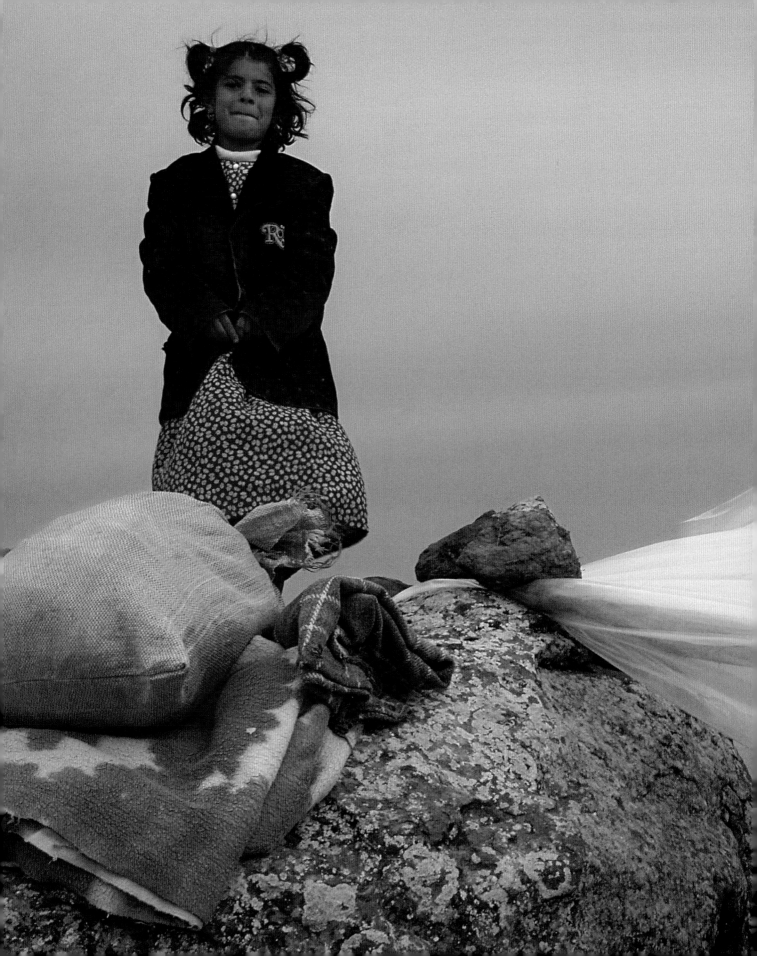

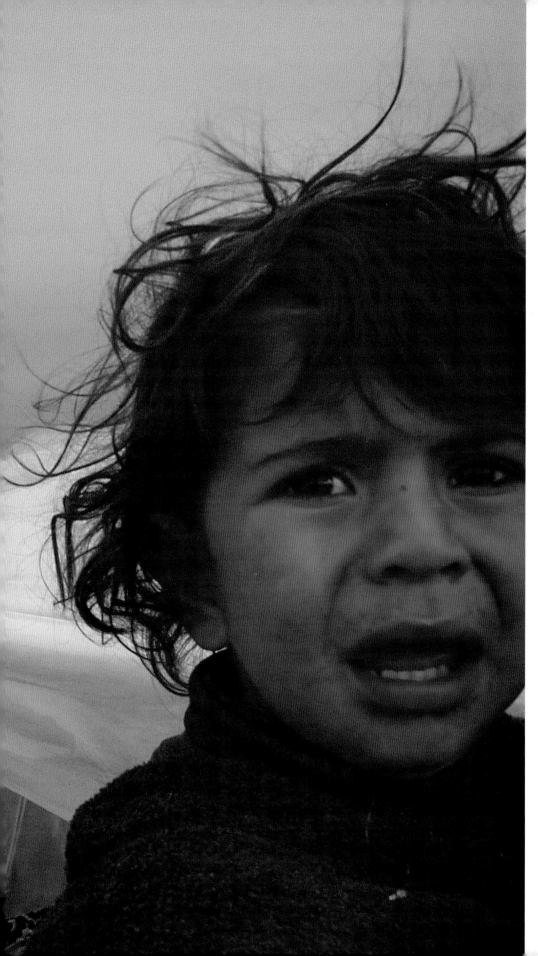

Refugees at their temporary home in the Kurdish countryside. Kurds abandoned northern cities in the lead-up to the invasion, fearing chemical attacks. They built plastic shelters between rocks that they said would protect them from both rain and poison gas.

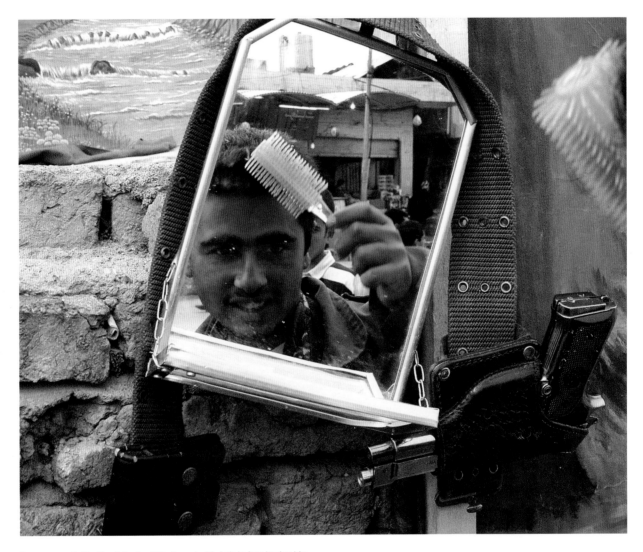

A young man in the Kurdish city of Ebril combs his hair before having his photo taken in front of a mural depicting an idyllic scene. Pistols and holsters are favorite props in a society long dominated by the politics of force.

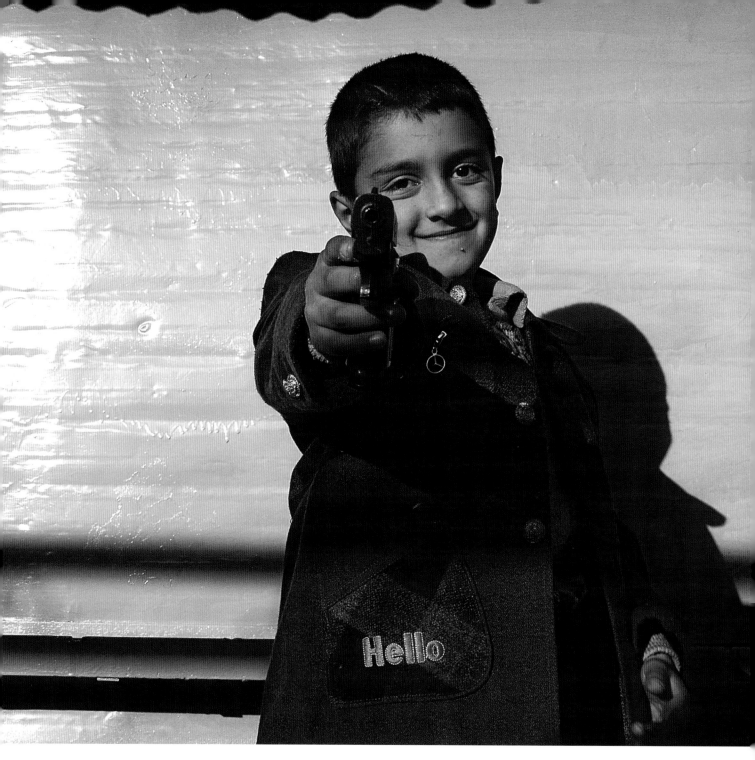

A boy welcomes me to his neighborhood with a toy.

A U.S. State Department employee guards the February 2003 Iraqi opposition conference in Salahaddin attended by Zalmay Khalilzad, America's ambassador-at-large. This was the first armed American presence I saw in the country.

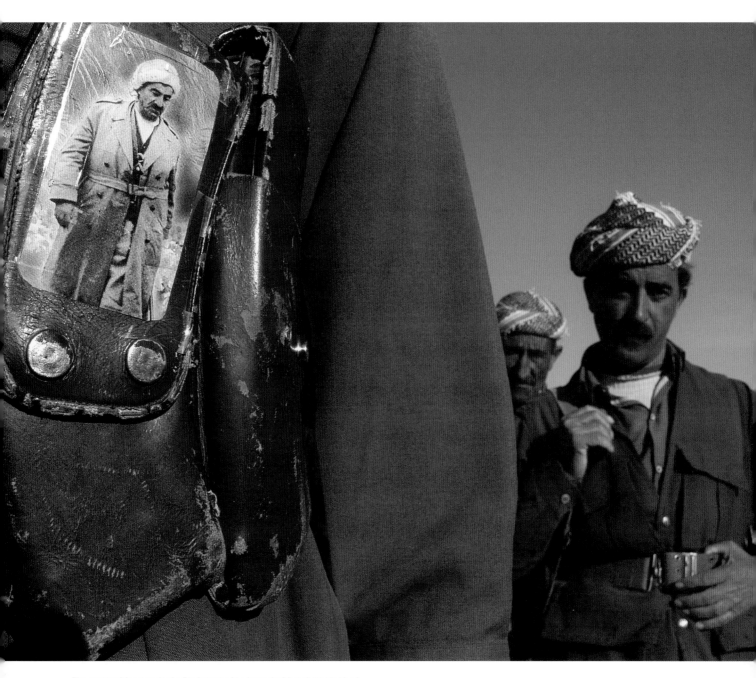

The ammunition pouch of a Peshmerga is adorned with a photograph of
Mustafa Barzani, the legendary Kurdish fighter and father of their current
commander, Massoud Barzani.

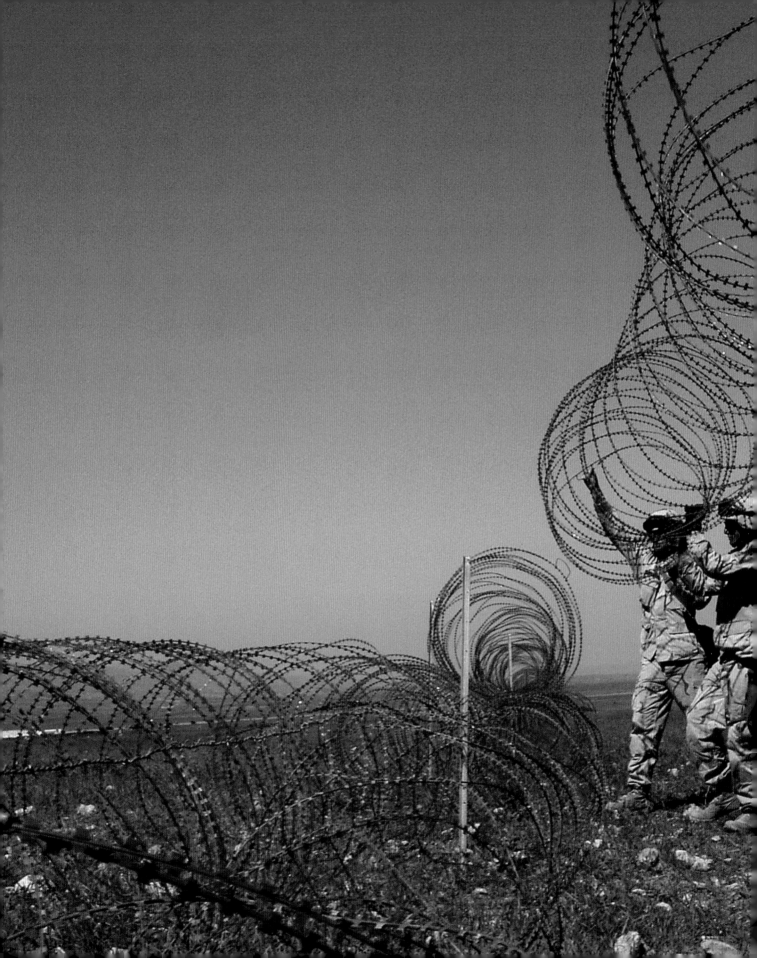

U.S. paratroopers from the 173rd
Airborne lay fencing around an
airstrip in northern Iraq.

American troops and Peshmerga fought side by side against Iraqi army positions in early April 2003.

A Peshmerga dodges machine gun fire from behind a berm as the Iraqis repulse an attack by U.S. and Kurdish soldiers.

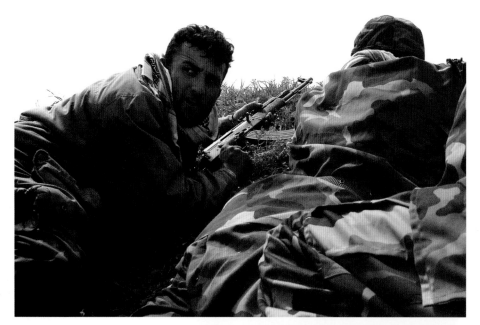

Heavy bombs drop on an Iraqi army trench.

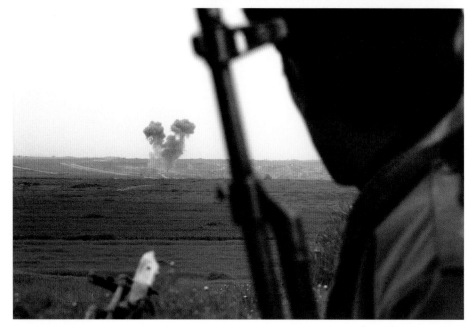

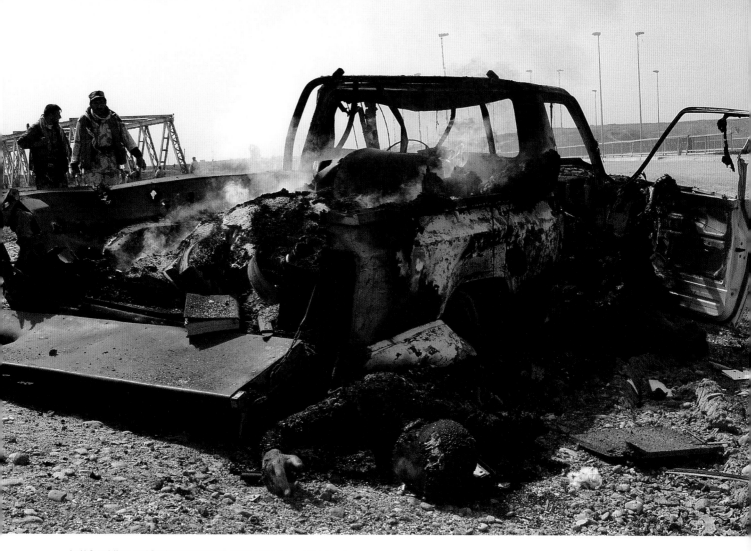

As U.S. soldiers and Peshmerga moved south against heavy Iraqi resistance, this truck was hit by American bombs and three occupants were burned beyond recognition. When I arrived on the scene moments later, I couldn't find any evidence that the men were combatants. The truck seemed to be carrying a load of books.

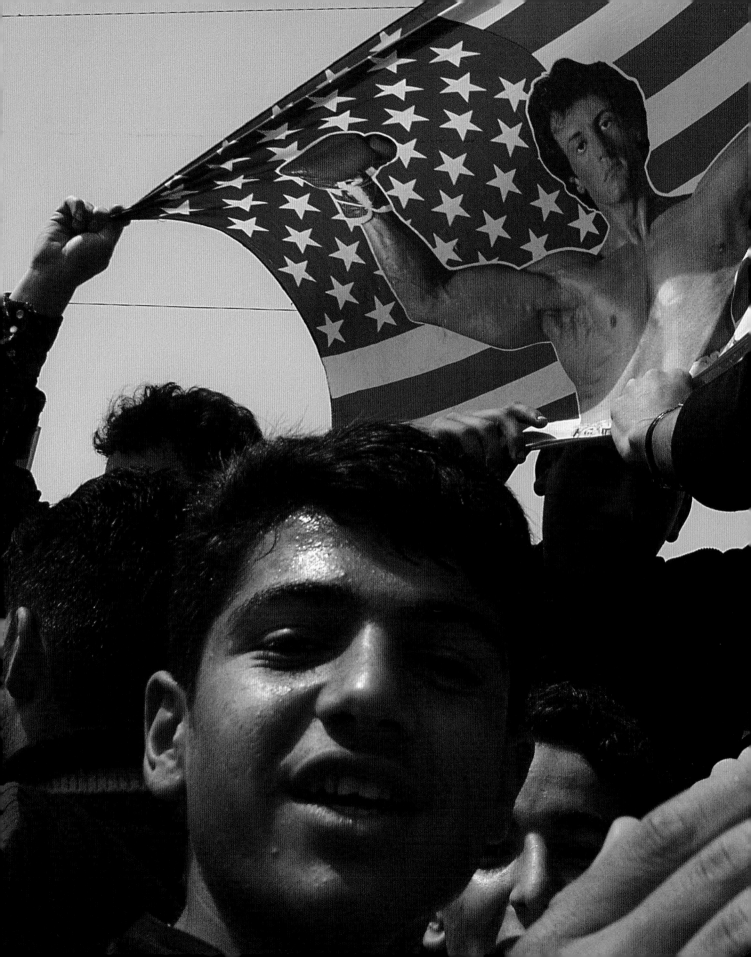

Kurds celebrate on the streets of Erbil as Baghdad falls to U.S. forces. Thousands of people partied through the city in what were the first mass gatherings since Saddam's seizure of power in 1978. American flags were hard to come by in Iraq, and these kids made do with a Rocky Balboa flag smuggled from Turkey.

Arabs and Kurds destroy some of the propaganda Saddam had installed throughout Mosul.

OPPOSITE Saddam's portrait burns in downtown Mosul. It was set ablaze by my fixer, Jaff. When I rebuked him and told him not to get involved, he replied, "Ashley, first I am an Iraqi. Second I am a journalist."

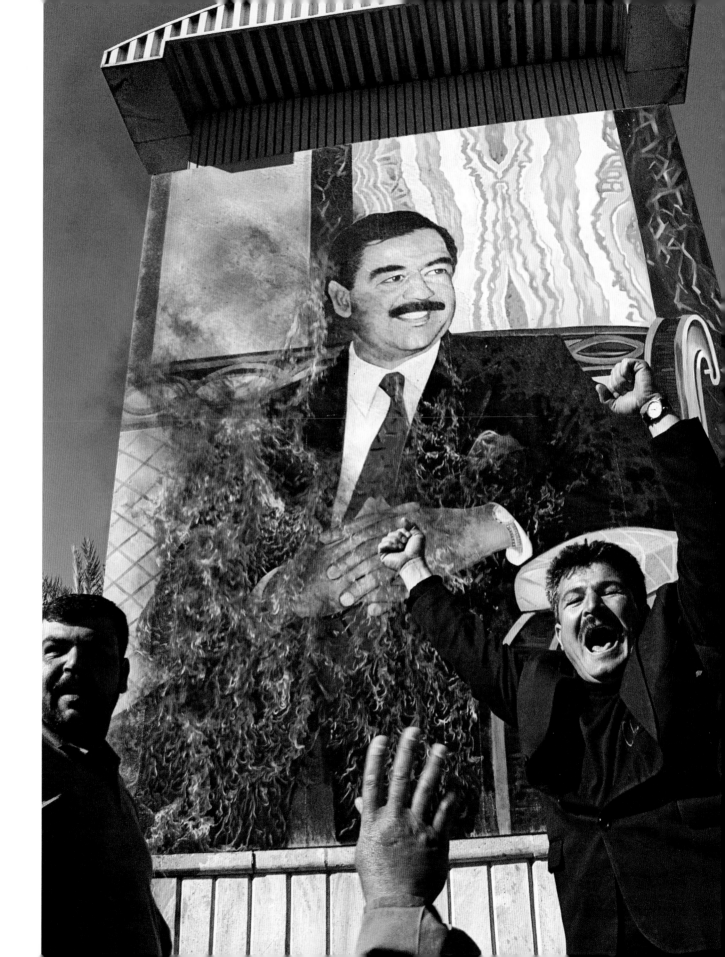

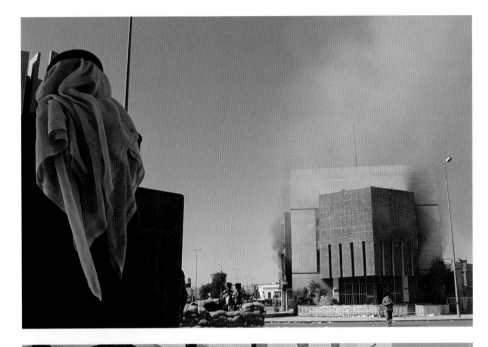

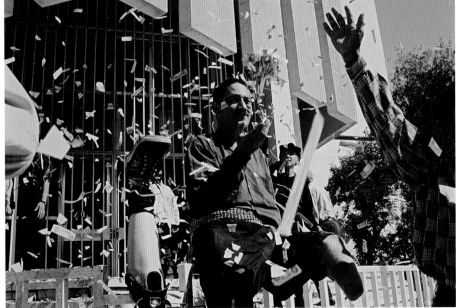

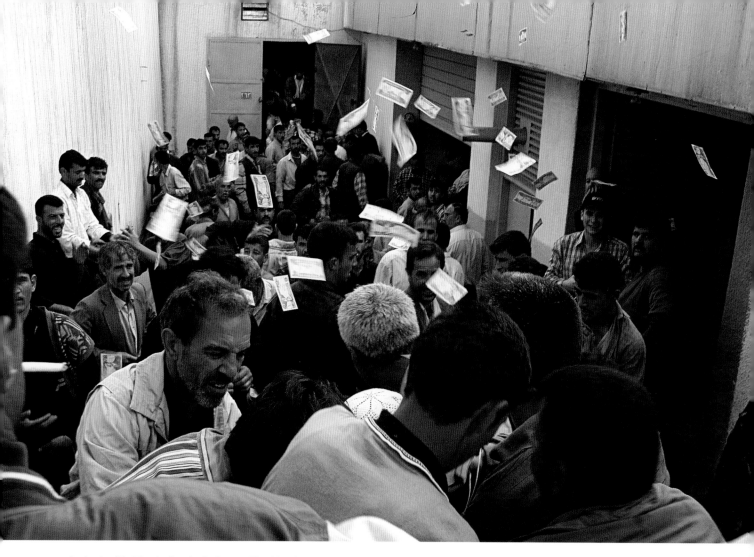

Banknotes filled the air after the Peshmerga blew Mosul's central bank vault. Arabs and Kurds grabbed what they could, risking burnt hands and worse. People only left when the burning bank was completely looted.

Arab children loot rice from a United Nations food distribution center.

Saddam's personal toilet, carried away from a palace in Mosul, had golden crests. "Every time I take a shit, I will think of Saddam," one of the looters said, though the men who stole it had no running water.

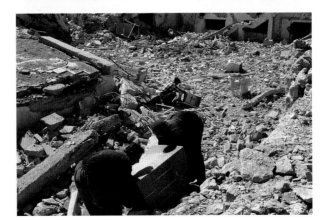

Two Mosulis steal an air conditioner from a military building that had been leveled by a 2,000-pound bomb. There was no electricity in the city at the time, but presumably they were optimistic that would soon change. It didn't.

Jamila Hussein was sitting in her Mosul home playing alone when she was hit with a 7.62 mm bullet. Her parents, having heard the shot, got her to the hospital in time. The round went straight through her left side, just missing her heart and lung.

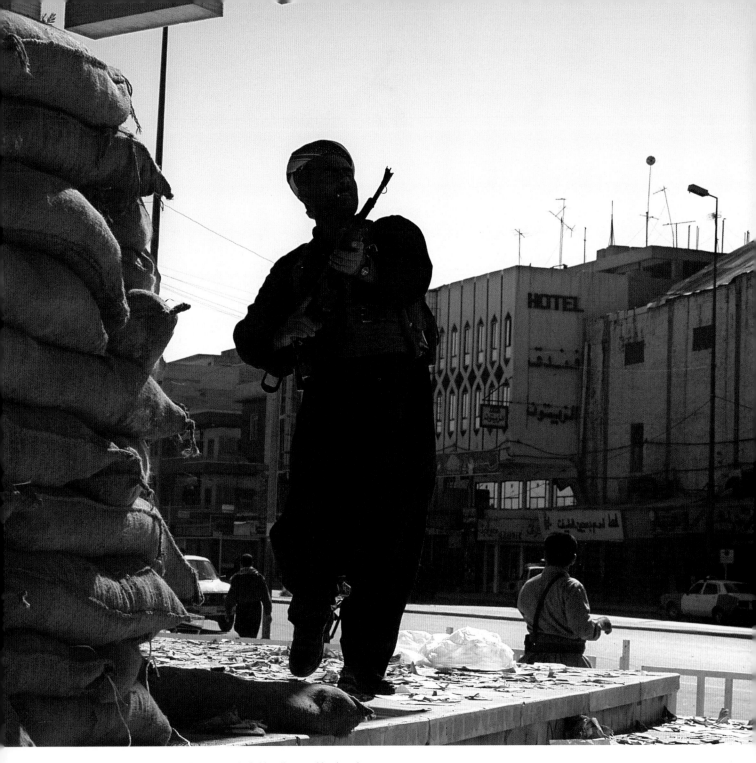

A Peshmerga from Erbil defends his stake in Mosul's central bank vault.
The Kurdish authorities conspired to steal valuable resources from the
city—money, ambulances, heavy weaponry, hospital cots.

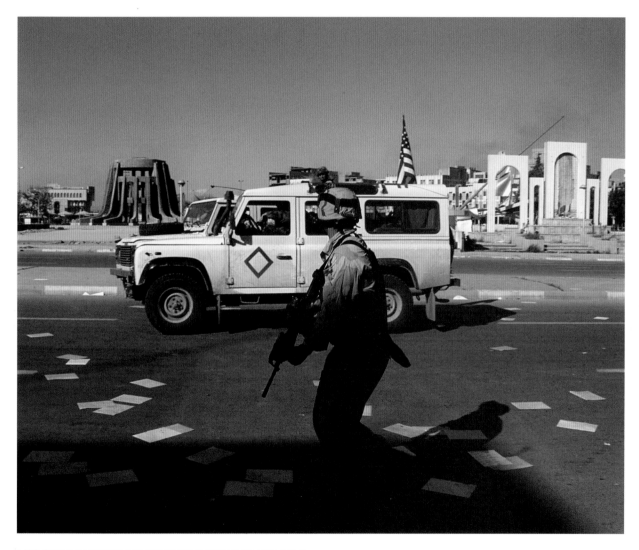

A U.S. Special Forces soldier dodges Fedayeen Saddam fire after government offices around Mosul were looted and burnt.

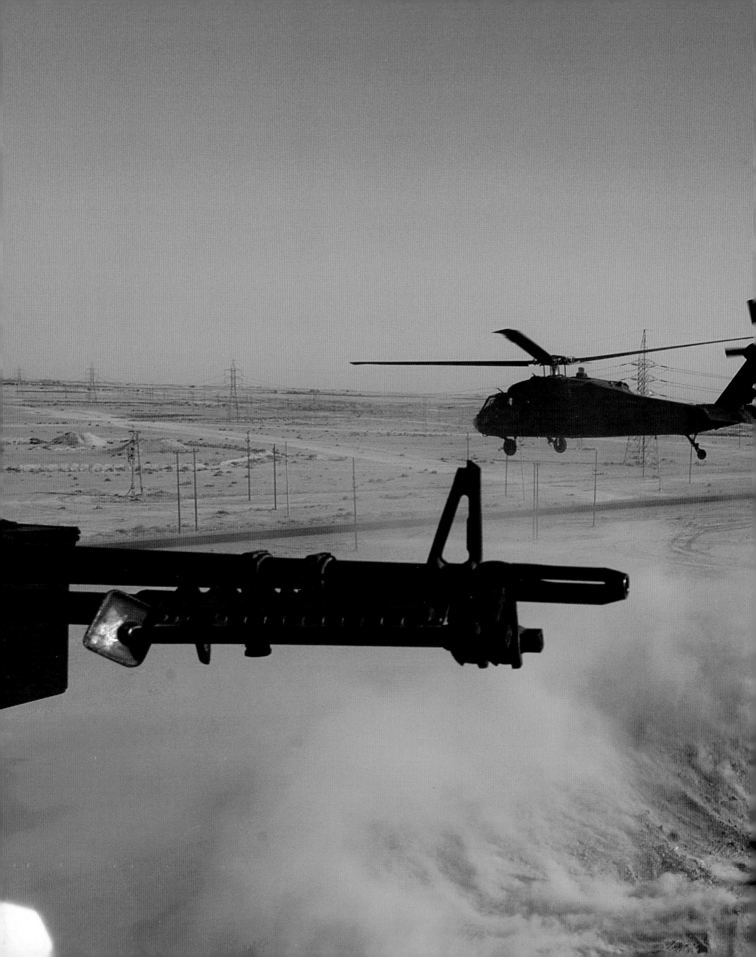

An American Black Hawk performs a combat takeoff in the desert near Tikrit. Pilots were advised against flying too close to shepherds because the helicopters would frighten their animals, sending them fleeing across the desert.

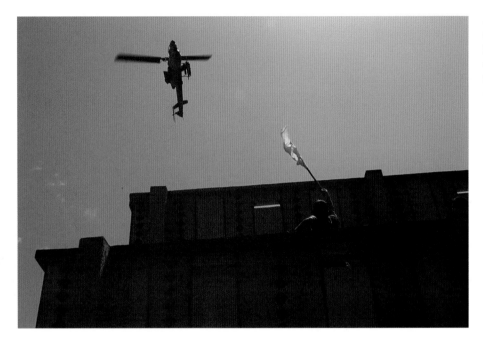

An Iraqi child waves a white flag as a Cobra helicopter flies over his home. The chopper attacked dozens of targets in Saddam's hometown of Tikrit while the U.S. Marines cleared buildings.

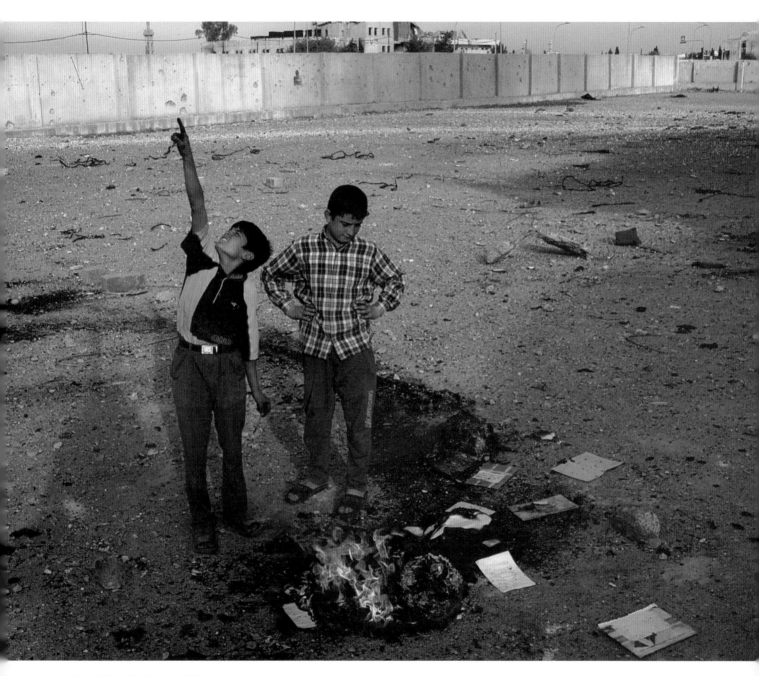

Two children kindle a fire with books to extract copper wire from looted
electrical cords while a fighter jet passes overhead.

A marine slides down the marble handrail in Saddam's palace in Tikrit.

After waiting in line for three days, an Iraqi pushes his car to a Mosul gas station guarded by U.S. troops. American soldiers took over from the Iraqi police immediately after the invasion because the U.S. government decided that Iraqi forces could not be trusted; their decision further taxed inadequate troop numbers. Everywhere I went in Iraq for the next four years, U.S. soldiers monitored gas stations.

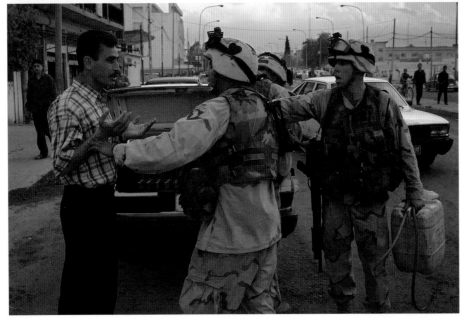

Soldiers confront an Iraqi who was carrying an empty twenty-liter container and siphon in his trunk. They accused the man of planning to sell the gasoline he had lined up to buy.

Marines cover a man's mouth with duct tape after finding guns in his car. He had tried to explain that everyone in Iraq has weapons, but the Americans didn't have a translator and the conversation was brief.

In Mosul, the 101st Airborne found two trucks they thought were mobile chemical weapons labs. The Army was keen for the media to expose what they took to be Saddam's weapons of mass destruction. The trucks proved to be made for producing balloon-grade helium.

A cameraman from the Qatar-based network Al Jazeera prepares for a
live broadcast from central Tikrit.

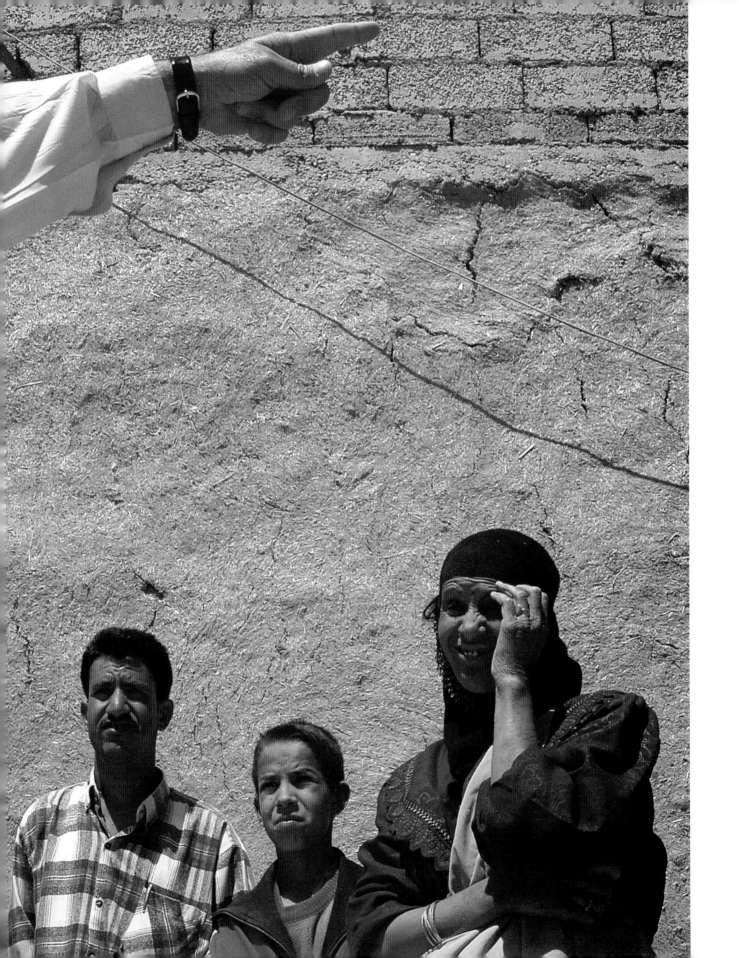

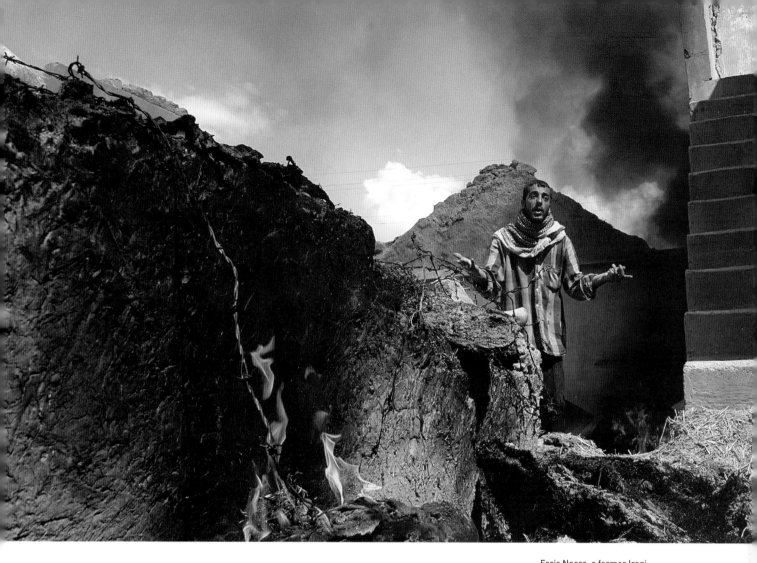

Faris Noore, a former Iraqi soldier, stands by what was once his house on the outskirts of Kirkuk. Kurds told him he had to leave because they owned the house he'd lived in his entire life. In a rage, he burned his home to the ground. If the Kurds were coming back, he told me, he wanted them to have nothing.

OPPOSITE

"If you don't leave by Friday," the Kurd said, "we'll work it out with guns at the mosque." Saddam had given Arabs from the south and center of Iraq incentives to displace Kurds as part of his policy to Arabize the oil-rich north. Kurds were now taking the opportunity to return. This Arab family in a village west of Kirkuk had been living in the Kurd's home for twenty years.

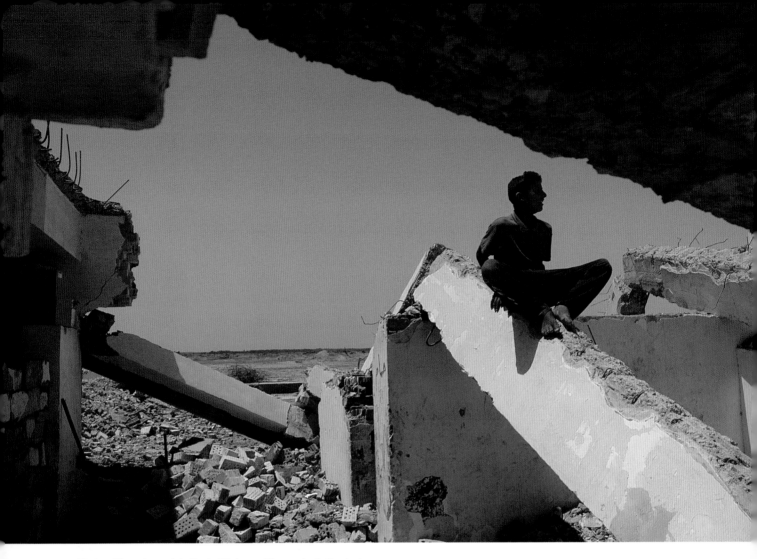

Displaced from the north by Kurds, this boy and thousands of other Arabs took shelter in a bombed-out military base in Baqouba, a stronghold of the insurgency in the Sunni Triangle.

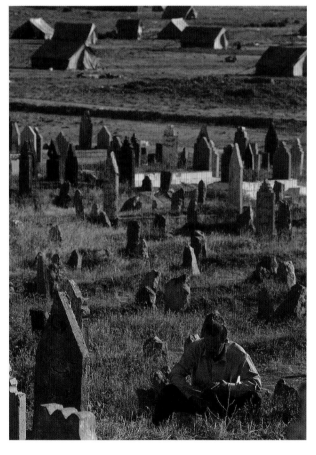

Osman Mohammad Abbas, a Kurdish teacher, returns to his village ten years after he was thrown from his home by Ba'athist thugs. This was his first chance to pray at his mother's grave. Beyond the cemetery, tents house Kurdish refugees while they rebuild their houses in their old village.

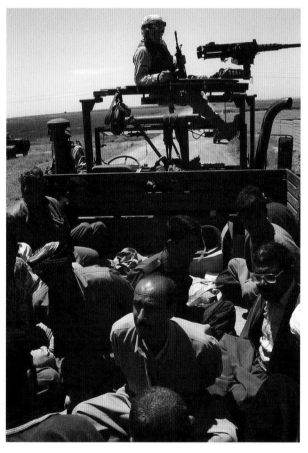

U.S. troops arrest Kurds for attempting to evict Arabs from homes they had lived in before Saddam's Arabization policy.

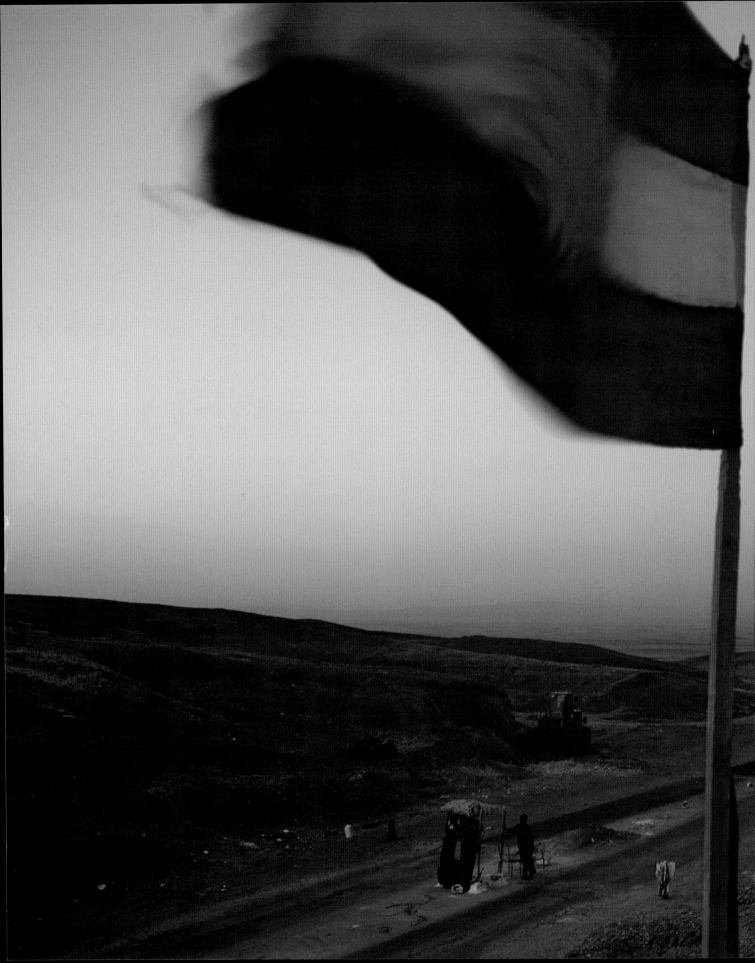

Two Peshmerga stand on the green line that divides the Kurdish region from the rest of Iraq. The Americans were paying them to work for the fledgling Iraqi Army. American policy forbade Kurds to reclaim homes they had lost to Arabization south of the green line. The Kurds paid little heed to the occupiers' new rules.

59

TWO

OCCUPATION

THE NEW GRUNT

In early 2004, Royal Jordanian Airlines began direct service from Amman to Baghdad. A one-way ticket for the forty-five-minute flight cost $600. It was safer than driving, but threats abounded in the air as well. Insurgents routinely shot down military helicopters and had successfully rocketed a civilian plane taking off from Baghdad International Airport (BIAP). To elude attacks, Royal Jordanian's little twin-engine Fokker would descend into Baghdad in what felt like an impossibly steep and dangerous corkscrew, leveling out at the very last second above the runway. I fell asleep during takeoff one morning, only to be awoken two hours later by the captain welcoming the passengers back to Amman. My neighbor explained we had made it all the way to Baghdad, but fighting on the ground prevented the aircraft from landing.

Arrival in BIAP only meant that we'd jumped one hurdle. There were the sluggish and corrupt Iraqi customs, where bribes helped your small luxuries from planet earth (only forty-five minutes west) pass through unquestioned. Then there was the airport road. I hated this more than any other leg of the journey. It was a ten-mile stretch connect-

ing BIAP to central Baghdad and was the most danger-
ous road in the world. The Americans named it IED alley,
for all of the improvised explosive devices insurgents
planted there. The Iraqis just called it Death Street. Vari-
ous options were available to make the trip: a military
Rhino truck, a rocket- and bomb-proof bus that made the
trip every midnight, an armored taxi service provided by
mercenaries that cost $2,390, or in my case, the *Times'*
armored car, which would ferry me to the bureau shad-
owed by an additional carload of gunmen intended to cre-
ate a diversion in the event of an ambush.

To really set my nerves at rest, Mark, then the *Times'*
security advisor, would update me on the hellish state of
the country, emphasizing each "incident" by pointing to
fresh examples of roadside bombs, suicide car bombings,
and ambushes on the road. It always seemed to me he did
it for effect. Well, Mark, here it is: it worked.

My assignment in November 2003 was two months long,
and my first major contract. In the past I worked by driv-
ing about with a trunk full of beer, photographing whatev-
er interested me. Filing every day, on deadline, was still a
new concept, as was working directly under tough editors
at a major newspaper. A small bit of comfort was that Jaff
had landed a job at the *Times* too.

The *New York Times'* enterprise in Baghdad was like a
military operation, and I was the new grunt. Ranked pho-
tographers snagged all the high-profile jobs, and it took
the reporters a long time to warm to me. One miserable
night in the newsroom, I sat alone drinking beer, try-
ing to work out what the foreign desk was thinking. Did
they like my pictures? Was I doing my job properly? I had
no feedback from anyone. Two photographers strolled
in and announced they were leaving to attend a party at
the Hamra, a nearby hotel. I don't know why they both-
ered telling me, since no invitation was extended. Well,
if war photographers had a club, I decided I didn't want
to belong to it. I was so uncertain of my standing at the
Times that if I was exhausted, rather than nap at the
bureau I'd take a driver and have him roam Baghdad's
streets while I slept in the passenger seat. I'd tell the
driver to wake me if he saw anything interesting.

A photographer's mobility on the streets of Iraq was a
good indication of the country's state. On this rotation, I
could drive about freely in the mornings and evenings,
talking to people, photographing what I wanted with little
incident. Not six months later, most foreign press was
confined to heavily guarded hotels and houses. But this
didn't stop us from being attacked. The Palestine Hotel
was hit by a double suicide bombing, the first one opening
a gap in the blast walls around the complex, the second, a
concrete truck laden with explosives attempting to pass
through before getting caught in barbed wire and blow-
ing up. Another suicide bomber destroyed an entire wing
of the Hamra. When we could leave, a small militia was
dispatched to protect us. Almost all drivers were armed,
as were the translators. I knew of a few reporters from
various news outlets who had carried weapons at some
point, though this practice was stopped when security
was beefed up.

CHASED FROM SAMARRA
I made my own visit to Samarra shortly after a major
battle had taken place there. It was a bad town. Lots of
al-Qaeda and nationalist insurgents were inflamed by
the deaths of fifty-four Sunnis who had been killed in
a double ambush two days before. I traveled low pro-
file, driving in a beaten-up sedan without guards. I
arrived in town, and my driver Tariq parked outside a
small base in the center of town. A Special Forces sol-
dier ran out and told us to get lost—they were com-

ing under attack all the time. We drove to the edge of town. My sat phone rang, and we stopped the car so I could discuss a job with a photographer in Baghdad.

While I talked on the phone, a BMW pulled up on my right. I looked inside the car to see that there were four men, all staring back at me. Their eyes are what stay with me today, and it's something I wish I could photograph: pure hate. I put the phone in my lap with my camera equipment and said to the guys in the car "Assalamu Alaikum habibi, shlonak?" or "Peace be with you friend, how are you?" We were so close that I could smell the driver's bad breath. They did not reply, or even blink. I told Tariq that we should go. We pulled forward and made a slow U-turn. I saw the barrel of a Kalashnikov rise in the back seat of the BMW.

Then the bullets started flying.

Tariq lurched into a traffic circle, deliberately veering all over the road, and I am quite sure this is what saved us. Within fifteen seconds, he put a vehicle between us and our pursuers, who continued shooting. We raced to put more traffic between us and them, but they kept following. I ate dirt on the floor of the car, and Tariq drove almost blind as he hid below the window line. We sped through a bank of traffic before coming to an Iraqi army checkpoint. "Sahafi!" we shouted—Arabic for journalist—and they lowered their weapons and started shouting back at us. We slowed down to say, "Black BMW chasing us, four assailants, one gun we think, trying to kill us, have a nice day friend, yes thank you, and to you too, yes good-bye, peace be upon you . . ." Arabic pleasantries can be maddening at times.

When we hit the highway we had a good head start. Tariq had his foot to the floor but his rickety old car leveled out at only 100 mph. He kept looking nervously into the rear-view mirror saying, "They're coming." Honking and flashing our lights to get past traffic blocking our way, we hit a pile of glass in the road and blew out a back tire. We were now crippled on the side of the road. The only approaching cars we could see were in the distance coming from Samarra, and one of them was madly veering in and out of the traffic. It was the BMW. There was a wide expanse of desert on all sides of us. There was no escape nor any way to hide.

Out of nowhere an Apache attack helicopter flew over at thirty feet and circled us. The BMW made a U-turn.

A military convoy came through moments later, and it evacuated us to a base south of Tikrit. I called the foreign desk, and my editor asked whether I was all right finishing my rotation in Iraq. I did want to stay. There was a town just to the south of there that *Times* reporter Dexter Filkins was planning to travel to the next day, and I knew I could get a ride there with the military.

SHOOTING SASSAMAN

Dexter was writing a feature about Abu Hishma, a town that was under the command of Lieutenant Colonel Nathan Sassaman of the Fourth Infantry Division, a West Point graduate and former Army football star. Abu Hishma was an extremely violent town in the Sunni Triangle, and Sassaman and his men were getting attacked four or five times a day. Finally, one of Sassaman's men died after an RPG, or rocket propelled grenade, flew through the front of his vehicle and lodged itself into his chest. Sassaman decided to take extreme measures to control the region. There was no Army manual on how to subdue a town in the Sunni Triangle, but there were techniques he unofficially picked up from the Israeli military. Sassaman had Abu Hishma wrapped in razor wire and imposed

a curfew. He demolished any building used by insurgents. He set up a single checkpoint leading in and out of town and issued identification cards to male residents to monitor their comings and goings. Anyone caught beyond the wire after 8:00 p.m. was, at best, detained. If they acted aggressively they were killed. Along the razor wire, signs were hammered into the ground warning the residents that if they tried to cross the fence, they would be killed. If Sassaman at all believed that someone was an insurgent, soldiers would arrest his family. When the suspect appeared to collect his relatives, he was arrested, too.

Sassaman had had Abu Hishma locked down for two weeks when Dexter and I arrived. The town was awash with evidence of heavy fighting. We saw trucks with windscreens shattered, pockmarks in walls. Some houses that Sassaman had bulldozed to punish families with insurgent members were partially rebuilt. An old man in town told Dexter of Sassaman, "When mothers put their children to bed at night, they tell them, 'If you aren't a good boy, Colonel Sassaman is going to come and get you.'"

We drove out of town to find Sassaman. Before we reached the base, we recognized him with a group of his men on the side of the road. He was interrogating an Iraqi he thought was involved in the RPG attack that had killed one of his men. "If you weren't here with your camera," one of his grunts said to me, gesturing to their suspect, "we would beat the shit out of this guy."

A month later, a platoon of Sassaman's men threw two Iraqis who had violated curfew into the Tigris River. One of the men drowned, and the survivor reported the incident to military police. Sassaman tried to cover it up to protect his men, who he thought had merely made an error in judgment. Two soldiers were charged with assault—they escaped manslaughter charges after questions of

authenticity of the drowned man's body were raised. Sassaman, one of the brightest and most promising midlevel officers in the United States Army, retired.

The pictures for the Abu Hishma feature covering Sassaman were without a doubt my strongest work on that first rotation for the *Times*. My editor said I might have a chance for the front page of Sunday's paper—which with double the readership of any other day made me hopeful she was right.

"You own the paper today, dude," one of the other photographers said while I had my first cup of coffee the next morning. I hadn't yet checked the frontings, a daily e-mail from New York listing every photograph and story in that day's paper, so I went back to the office to get online. Not only did it say that I had the front page but that I had two pictures stacked on top of each other, both three columns wide. Inside, I had another four pictures. I couldn't have asked for better play. I wanted to call Joanna, tell her the news, but it was far too early in New York. When I finally did call, I woke her up. She said that a winter storm had hit the city overnight, and New York looked gorgeous under a fresh blanket of snow. I tried to play it cool, making small talk and trying to hide my elation. I had never had so many pictures in a single edition.

I told her that there might be a surprise in the *Times* today—I always called my photographs that ran in the paper postcards made specially for her—and that I'd wait while she went to the door to get the paper. She came back and told me that my cover wasn't there—the lead story was the weather. I couldn't believe it. My first good run had been ruined by a fucking snowstorm. Worst of all, the *Times* had run some cheeseball picture of a bride walking to the chapel through the snow. I went into Dexter's room and started ranting. Dex didn't have a lot to say

about it, but it was nothing new to him: "Newspapers will break your heart, man."

THE BOMB SQUAD

Meanwhile, in Baghdad roadside bombs drummed a chorus through the capital's daily life. American patrols sometimes found the carefully placed IEDs by the road before they were detonated by timer or a waiting insurgent. Then, they'd call in one of the bomb squads.

When American engineers got the call, they arrived with Kevlar suits and robots, and they would sometimes spend hours defusing the insurgents' signature weapon. But often the job fell to an Iraqi bomb squad, and they had no such technology. Underfunded and unappreciated by the American soldiers whose very lives they were saving, Lieutenant Majid Mahdi and Lieutenant Hazim Kadhem of the Iraqi police used the one tool at their disposal: speed.

Their procedure was simple. They drove to the site, got out of their beaten up pickup truck, and sprinted toward the bomb. The trick, they explained, was to cut the wires before the insurgent responsible for placing the device had a chance to press the button and blow them up.

I spent five days with Majid and Hazim. It was hard to portray their jobs' risk without getting as close to the bombs as they did. On my second outing with them, they were trying to dismantle a huge artillery shell attached to a garage door opener that had been buried under bushes on the side of the road. I ran at the scene so quickly that my picture showed movement and was badly composed. I was so impressed by these guys—I wanted the perfect frame, one that would run prominently on the front page and show their bravery to the world.

One day, Majid and Hazim arrived on a scene that had been cordoned off by U.S. military police. I ran with them across a messy road of confused soldiers toward a suitcase that had been hidden under a tree branch. While they began cutting open the case with a knife, an American soldier started shouting wildly at me from at least forty yards away, ordering me to get out of the immediate blast area. I shouted back at him, asking why my life was more important than Majid's. The soldier yelled that it didn't matter why, that I had to get out of the explosion zone. If he really wanted me out, I yelled, he could come and get me.

A couple of weeks later, the Americans awarded medals of bravery to Iraqis who had assisted the occupation. Not one member of the Iraqi bomb squads received a medal. Both Majid and Hazim were eventually killed in separate incidents while the bombs they were trying to defuse exploded.

I felt dejected at the end of most of my rotations; it's pretty normal after a couple of months in country. Every day in war is difficult at the best of times. I often cried in Kosovo—my first war—when I wasn't drunk. Experience is a journalist's only training. We learn how to cope with the present, to put most of our emotions aside until later. We have to be largely detached to get the job done, letting our cameras and notebooks act as emotional buffers. But the day Majid and Hazim didn't receive medals, I was heartbroken.

At the end of another two-month contract with the *Times*, reporter Jim Glanz invited me to shoot a story he was covering in the Persian Gulf. A suicide bomber at sea on a low-slung Arab dhow had tried to blow up Iraq's main oil pipeline, and security had been stepped up. I jumped at the chance to photograph the U.S. Navy's activities along Iraq's thirty-six miles of coastline. The blue ocean would be a welcome change from the country's endless deserts.

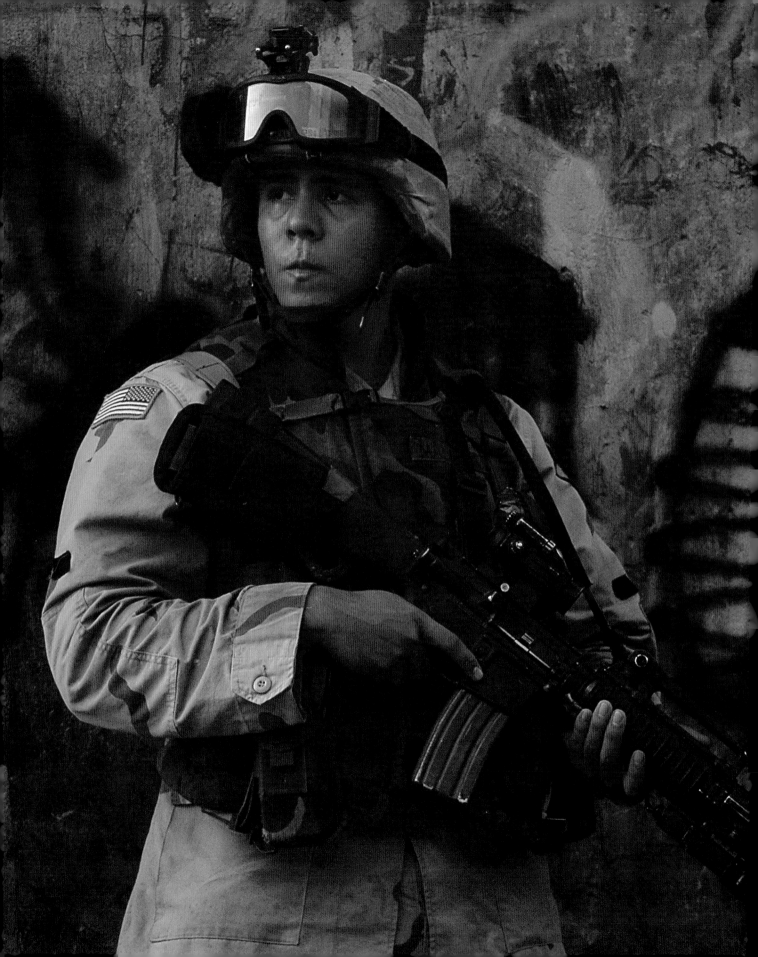

A soldier from Task Force 1-9 of the First Cavalry Division patrols Haifa Street, a dangerous thoroughfare in north central Baghdad. Mujahedeen controlled Haifa Street and the warren of streets around it. The area was one of the first "no-go" zones for the press in Baghdad.

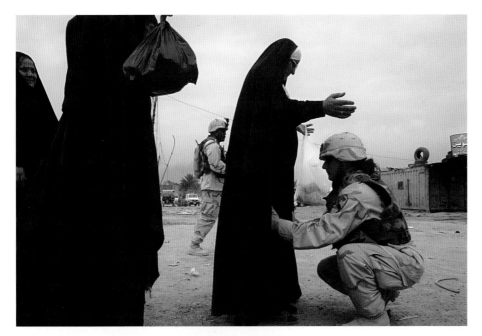

Sergeant Rosa Olivo of the Sixty-Eighth Chemical Company, First Cavalry Division, searches women near Doura, a violent neighborhood in southern Baghdad.

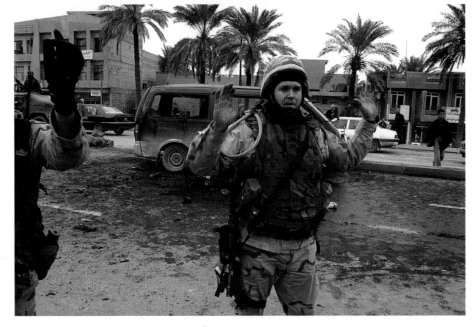

A soldier controls a crowd at the scene of a roadside bomb. The bomb exploded too late to hit its target, a military convoy. Instead, it killed two civilians.

A crib sheet listing simple Arabic phrases is wrapped around a rifle stock. American patrols rarely have translators accompany them.

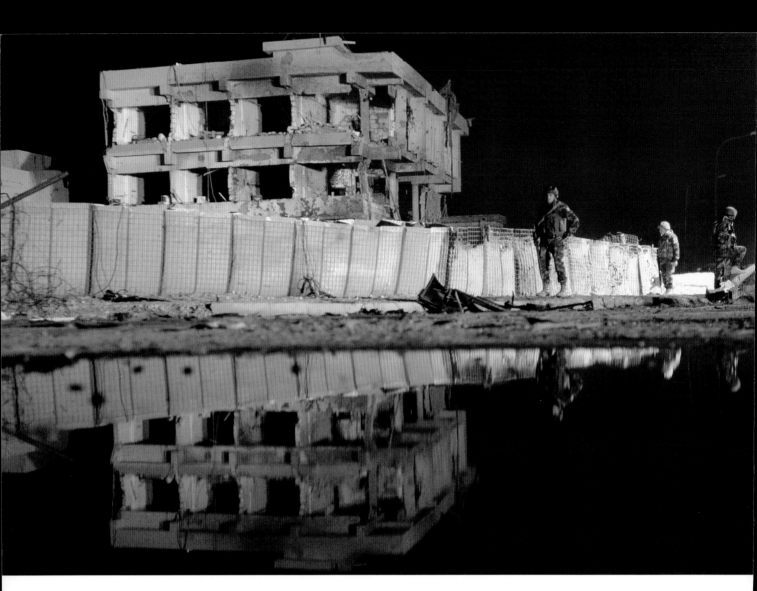

Italian Carabinieri stand watch over their base in Nasiriya after a suicide bomber destroyed it with a truck of explosives. The blast killed twenty-six Italians and nine Iraqis. This single attack, in November 2003, killed more coalition soldiers than any before it.

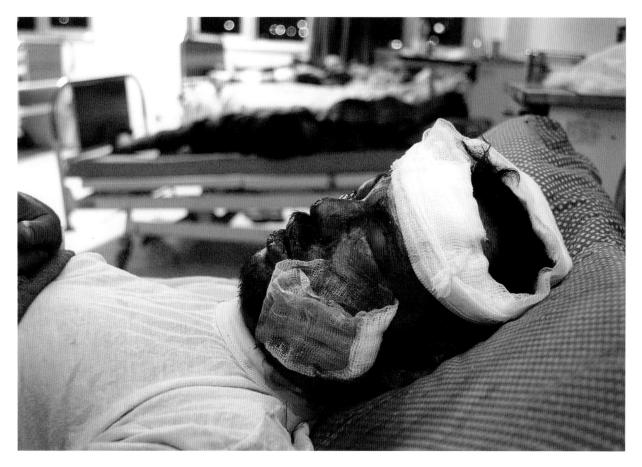

Ali Shaker, age twenty-six, recovers from the attack on the Italian base in Nasiriya. The attack killed his son and injured his wife. Shakar was one of 105 Iraqis wounded.

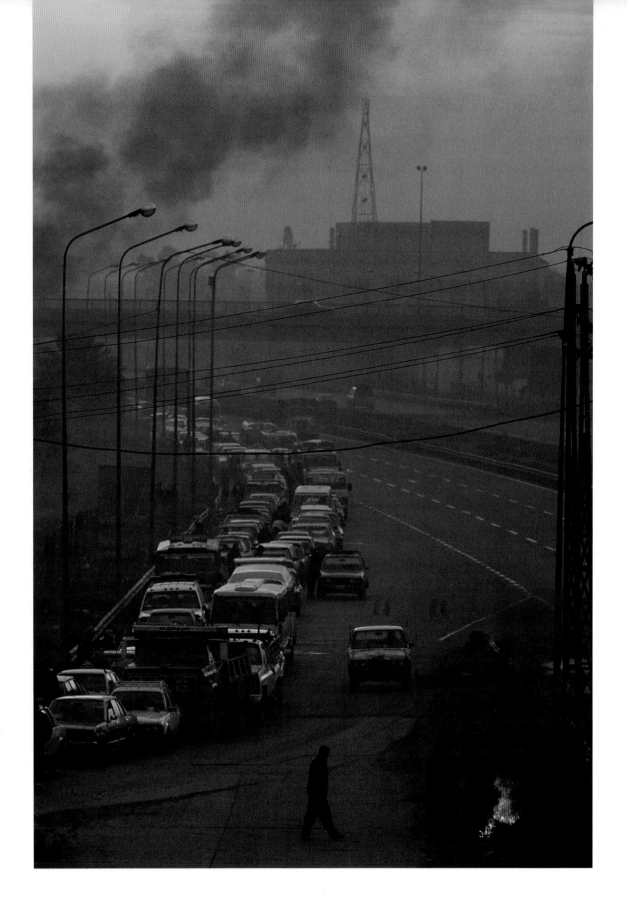

Adil Makhmoud sleeps in his car waiting in line for gasoline. At the end of 2003, the wait to receive gas in Baghdad was eighteen hours or longer.

Paul Bremer leaves the Iraqi Governing Council's headquarters. Bremer was the chief civilian administrator to Iraq from May 2003 until the transfer of sovereignty on June 2004. Covering politics is a crappy job, but I photographed him many times when I was the new grunt at the bureau.

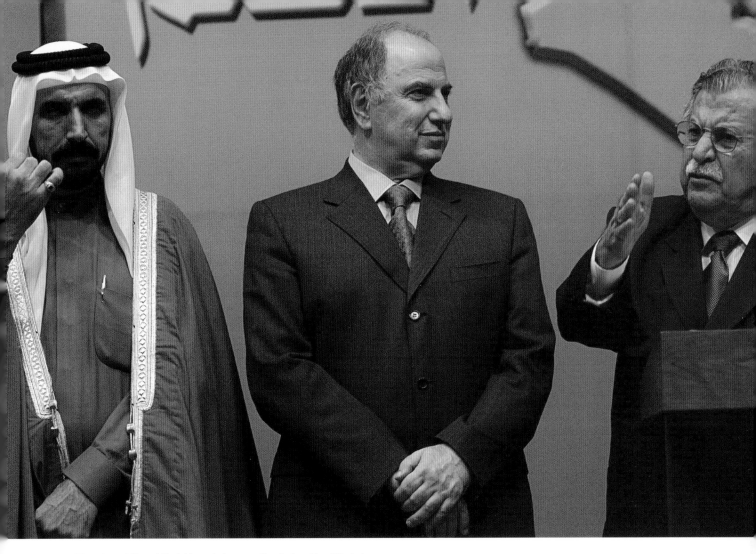

CIA-endorsed Ahmed Chalabi stands between Abu-Hatim of Iraqi Hezbol-
lah and Kurdish leader Jalal Talabani during a November 2003 press
conference announcing the upcoming elections. The U.S. appointed all
three to Iraq's transitional government.

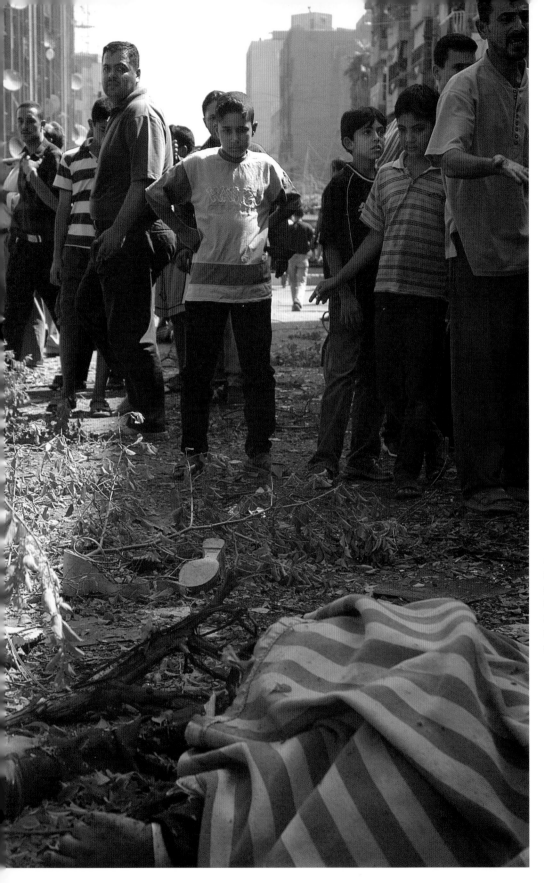

A boy stares at the bodies of dead newlyweds on a Baghdad street. The couple was shopping for furnishings when a Katyusha rocket slammed into a nearby car. The rocket also destroyed the storeowner's shop.

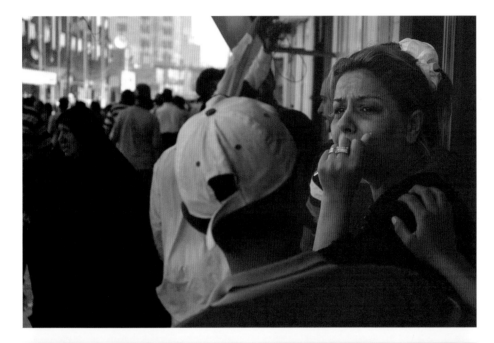

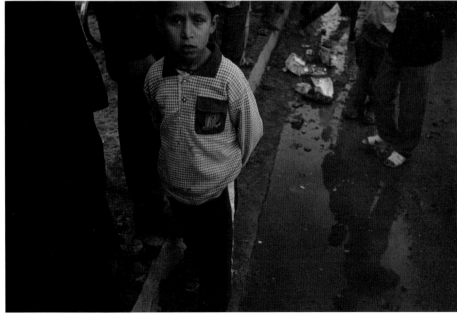

A young Iraqi stands by a pool of blood and water after a bicycle bomb tore through a Shia mosque in Baqouba. The bomb killed five and wounded thirty-seven.

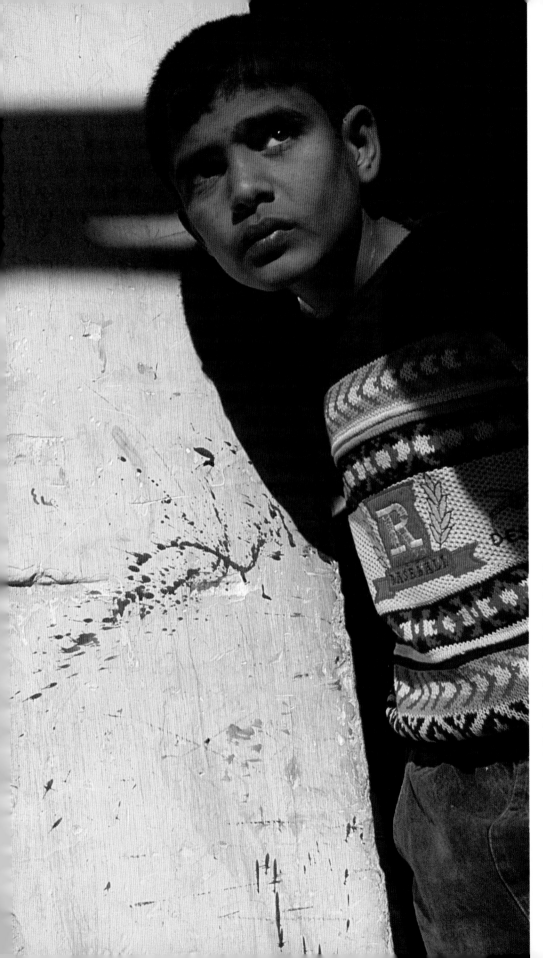

A young boy stands in the blood-spattered threshold of a guesthouse belonging to Sheik Amir, the head of Ramadi's governing council, after a November 2003 car bomb attack. The U.S. military had planned to pull out of Ramadi the night before and turn over security to Iraqis, but the insurgents' attack on this house and others postponed their decision. Subduing Ramadi would remain the Americans' task indefinitely.

A doctor at the morgue in Ramadi stands reflected in a pool of blood while
waiting for more victims from a car bombing.

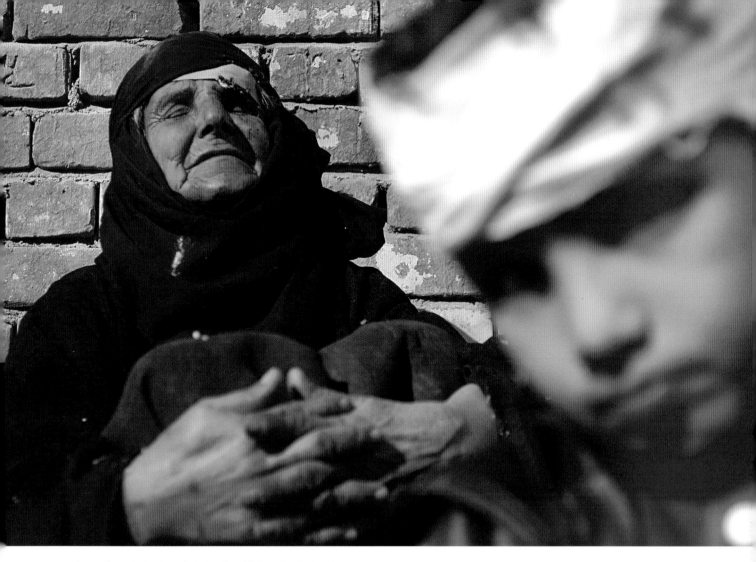

Jassen Hatern's daughter died when Sunni fighters bombed her home. Her grandson, in the foreground, survived with only minor injuries. I saw Iraqis suffering every day in Baghdad, but usually on streets crowded with people trying to catch a glimpse of a car bomb's aftermath. This bomb targeted a Shi'ite family living in a Sunni neighborhood, and the crowds never gathered.

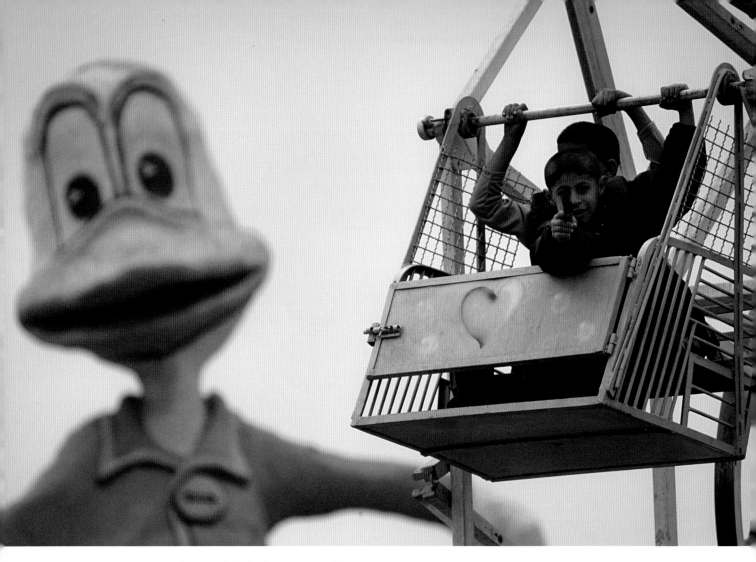

At an amusement park on Baghdad's Palestine Street, a Sunni child
points a toy gun at me during Eid al-Fitr, the holiday celebrating the end
of Ramadan.

Iraqis dressed as Mickey Mouse and Winnie the Pooh entice Baghdad motorists to celebrate the end of Ramadan with a feast in a nearby restaurant.

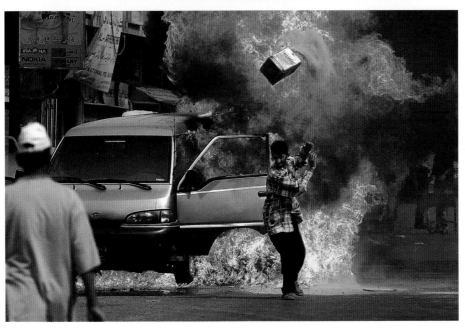

An Iraqi tries to extinguish a flaming van with a bucket of sand.

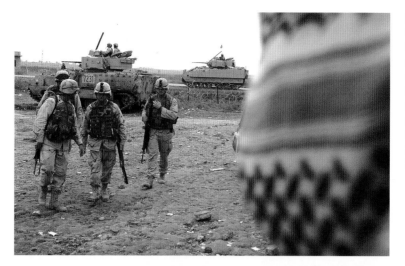

In November 2003, Lieutenant Colonel Nathan Sassaman of the Fourth Infantry improvised a crackdown on Abu Hishma, a town about fifty miles north of Baghdad. Sassaman's troops enclosed the town in razor wire, bulldozed homes, and detained entire families. It was not lost on Abu Hishma's residents that these tactics echoed those used by Israeli forces against Palestinians.

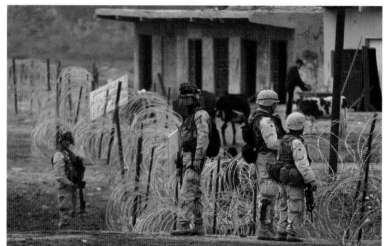

Soldiers stand guard near a sign warning that anyone who tries to cross the wire will be shot.

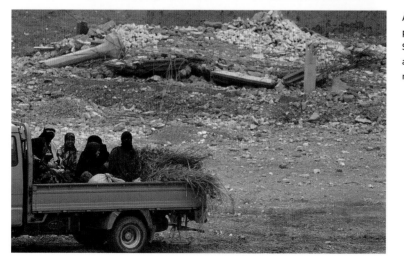

A group of Sunni women drive past the rubble of a house that Sassaman ordered destroyed by an airstrike after gunmen inside repeatedly shot at his unit.

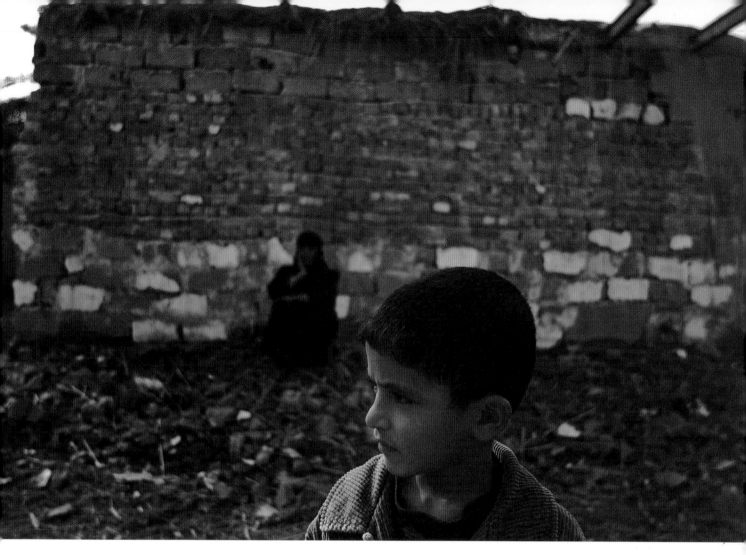

A boy stands in the ruins of his family's kitchen, which had been bulldozed
by Sassaman's troops.

Sassaman issued ID cards to all male residents aged eighteen to sixty-five that had to be presented at the town's only checkpoint to enter or leave. Sassaman's tactics temporarily stopped insurgent attacks in Abu Hishma, but two of his men were later court-martialed after a man they had thrown in the river drowned. They were jailed and Sassaman's military career was over.

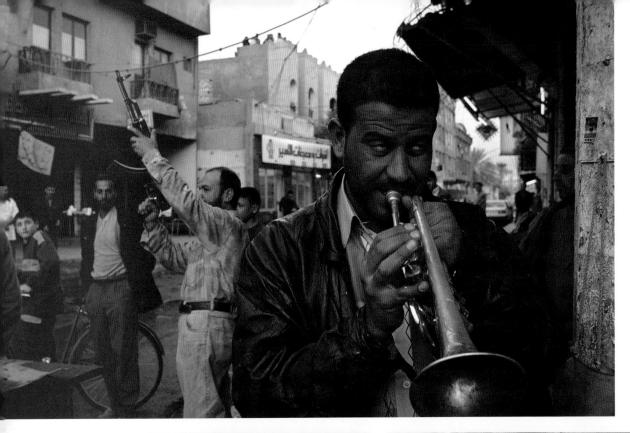

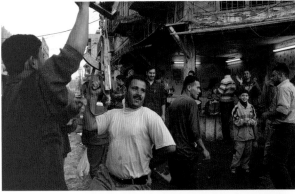

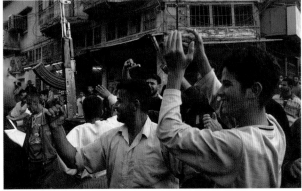

Several hours after hearing news of Saddam Hussein's capture, Iraqis were still celebrating on the streets of Baghdad, dancing and firing Kalashnikovs into the air.

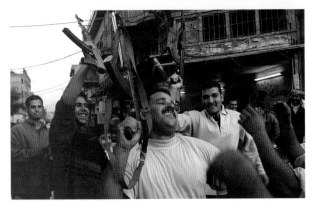

New York Times reporter Ian Fischer and his translator listen to a crowd of Fallujans anxious to relate their opinions on Saddam's capture. An hour later Ian interviewed residents from inside our armored car. While some tried to persuade us that Saddam had not been captured, others opened a rear door to try to steal our spare gasoline and tire. "Would you mind closing the door," Ian said calmly. They did. He turned to me and said, "I shouldn't be doing this. I'm a short timer."

American soldiers attend Christmas Eve services at St. Raphael Catholic Church in Baghdad, 2003. Mass was held at 5:00 p.m. because people were too afraid to leave their homes late at night.

Soldiers smoked Cuban cigars while celebrating Christmas at a military base in Adhamiya. They had been raiding houses all day as part of that week's operation to secure Baghdad.

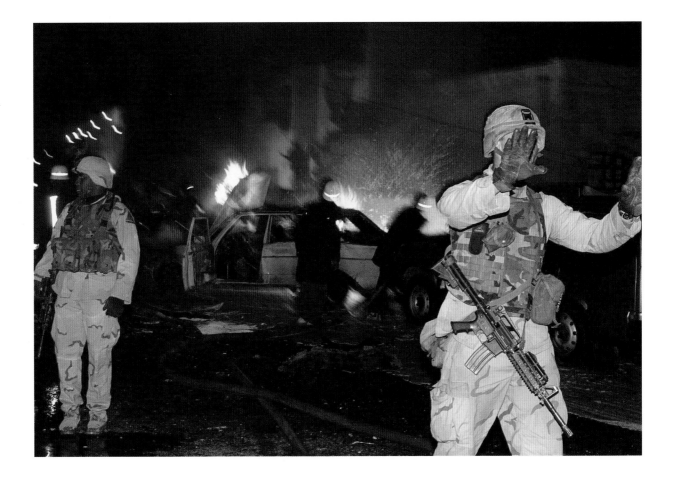

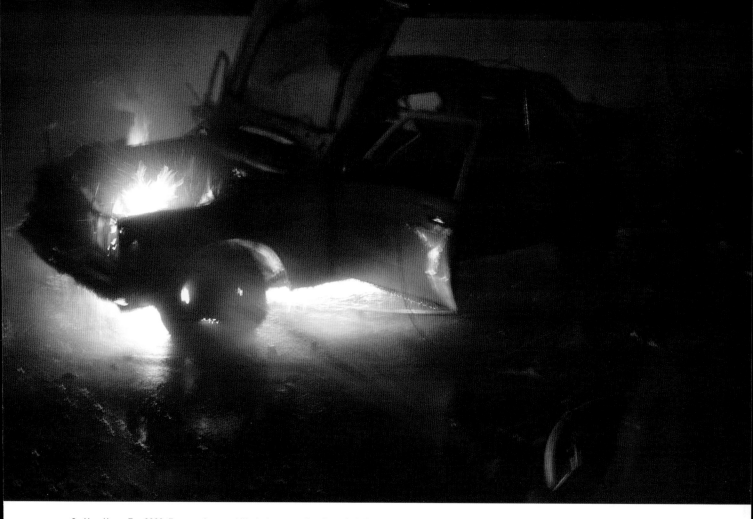

On New Years Eve 2003, five people were killed when a car bomb exploded
outside the Nabil restaurant, and forty more were wounded. The Nabil was
Baghdad's best restaurant and was popular with the press. I had dined
there two days earlier. Among the wounded were eight staffers of the *Los
Angeles Times* who had gathered at the Nabil to herald in the New Year.

Soldiers on R&R from the First Armored Division warm up in a sauna after a diving competition at Baghdad Rest in the Green Zone. When Saddam's Republican Guard was in power, the resort was their playground.

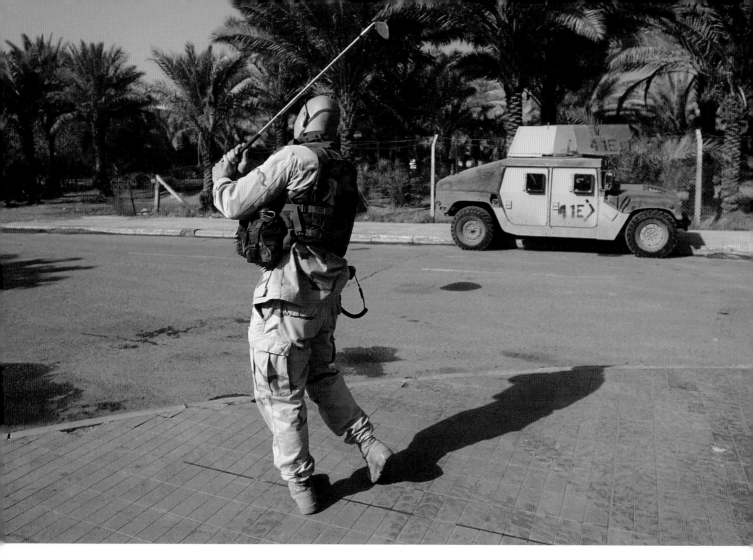

An officer from the Third Infantry Division practices his swing in the Green Zone.

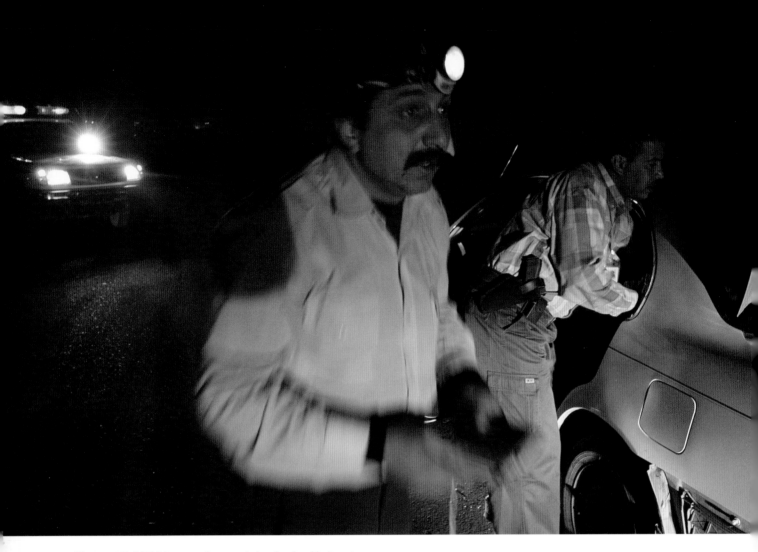

Lieutenant Majid Mahdi runs past a suspected car bomb as Lieutenant
Hazim Kadhem searches it. They were one of the bomb squads in the
Iraqi police force. This car had nothing in it except personal effects of the
owner, who turned out to be an Egyptian coalition contractor attending
church services across the street.

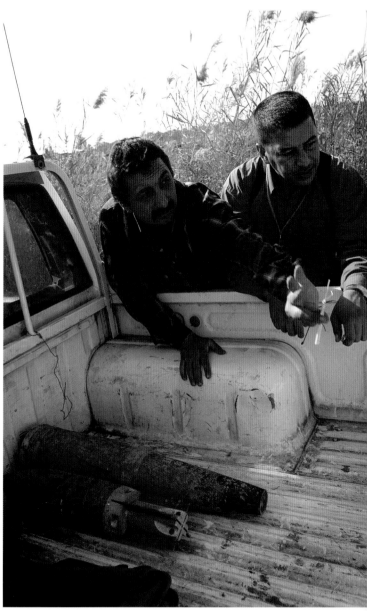

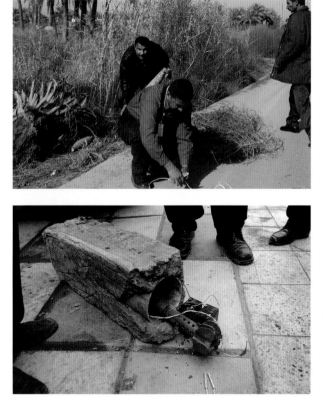

Majid cuts the wire on a roadside improvised explosive device, or IED.

Majid and Hazim told fish stories, but it didn't matter whose bomb was bigger—if any of them detonated it meant certain death.

Majid and Hazim try to disarm another potential bomb. From at least forty yards away, an American soldier ordered me to get the fuck out of there. Majid, Hazim, and I were lucky that the suitcase turned out to be just a suitcase. Within months, both Majid and Hazim would be killed in separate incidents when bombs they were trying to diffuse exploded.

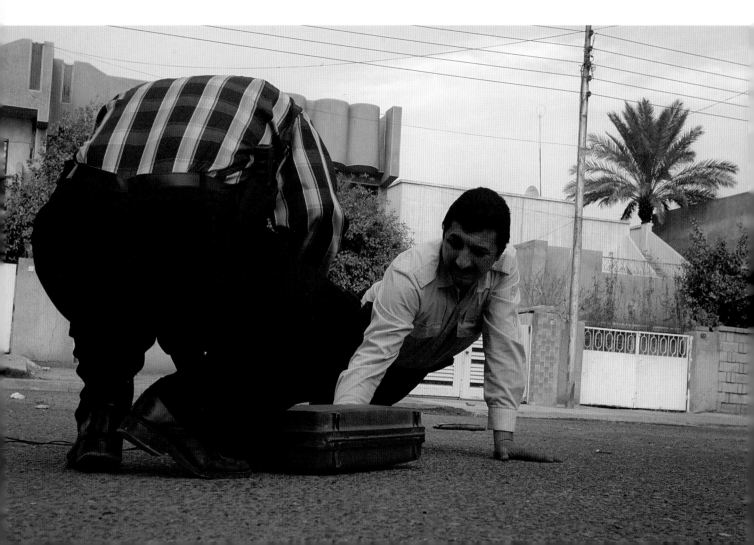

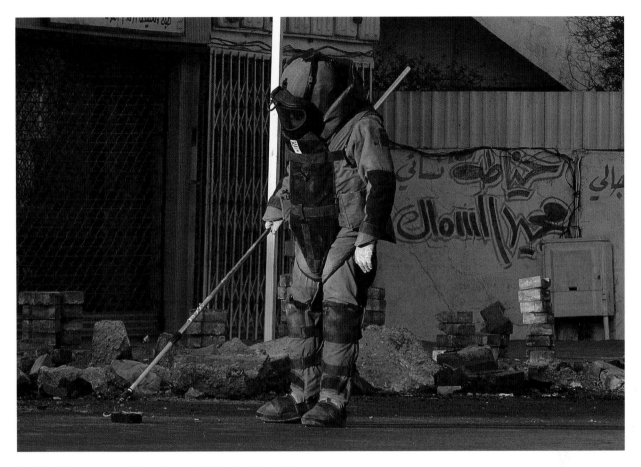

The U.S. military approached detonating roadside bombs differently from
Iraqi bomb squads. This soldier checks a suspicious motorcycle battery.
A robot preceded him.

A soldier from the First Cavalry
Division searches for IEDs in an
area alongside the highway to
Baghdad's airport. A boy guides
him, pointing out where roadside
bombs have already detonated and
where others might be hiding.

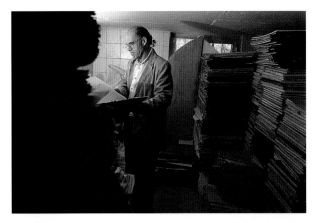

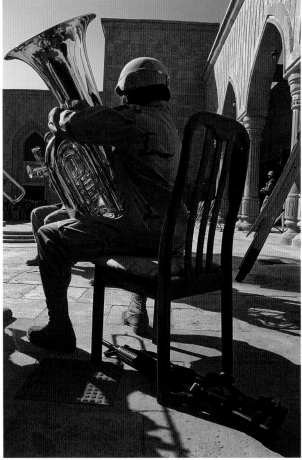

Iraqi author Kanan Makiya investigates official Ba'ath Party documents given to him by the U.S. military. Makiya established the Memory Foundation, documenting the party's inner workings, specifically those using torture and murder.

The First Infantry Division band plays at a badge ceremony outside of Tikrit. The Second Brigade Combat team was awarded combat badges for valor on the field and for facing thirty days of combat. Exactly sixty years before, the First Infantry Division spearheaded the D-Day invasion.

OPPOSITE

John F. Burns, *New York Times* senior correspondent, leaves the Green Zone in Baghdad.

President Ghazi Ajil al-Yawar (a Sunni), Vice President Ibrahim Al-Jaafari (a Shi'ite), Prime Minister Ayad Allawi (a Sunni), and Deputy Prime Minister Barham Salih (a Kurd) attend a June 2004 ceremony declaring Iraq's "return to self government."

Ayad Allawi, the prime minister of Iraq, his spokesperson George Sadr, and Major General Ron Johnson of the United States Army Corps of Engineers tour the Qudas power plant.

Bill Roberts, a civilian public affairs officer for the United States Army Corps of Engineers, delivers remarks at the Qudas power plant. The military called in the press to celebrate the opening of the plant and claimed it would return much of Iraq's power to the electrical grid. In fact, the plant was not yet finished because of a lack of spare parts.

An American soldier searches an Iraqi at a temporary checkpoint set up near Abu Ghraib in Baghdad.

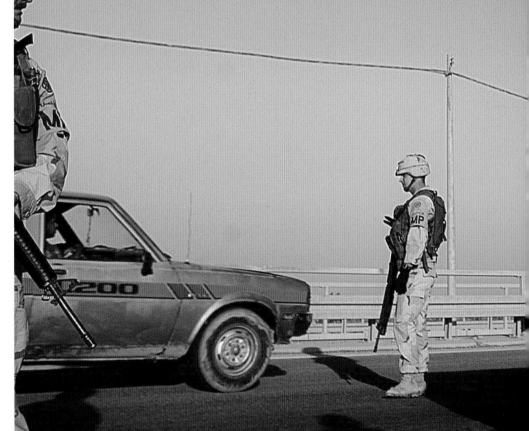

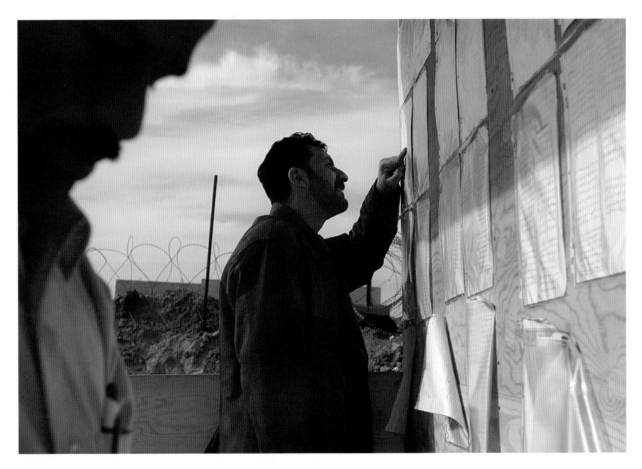

An Iraqi searches for relatives' names on lists posted outside Abu Ghraib prison. Bremer posted the prisoners' names after news of the abuse scandal broke. Prior to that, there was no way to know who was being held.

Specialist William Wimberly watches George W. Bush apologize on behalf
of the U.S. military for the torture that took place at Abu Ghraib prison.

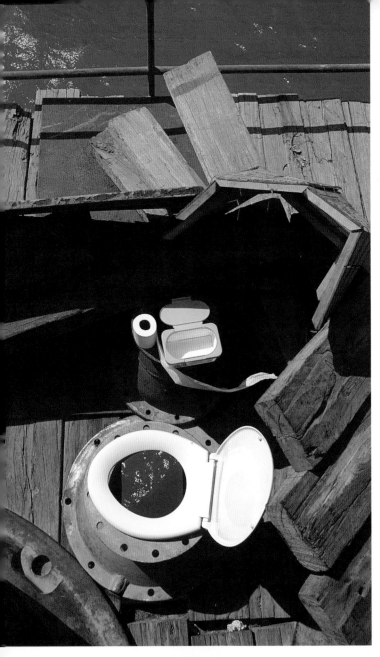
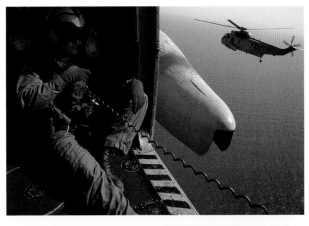

Sailors from the U.S. Navy's USS Cushing, Fifth Fleet, Taskforce 55, protect oil platforms near the Al Basrah Oil Terminal in Iraq's territorial waters near the Iranian border. The platforms pump between 85 and 95 percent of Iraq's oil output into tankers, generating about $11 billion in oil revenue for the country per year. After insurgents mounted a suicide attack from a small boat (dhow) on April 24, 2003, the U.S. Navy set up a security cordon around the facilities.

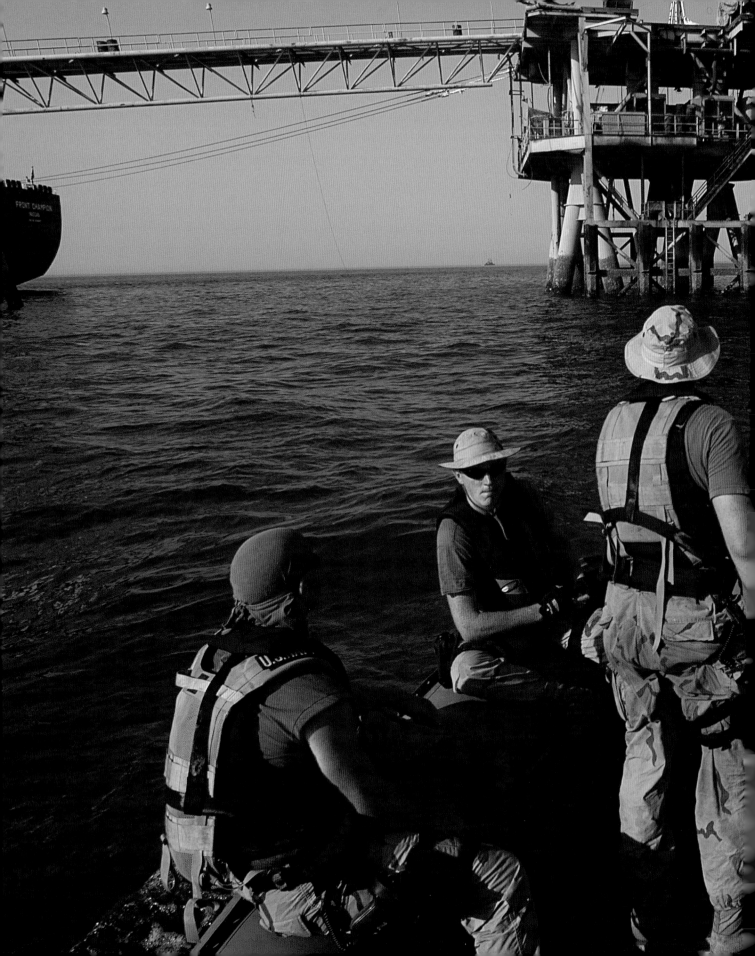

THREE

WHISKEY TANGO FOXTROT

KARBALA: THE COALITION OF THE UNWILLING

In March 2004, Paul Bremer ordered soldiers to shut down Muqtada al-Sadr's newspaper for having published anti-American propaganda. In response, this powerful, fiercely anti-American cleric sent his militia, known as the Mahdi Army, into battle against American troops.

After the fighting had killed scores of Americans and Iraqis in Baghdad, al-Sadr took his uprising to Karbala, fifty miles south of Baghdad. Until then Karbala had been relatively calm, so its security had been entrusted to Polish and Thai troops—part of the "coalition of the willing." This unlikely partnership quickly lost control of the city, allow-

ing al-Sadr's forces to overrun checkpoints and police stations. The coalition of the willing was, in fact, not so willing after all.

At the war's outset, the Thai government had sent 422 soldiers to Iraq as a strictly humanitarian force. In a country under siege, their presence was virtually useless. On one memorable evening, I waited in a line of hot, battle-fatigued American soldiers for sloppy outsourced food. Not looking forward to our meal and prepared to kill for a beer, hundreds of Americans and I looked on as not ten yards away a group of lively Thai soldiers mingled around

a barbeque, grilling delicious-smelling meats, and chasing whiskeys with ice-cold beers.

While Americans were forbidden to drink alcohol, the Thais were only forbidden to leave the base. The Bangkok bureaucrats had offered their soldiers as peacekeepers. They did not want to lose any political points by having a soldier killed in what was already a massively unpopular war. Should the Thais have been allowed to cross the wire, they would not have been able to carry weapons due to their "humanitarian" status.

Very occasionally the Thais were asked to take over guard duty for the American soldiers at the main gate. It was an easy job. The post looked over a one-lane road that led into the base, which was surrounded by high concrete blast walls. One day the Thais noticed a young Iraqi's head popping over the wall. In what must have been one of the few times they discharged a weapon in Iraq, they blasted a bullet through the boy's head.

A couple of days after the incident, an elderly Iraqi man appeared at the same gate. His son had disappeared while looking for work at the base, and he wondered if they had seen him. American civil affairs officers were given the task of informing the father that his son had been killed, and of trying to work out a fair sum for compensation.

Between ball games, chess, and barbeques, the Thais were only slightly less useful than the Polish forces. The Poles had committed about 2,300 troops to Iraq and headed the multinational task force in south-central Iraq. They had been charged with keeping security in Karbala, but their government had deemed the situation too dangerous for them to venture into the city.

To Poland's credit, they offered a handful of Polish Special Forces during the American operations to regain control of the city. But as one U.S. soldier put it, "the Polish Special Forces are not so special."

THE 778TH SOLDIER

Edward Wong, a reporter from the *New York Times*, and I left Baghdad for Karbala in a Black Hawk with Brigadier General Mark Hertling and an advance party sent to prepare the base for a U.S. brigade that would regain control of the city. No matter how often I fly in Black Hawks, forty feet from the ground at top speed, the thrill never wears off. Hertling's grunts, however, were not so thrilled. At the last moment, their completed twelve-month tour had been extended to fifteen months. They had already shipped all their possessions home when they were told they had to stay and fight in the largest operation since the 2003 invasion. These soldiers were pissed. In their eyes, a man who died in Karbala was a man who should have been at home with his family.

I accompanied Specialist Ian Spakosky, known to his buddies as Spanky, on his last mission. We had met only that day, May 14, when I photographed him returning enemy fire from the back of an armored personnel carrier. He was a nice guy, laid back and funny. He looked very young, about eighteen, or at least young enough to get carded at a liquor store back home.

It turned out Spanky was twenty-five, married, and had three children. Over his rifle cracks, I joked with him that his name was difficult to spell, that I should have been used to all those consonants by now, given the number of Polish soldiers' names I had written down back at the base. There were lots of jokes and laughter right up until Spanky and his comrades stood in a doorway of a building, readying to run across a street under sniper fire. Spanky made the dash and fell in the middle of the street. A bullet had passed through his hip, and at 12:20 p.m. he became the 778th American soldier killed in Iraq. In my count,

Spanky was number one—the first soldier killed on one of my embeds in Iraq.

The mood was somber back at the base. The telephones and Internet kiosks were temporarily shut down to stop word of Spanky's death from getting out before his next of kin could be notified. After I called the *Times* to ask that they hold Spanky's picture until his family got the news, I bumped into Sergeant Michael Cannon. He had been a friend of Spanky's. The sergeant told me Spanky had received a message from his wife Keisha, that she urgently needed to speak with him. Spanky had been worried Keisha was leaving him, but when they spoke by satellite phone the night before he was killed, Keisha told her husband that she had just had his name tattooed over her heart.

Generally, the only rule of embedding is that we don't release the names of the dead until the next of kin are notified. Break that rule, and you're out. Brigadier General Hertling, however, combed the early bird every morning for negative press. The early bird is a compilation of military-related stories from major newspapers put together by the Pentagon. He often frowned upon our reports—especially when Ed discussed the low troop moral—and he'd send us e-mails threatening to replace our spots on the embed with correspondents from competing newspapers.

We tried to find the humor in his antics: every time Hertling threatened us, Ed replied with a forceful defense of his story, and I'd send another note thanking Hertling for the access we had to his courageous men, along with a photograph of him on the battlefield, pistol drawn, looking heroic. The good-cop-bad-cop routine usually worked. Our only concern was that while Ed could always come back with venom, I only had a limited supply of "hero" pictures.

The fighting usually took place at nighttime, a bitch for photographers: if we had it our way, we'd plan every action at dawn or dusk. I tagged along with different units until I eventually met up with a platoon known as Black Sheep, in the First Battalion, Thirty-sixth Infantry Regiment, First Armored Division. With them I felt the safest, despite the fact that they were usually in the most violent part of the battle, largely because of their sergeant.

Sergeant First Class Garcias was a battle-hardened lifer who specialized in urban warfare. One day under fire, while I was desperately trying to bury myself in a shallow hole, I watched in amazement as sniper rounds cracked inches from Garcias's feet. After shouting from the middle of the street for his soldiers to advance, he noticed my bewildered expression. "They're terrible shots," he explained with a grin. Garcias might have been fucking crazy, but he knew what he was doing.

The offensive dragged on for about three weeks. Soldiers rolled out of the base at all hours in Bradley fighting vehicles. Those vehicles are some of the toughest, loudest, and least comfortable machines in the American military inventory, designed to carry about a dozen infantry. Crammed in these hulks, the soldiers peered through tiny periscopes at passing streets, and waited for the rear hatch to drop and lead them into a hail of bullets and rocket fire. Some soldiers prayed, clutching rosary beads they wore under their bulletproof vests. I meditated on how to make myself as small as I possibly could.

On the way back to base in Bradleys crowded with wounded men and detainees, I managed to sleep. Garcias told me that the fact I could take a nap in the tank made me a member of his team—no one but a grunt could sleep in a Bradley. The last thing I wanted was to be part of the military, but I had to admit that his comment made me feel manly and accepted.

THE SAMARRA OFFENSIVE: CHASING DRAGON

I'd been run out of Samarra twelve months earlier by the black BMW, and since then the city had been largely under the control of the insurgency. Talk was circulating about a major offensive to wipe out the jihadist and nationalist insurgents, and deliver Samarra back into the hands of the military. I needed to be there. It was a major battle that would be the beginning of a broad offensive against restive cities throughout Anbar province. I also wanted to get back to the place after my hasty escape from it the year before.

The key to Samarra was Colonel Randy Dragon of the First Infantry Division: he commanded all the troops in the region. It was no secret Dragon didn't like the press; the public affairs officers told me as much every time I asked about seeing him. Attempting to make an impression on the man, I traveled back and forth to Tikrit—the headquarters of the division—using any reason I could find. I went up for every one of their dog-and-pony shows, hoping I would bump into Dragon.

One event was a bridge opening that I had been assured Dragon would attend. Along with the Army, an American civilian contractor stage-managed the event, and it was clear he had been pushed very hard to finish on time. He talked about his fondness for Cuban heeled cowboy boots, which he wore that day. The asphalt hadn't had time to dry, and when it tore the heel from one of his boots, he cursed the road to no one in particular.

Once the speeches were out of the way, an American soldier appeared from the crowd and presented a pair of four-foot-long scissors to the Iraqi mayor. After several attempts to cut the ribbon with the giant scissors, the soldier had to step in and cut it with his own knife: the scissors were made of wood.

I really have no idea what the *Times* editors thought when I sent photos back from events like this. Probably something like "Great. A big pair of scissors. Guess I'll see what AP has."

MONEY MIKE

I don't know whether my attendance at PR events persuaded Dragon, but we got the spot on the Samarra offensive. Reporter Rick Lyman and I were hastily pulled out of a different embed and plunked on a Black Hawk. No one would tell us where the flight was headed. An hour later, they dropped us at a larger airstrip, where we were herded toward some reporters from *Time* magazine and CNN. It was unanimously agreed upon that we were all headed to Samarra. CNN was traveling with a mountain of gear and complained that it wouldn't fit on the Black Hawks that were coming to pick us up. Nothing could be done to accommodate them at the time, and they were forced to travel on without their transmission equipment. During the offensive, the Army made a highly unusual decision to allow CNN use of their military satellite to transmit the network's logged footage, as well as to broadcast a couple of live stand-ups. Witness the power of television.

The flight dropped us off at a pitch-black base where Rick and I were immediately hustled to an armored vehicle. The place was buzzing with soldiers performing last-minute pack checks and lining up tanks. Our escort disappeared before telling us what was going on, and no one else would fill us in. Four days later I learned we had landed in Abu Hishma, not far from Samarra. For hours, we rode in the back of the armored vehicle, which didn't have windows or lights. It was a strange feeling being kept so much in the dark, literally and figuratively. We got out in a desert. While Dragon and his men set up a command post around us, Rick and I could do little more than sit back and watch explosions rock Samarra, a mile away, as an AC-130 gunship belched thousands of rounds into the city from above.

We were allowed to enter the city the next morning when the infantry started its house-to-house sweeps. The token Iraqi troops, weighed down by swords, cigarettes, soft drinks, and other items that they had looted from families, joked with one another as the Americans did the soldiering.

Looking back, this was a perfect embed. The fighting wasn't incredibly dangerous, and the pictures were strong: families throughout the city held at gunpoint while Americans searched their houses for weapons; Iraqis stealing anything of value in front of the guarded civilians; Americans kicking in doors when they could as easily have turned the handle; Americans shooting to pieces every car or truck they came across.

U.S. soldiers are trained to respond to low-sitting cars as potential bombs—often, they're rigged with explosives. One day a platoon of New York National Guard reservists was dispatched to search a house thought to be occupied by a commander of Saddam's much-feared Fedayeen. Parked outside was a suspicious vehicle, so a machine gunner got into position and fired dozens of rounds into it. Soon enough, it caught fire and the petrol tank exploded, but nothing else detonated—a clear sign that the car was weighed down by something other than bombs. The guard soldiers ran past the inferno and performed their search.

When they emerged, a child approached the soldiers, and they asked him if he knew whose car they'd set on fire. Seemingly unintimidated by the soldiers' presence in his city, he told them that the car did in fact belong to the Fedayeen commander. Every time he or any child touched the car or accidentally kicked a football onto it, he explained, the commander would hit the offending child with a stick. A soldier asked if he was happy the car was on fire. The kid just smiled, and walked away.

The platoon, led by Lieutenant Shawn Tabankin, contin-

ued on to the house supposedly owned by the insurgent commander. No one was home. The platoon searched the house and found some documents, a few guns, and a stash of heavy artillery shells. Next door, in an abandoned lot, soldiers discovered more shells buried in the dirt. They carried the shells into the house and carefully placed them in various rooms before the engineers came in to set the explosives that would detonate them.

Soldiers started getting excited as the engineers left the house. Rick and I were hustled off to the lieutenant's humvee, where we could sit and watch the explosion in relative safety. Another unit started to drive up the street toward the house, and someone in our vehicle got on the radio trying to warn them about the imminent explosion. The radio didn't work so well, so a soldier jumped from the humvee to shout at the approaching unit. They turned around and drove away.

Our vehicle rocked as bricks and mortar blew high into the midday sky. Dust clouded the scene, and bricks started falling around our truck. Someone yelled, "That was fucking awesome!" Obviously, however, not everyone was expecting it. From the front seat, I heard a voice crackle through the radio, "Whiskey Tango Foxtrot?"

I had no idea what it meant, though I had heard it dozens of times in Iraq. Only after I got home in 2006 did I discover it was radio code for "What the fuck?"

In another house, the platoon of reservists found a booklet with a photograph of Osama Bin Laden on its cover, and another depicting the Twin Towers falling. Tabankin was a New Yorker who studied law back home. He was outraged: the books hit a nerve. "This guy killed a lot of people, and people I love," he reproached the house's owner, just controlling his rage. "If I find out this is yours, I'll set Mike on you."

"Money Mike" was a captain in the Iraqi National Guard who moonlighted as Tabankin's translator. Mike identified, incredibly, with the antics and grunt jargon of young American soldiers. Sometimes when he chatted with me in sentences peppered with English expletives, he'd describe his own people as Hajis, the derogatory term used by American soldiers for Iraqis. He liked to ham it up for soldiers' cameras, striking a Bettie Page pose over captured artillery shells. He'd follow along intently during soldiers' tutorials on how to shoot "gangsta style." Most importantly, Money Mike had likely learned many of his interrogation methods when working under Colonel Sassaman of Abu Hishma infamy.

It seemed that the offending booklets did belong to the house's owner. Before a semicircle of American soldiers, Money Mike grabbed the suspect, threw him against a wall, and shouted him to the ground until the man cowered below him like a scared dog. Mike took a baton he had looted and beat the man, hitting his arms and stabbing his ribs and stomach. He then drew a bayonet from his belt and started threatening the man with renewed fury. Lieutenant Tabankin finally stopped him with the words "I hate to say this Mike, but put the knife away . . . I mean, I have to be frank: there's a reporter here."

I looked the lieutenant in the eyes and lied, "Don't worry, I didn't photograph it." He looked relieved. Good one, I thought to myself.

After Money Mike finished interrogating the man, he took him into the street and pretended to kick him mercilessly. Neighbors watching the scene thought the man was really injured. This was the only generous act to his countrymen I ever saw him perform. Had Money Mike not publicly assaulted the man, the neighbors would have known he had cooperated with the Americans, and they would have killed him.

That night, I searched my images for the frame with the bayonet, only to find that I had not lied to Tabankin: the photo of the bayonet wasn't there. At first, I thought someone had gone through my flash card and deleted it. Ultimately, though, I realized I had failed to shoot the photo. I had grown too close to the platoon and had unintentionally protected them. I was incredibly upset. I most certainly would have filed the image to the paper. All I had was a shot of Mike threatening the man with a baton, a picture that appeared in the next day's paper. That failure to photograph Mike with the bayonet was the first and last time I allowed camaraderie in war to obstruct my work as a photojournalist—on an embed or anywhere.

RAMADI: THE SUICIDE TRAIN

The Marines' mission in Ramadi was keeping access open along route Michigan, a four-and-a-half-mile east-west stretch of road dotted with mosques and marketplaces. Ed Wong and I were dropped off at a large camp on one end of the city. To give us an idea of the severity of the mission, they stuck us on Boxcar, a convoy that delivered warm food twice daily to a smaller base named Snake Pit at the other end of Michigan. The marines had another name for Boxcar: the Suicide Train. They laughed while telling us that the convoy got hit every day. One time, they said, they encountered nine roadside bombs on the trip.

Lying between Baghdad and Falluja, Ramadi is the capital of Anbar province and a stronghold of the insurgency. The U.S. command in Baghdad claimed to control the city, but on the ground, the marines, who sat around playing cards behind wall after fortified wall, had a very different assessment. A reporter from *Time* magazine asked a roomful of grunts if they controlled Ramadi. "Oh, fuck no!" they replied.

Everything about Ramadi was a nightmare. Anbar's governor had recently assumed his post in the Government

Center. His predecessor had fled to Jordan after insurgents kidnapped his family. Powerless, the governor tried to manage the entire province with almost no staff, further troubled by the fact he was also the acting mayor—the last one had been assassinated. The chaos meant that for U.S. troops, simply moving from one camp to another was a major operation. I sat in on one mission briefing while marines prepared to roll out. Their plans were elaborate. I thought they would be traveling to the other side of the city, but it became clear to me that the post they were trying to reach was across the street.

We made our way on the Suicide Train to Snake Pit base without being hit, although the convoy would not be so lucky heading back. At the base, we were welcomed by a view that will never find its way onto any postcard. Snake Pit was flat and colorless, lightly littered with drab buildings and shelters, pockmarked by shrapnel, hemmed in by blast walls and vast spirals of concertina wire. Beyond the base lay low houses and a soccer stadium the insurgents often used to mount assaults. Early one evening as I was squatting outside on a sat phone call with Joanna, a mortar round came in and exploded a hundred yards away. I scrambled for cover. From the safety of a concrete wall, I saw that the marines hardly seemed to notice the explosion. Situation normal at Snake Pit.

We had been told the grunts were not permitted to use the portable toilets on the base. Squatting over my freshly dug hole, I wondered, why on earth was this necessary? As retribution for working with the Americans, Ed told me, insurgents killed the local Iraqi who had been contracted to empty the toilets. Not a single person had applied for the job since. The marines were having similar troubles finding translators after insurgents recently beheaded one. Not that it mattered, the marines didn't chat very much with the locals, and warning shots generally don't get lost in translation.

One morning as the sun rose, I sat in a former hotel the marines were using as an observation post over Michigan. The building had been hit by dozens of rockets and a suicide truck bomb, and assaulted by insurgents more times than anyone cared to count. A marine watching over the city heard the distant roar of a humvee and motioned for me to look down route Michigan. He explained that he could see everything on that road except for one passage a short way up, where almost every morning a bomb went off. When the bomb didn't strike there, it would blast even nearer the base, right under the marines' noses. They were constantly puzzled by how such explosives could be set up despite their around-the-clock monitoring.

The marine guarding the route casually began firing warning shots over a man standing near an empty cardboard box on Michigan. The man was the only person insane enough to walk into the marines' crosshairs that morning. The warning shots got closer and closer until he ambled away down a side street. After he left, the marine shot the box to pieces.

Trying to protect Michigan, the marines only provoked more fighting on the route, and attempting to keep the road open resulted in closing it for hours every day. A sergeant told me, with only a hint of sarcasm, that both the marines and the insurgents wanted the same thing: for the Americans to get out of Iraq. Other marines wondered aloud, why the fuck should they die while trying to help people who didn't want them there?

We watched as Boxcar left Snake Pit, rolled down Michigan, and, on cue, was hit by a roadside bomb. The convoy rumbled out of the scene enveloped in a plume of smoke, guns firing in all directions. That day, surprisingly, no one was injured, and those on the Suicide Train made it back to camp, having successfully delivered a warm breakfast to the marines at Snake Pit.

An American helicopter carrying General Hertling, *New York Times* reporter Ed Wong, and me into the camp on the outskirts of Karbala momentarily blocks Polish peacekeepers' sun. It was early May 2004, and the U.S. Army was about to launch an operation to regain control of the southern Iraqi city from the cleric Muqtada al-Sadr and his Mahdi Army. The fighting would continue for over a month, inflicting dozens of casualties on American soldiers and killing hundreds of rebel fighters.

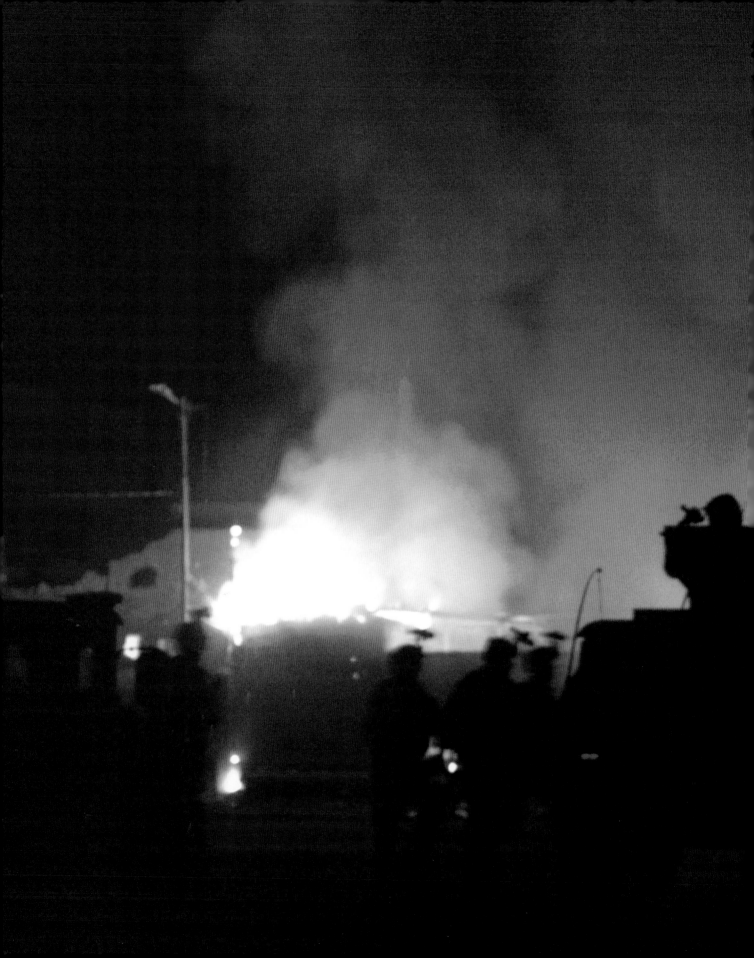

Special Forces soldiers storm a mosque that the Mahdi Army was using as a weapons cache and command post. The Americans had thrown grenades into the mosque, detonating the munitions inside. For the first time in days, I had not been able to get my hands on night vision goggles to strap to my camera, and before the operation I complained about it to a Special Forces guy. "Don't worry," he said with a grin, "there'll be light." I called the *Times* and asked them to hold the front page. Running to the mosque, I severely tore my quadricep, but Ed Wong threw my arm around his shoulder and half dragged me the remaining distance. I made three frames and dragged myself back to my laptop and transmission gear to file, only minutes before deadline. This picture made the front page.

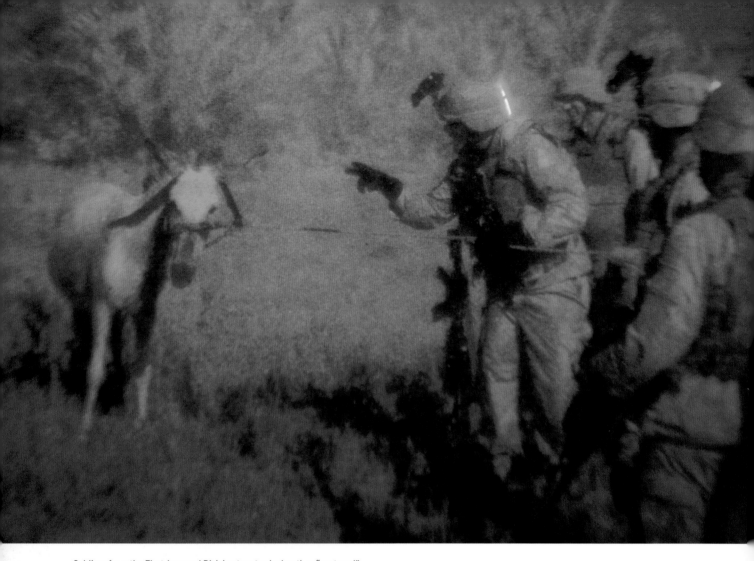

Soldiers from the First Armored Division taunt a donkey they "captured" on the battlefield. This was the first photograph that ran in the *Times* covering the offensive. After it was published, higher-ups demanded to know what the soldiers were doing, under fire on a battlefield, with a donkey. The grunts explained that they were trying to herd the donkey to safety. In fact, they were seeing if Crocodile Dundee's method of hypnotizing a water buffalo in the Australian outback would work on a donkey in Iraq.

OPPOSITE

Specialist Ryan Stewart looks for Mahdi Army fighters through his night vision goggles during combat in Karbala.

A soldier pours water over his face. Water was incredibly scarce during
the battle, but so was relief.

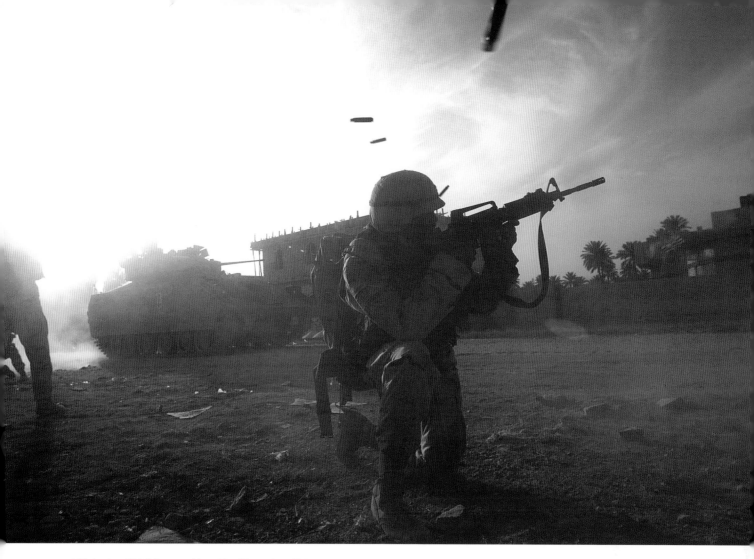

A GI shoots at Mahdi Army positions. The rifle cracks added another deafening element to a cacophony of heavy machine-gun fire and 30 mm cannon blasts.

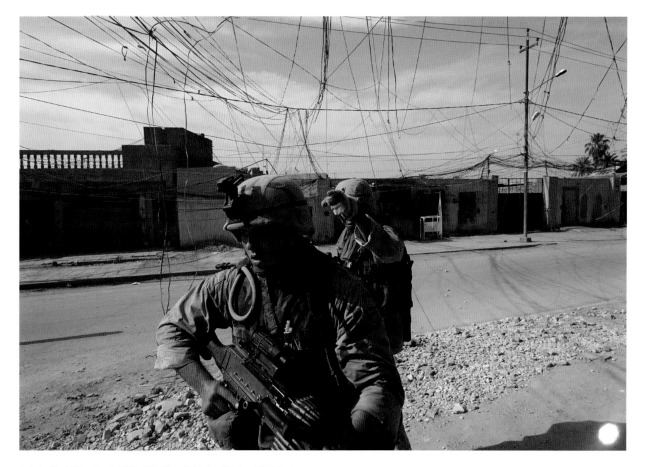

Private First Class Daniel Gill of the First Battalion Thirty-sixth Infantry,
First Armored Division, during combat operations in Karbala.

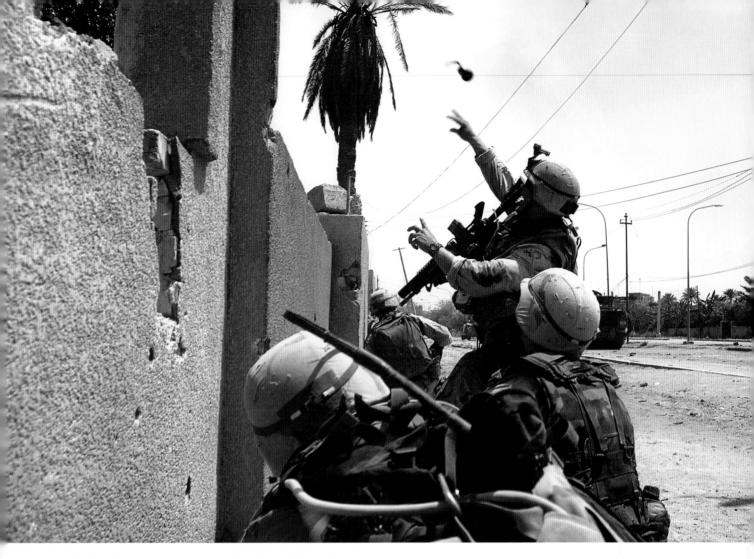

A soldier lobs a frag grenade at a Mahdi Army fighter hidden just beyond
the wall. The noises and gunfire stopped after the grenade detonated.

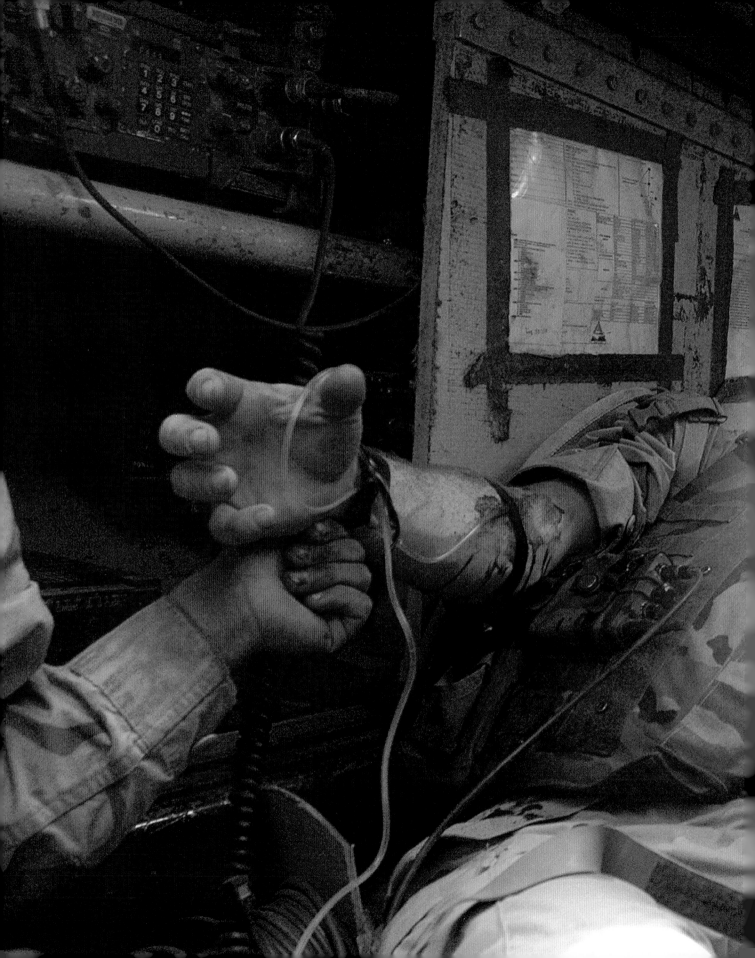

Sergeant Shawn Boothby of Maine was among soldiers in Karbala who were treated for dehydration during fighting in temperatures over 100 degrees Fahrenheit.

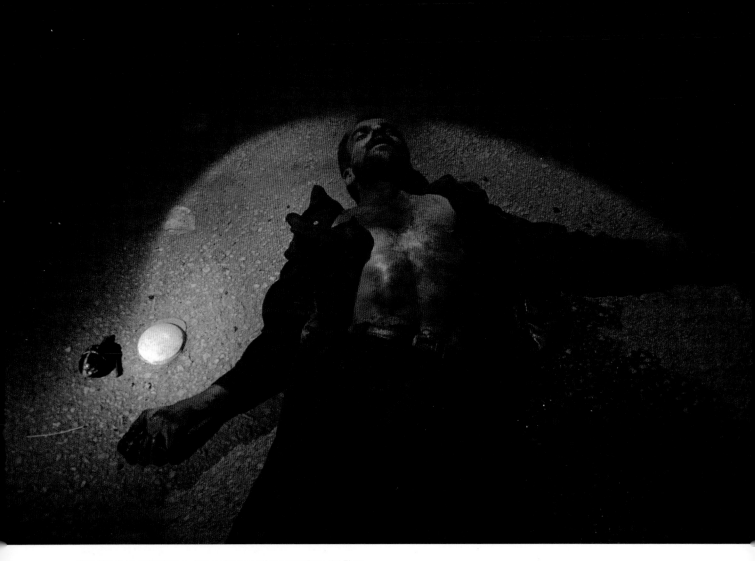

This Mahdi Army fighter was killed after engaging troops from the First
Armored Division in Karbala. Soldiers crowded around, shining flashlights
on him to have a better look at their rarely seen enemy. My editor at the
Times refused to run the photo until the soldiers said on record that they
had not planted the grenade. The three soldiers I interviewed were furi-
ous when I asked them the question, but all told the same story: the dead
man had crawled out of an amusement park's ticket counter, wounded,
grenade in hand. He and the soldiers had been lobbing grenades back and
forth at each other, and one GI had been badly wounded in the exchange.
My editor was satisfied, but the picture never made the paper.

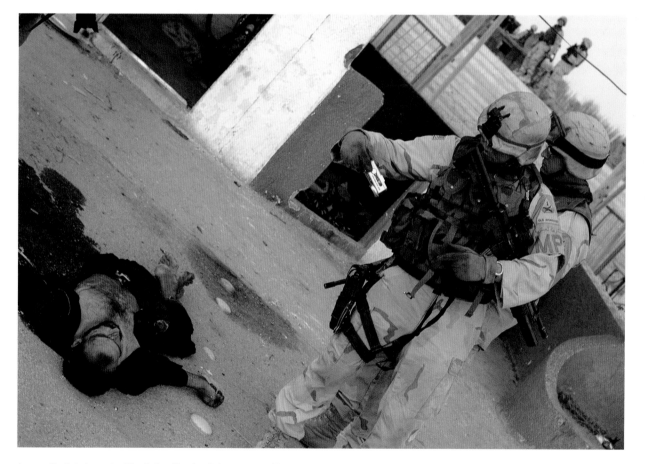

Army policy is to leave dead Iraqis for other Iraqis to recover and bury. "They clean up their own," said one soldier. The body of the Mahdi Army fighter was still on the street the next morning, an object of curiosity for GIs, one of whom takes a snapshot with his digital camera. By this time, the grenade had been removed by American troops.

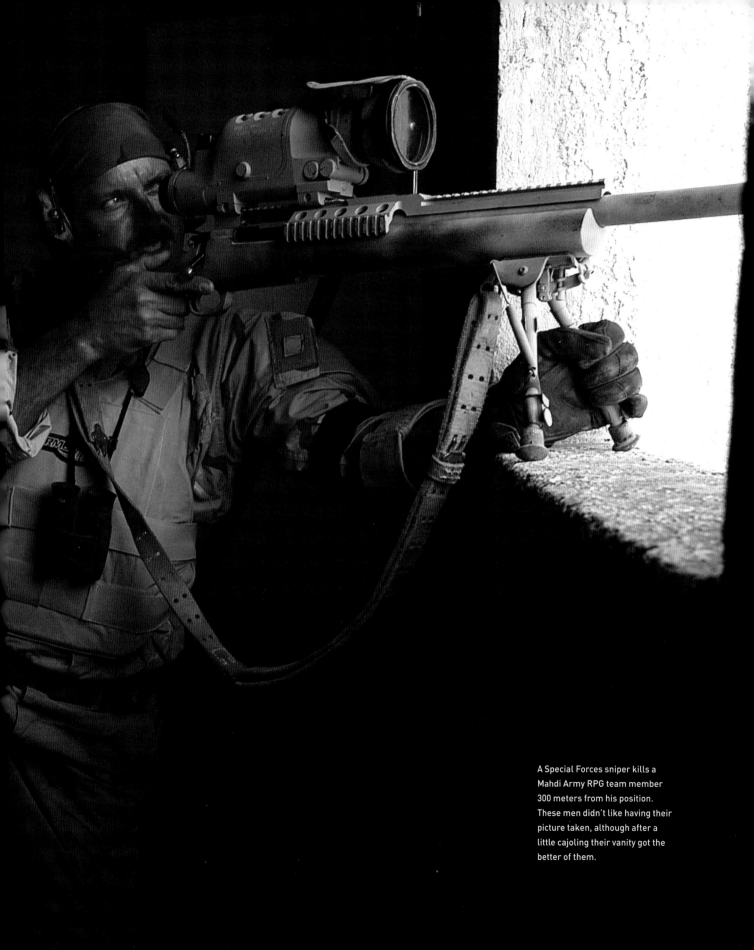

A Special Forces sniper kills a Mahdi Army RPG team member 300 meters from his position. These men didn't like having their picture taken, although after a little cajoling their vanity got the better of them.

A member of a Mahdi Army RPG team, shot by American soldiers, bleeds
on the street while fighting rages around him. He was there for an hour
and would have been collected sooner, but the Americans were pinned
down. They grew tired of his screams and moans. "I wish he would just
die," one grunt told me. The man was finally taken to a combat support
hospital where his arm was amputated. "He won't be firing any more
rockets at Americans," the medic joked with me later.

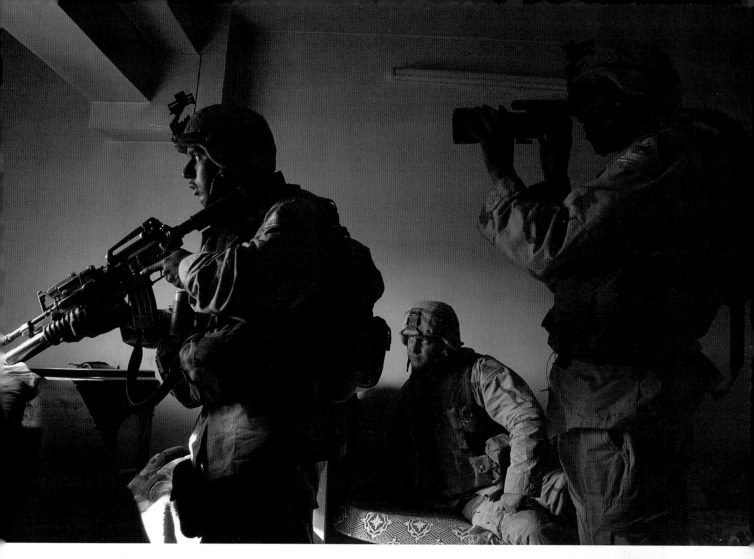

American soldiers started getting picked off by a sniper whose every shot landed above or below the bulletproof plates they wore. The troops suspected he was Iranian, and soon his prowess was legendary among them. For two weeks they couldn't get a shot at "the Iranian." The grunts changed tactics and moved into this abandoned hotel, far from their usual positions. Hours went by without a sound. Sergeant Michael Berry (seated), the American sniper, scanned the buildings and streets trying to find him. Finally, I got up to stretch my legs and, walking out of the room, I heard a loud crack. "I got his spotter," said Berry, but he never did get the Iranian.

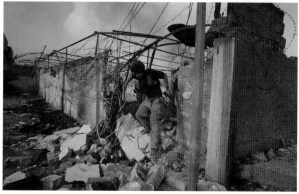

New York Times reporter Ed Wong takes the safest route out of a mosque, through a pile of rubble and burning munitions.

Specialist Michael West rests in an abandoned hotel he and his unit had
taken over during their search for the Iranian.

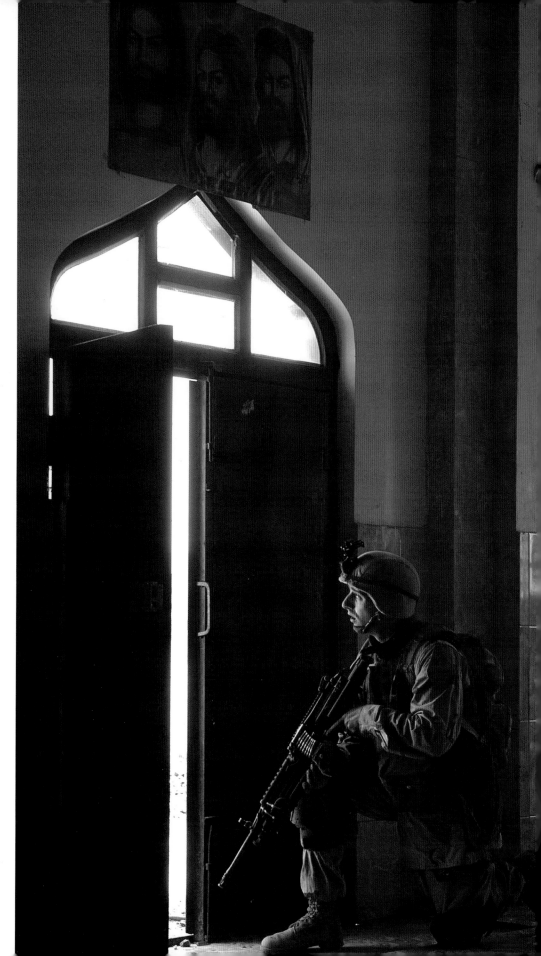

An American infantryman covers
his comrades searching a mosque
for arms in Karbala. Above him,
posters depict Imam Ali, Imam
Abbas, and Imam Hussein, the
central figures that mark the split
in Sunni and Shia interpretations
of Islam.

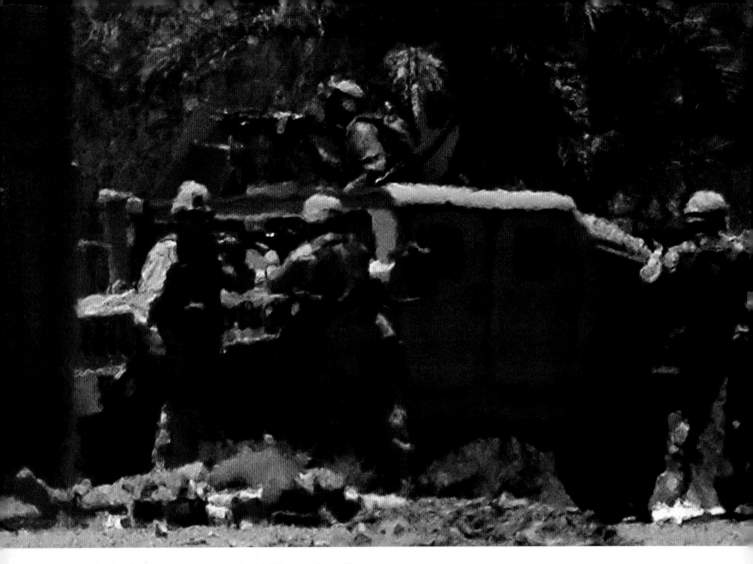

A soldier lies dead or wounded on the road as his fellow American military police fire on targets across the road. According to witnesses, a roadside bomb exploded as their convoy drove by, and upon stopping, they were ambushed with small arms and RPG fire. Four Americans were killed and five were wounded in the fighting. An Al Jazeera cameraman was also shot in the leg during the fight.

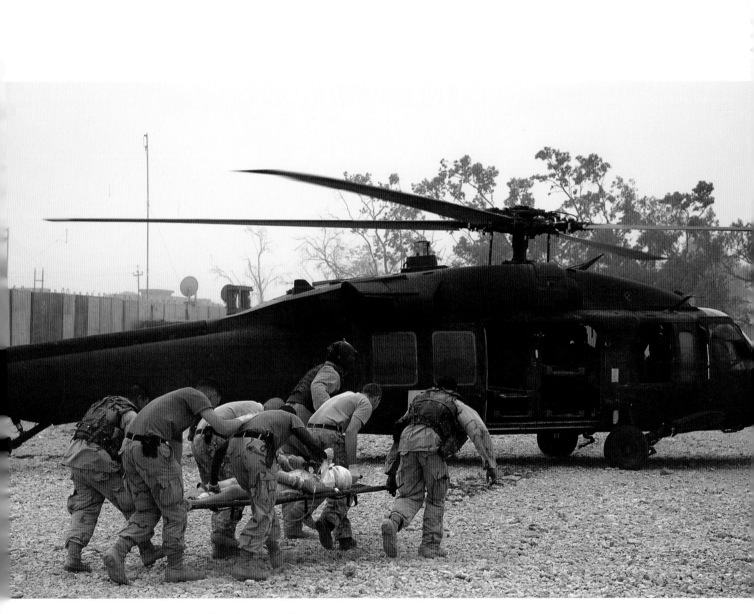

U.S. medics carry Sergeant Brud Cronkrite to a Black Hawk bound for Baghdad's combat support hospital. Cronkrite was wounded when shrapnel pierced his brain. The Black Hawk was operating in a dust storm, making the craft less visible and less vulnerable to RPG attacks. The helicopter landed safely in Baghdad. Cronkrite died in the hospital later that day.

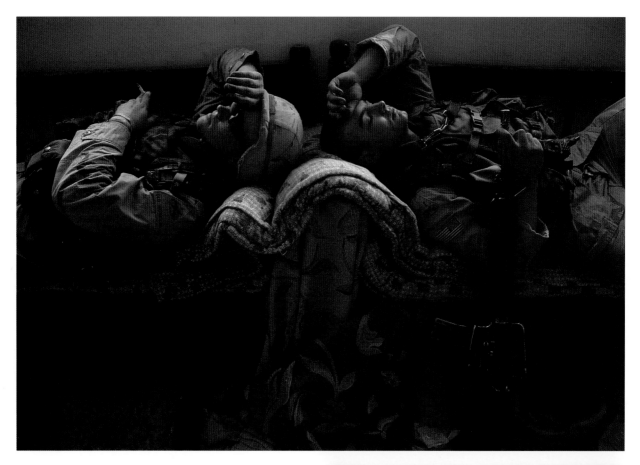

Exhausted GIs nap inside a mosque they took the evening before. The mosque had been used by al-Sadr's Mahdi Army to stockpile weapons and group fighters.

Lieutenant Colonel Garry Bishop plans an operation on a village eighteen miles northwest of Karbala. The Americans suspected a large number of weapons had been smuggled to insurgents living there.

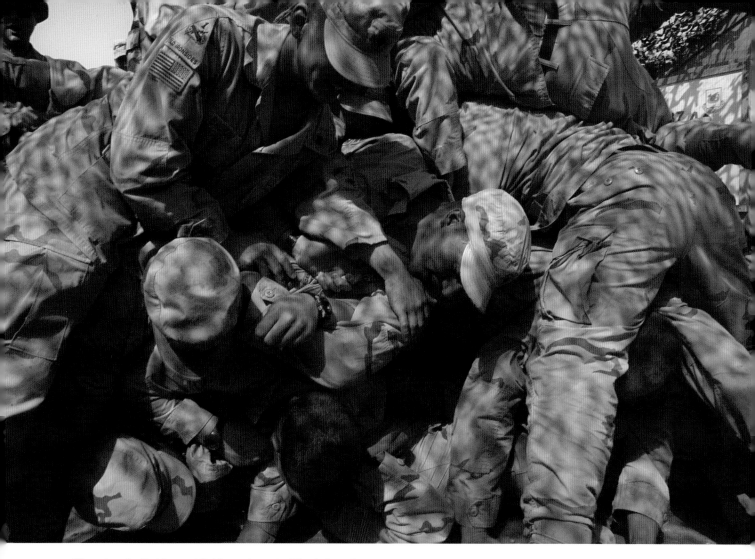

Officers from the First Armored Division perform a traditional pileup after one of their peers is promoted to Captain. The Abu Ghraib scandal had just broken; the scene reminded me of the human pyramid photographs coming from inside the prison.

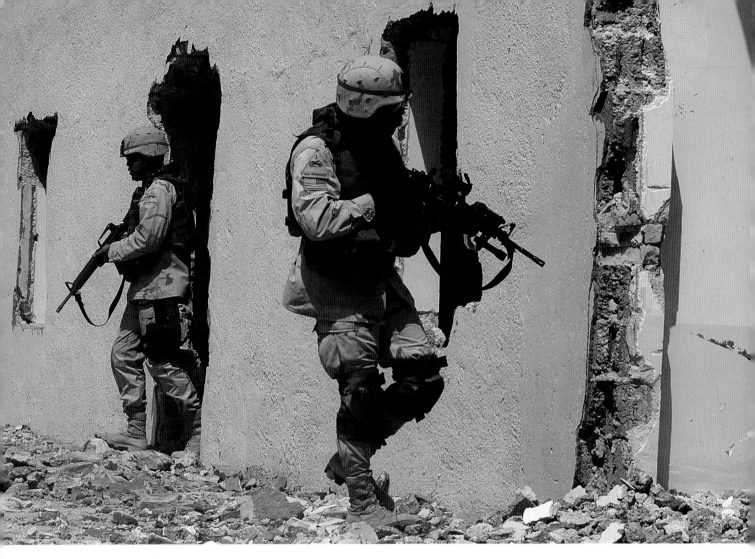

American soldiers "controlling the real estate" on the outskirts of Karbala.

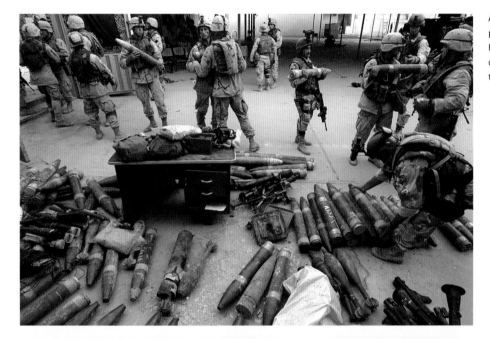

American and Iraqi Special Forces pile weapons inside a mosque that housed a massive cache. An F-16 destroyed the weapons, along with the mosque.

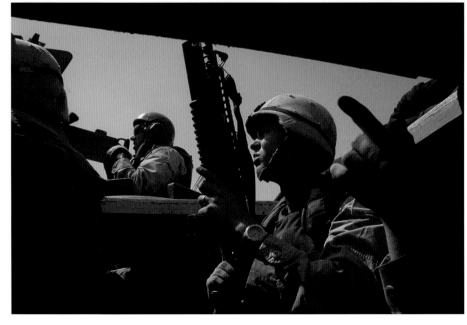

Specialist Ian Spakosky looks for the source of RPG fire that had narrowly missed the vehicle he was traveling in. His buddies knew him as Spanky. Exactly one hour later, he died when a sniper shot him in the hip. He became the 778th American soldier killed in Iraq.

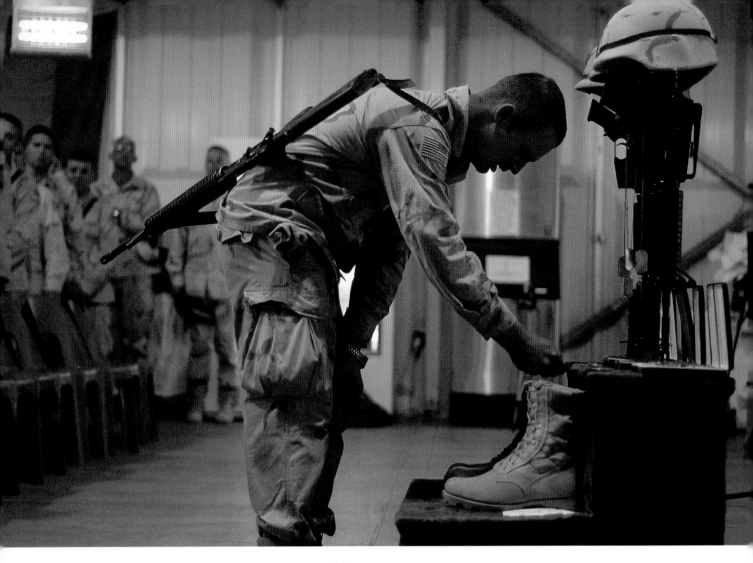

One of the soldiers in Spanky's unit pays his respects at a memorial
service for him and two other soldiers killed in the battle at Karbala.

Spanky's dog tags hang from his rifle at the memorial service.

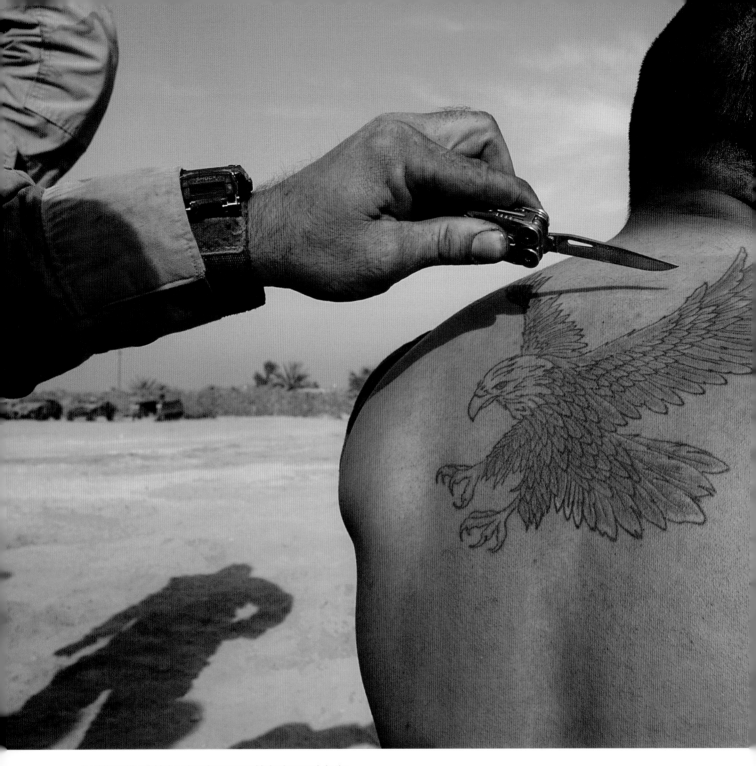

A soldier with prickly heat has the pores on his back opened. As the fighting in Karbala stretched into mid-June, the temperature during the day was 110 degrees Fahrenheit, and after more than seven hours in combat, soldiers' pores clogged with sweat.

A soldier shows off a message written inside of the soft cap he wears
around the Karbala base.

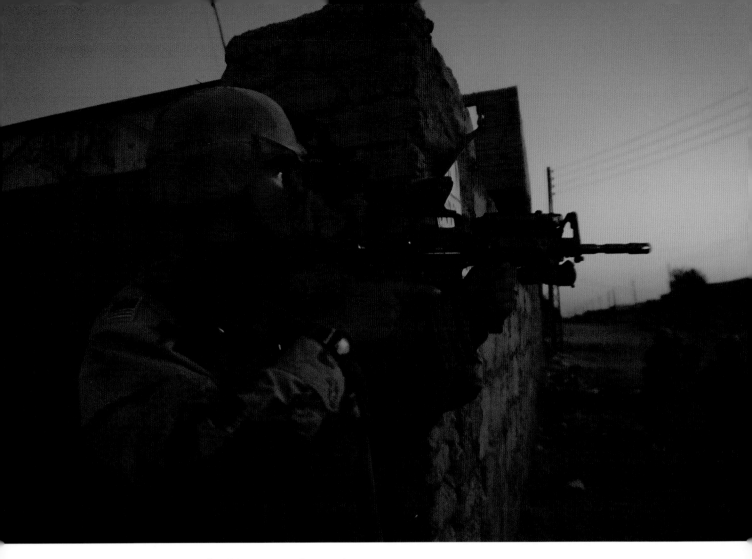

Lieutenant Erik Sarson from the "War Pigs" platoon conducts search-and-destroy operations in southern Samarra. The soldiers rested very little, stalking insurgents until dawn through their night vision scopes.

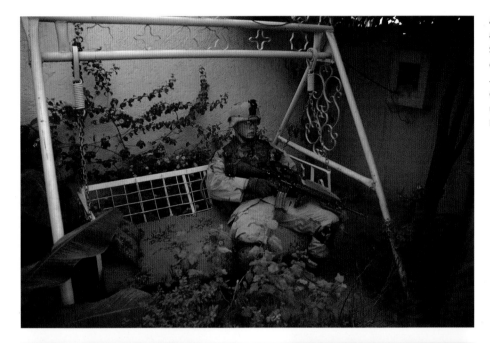

A GI rests on a porch swing outside a former al-Qaeda safe house in Samarra. His platoon found an extensive arms cache, a stack of Jordanian passports, and an ID card belonging to a private security guard they believed had been held captive inside the house.

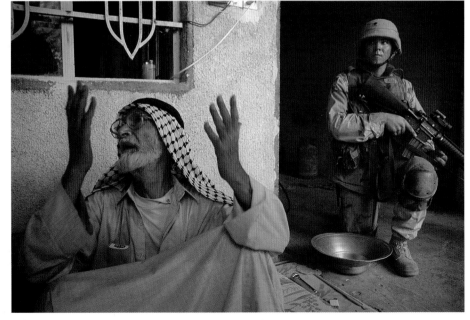

An elderly man in Samarra declares his innocence while American and Iraqi forces search his home for weapons. Home invasions like this infuriated residents. When the offensive wound down they took to the streets demanding compensation for damages and looted possessions.

153

The Samarra offensive interrupted
a wedding, trapping a dozen
people in the hosts' home. The
head of the family pleaded with
the soldiers to allow his guests to
return to their homes because his
was overcrowded. The soldiers
told everyone that they would have
to stay put for three days or more.

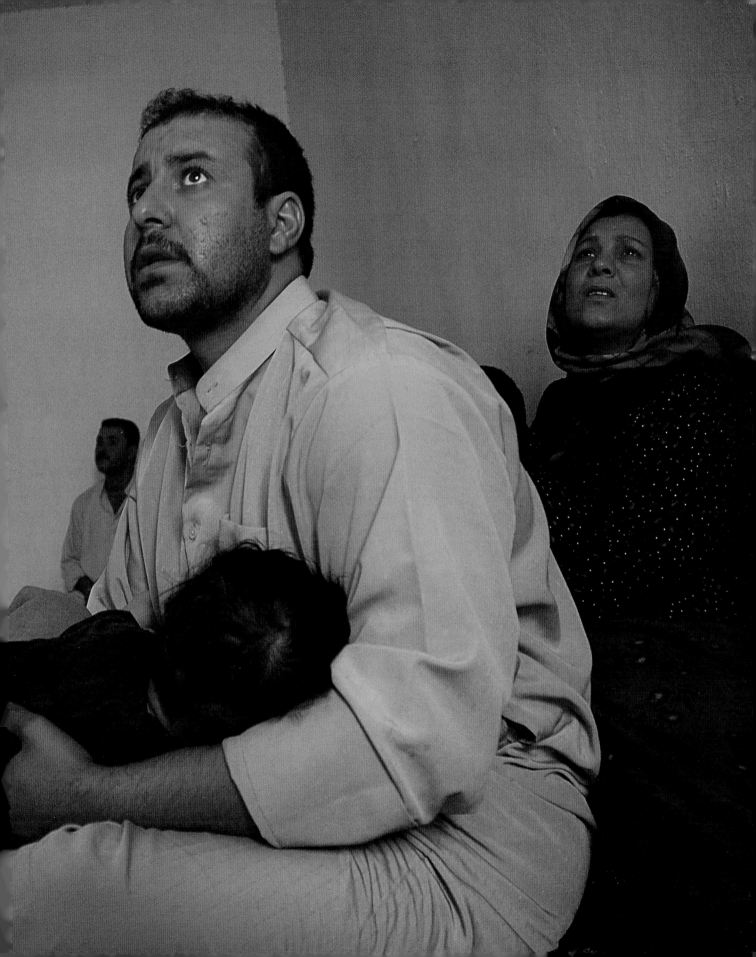

Sergeant Bill Willett searches for weapons in a former Ba'ath party general's home. In the process, he cut his foot on shards of glass and had to be evacuated for treatment.

An Iraqi national guardsman looks for anything of value in a Samarra kitchen. He was supposed to be searching the home for weapons, but like most of the Iraqis on the offensive, he mainly searched for things he wanted to keep for himself. When he found a knife sharpener in this house, he smiled and produced a knife he had looted earlier. Fifty percent of his fellow guardsmen fled their posts after being ordered to participate in the Samarra offensive.

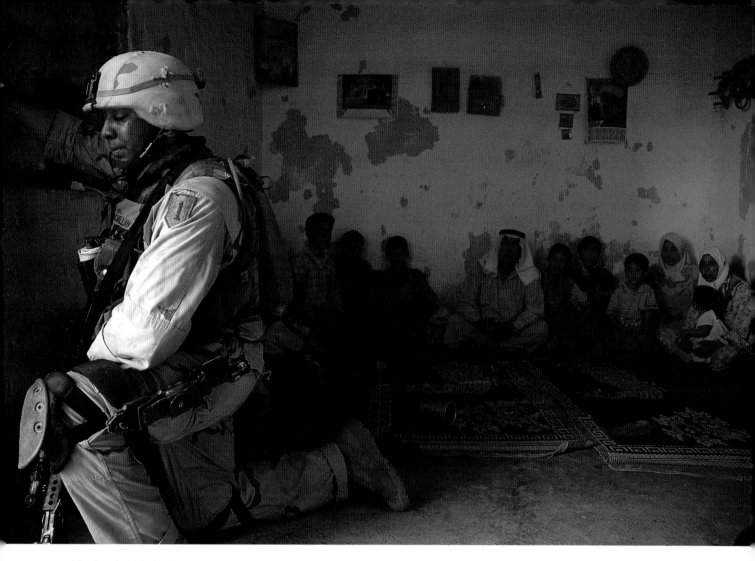

A family waits while American soldiers comb their home for weapons or evidence of insurgent activity. McMillan knelt to rest while the children cried. He surveyed the room and, looking despondently back outside, said, "This is the worst part of the job."

Three detainees await their fate in a makeshift detention center. They were caught carrying an RPG trigger in downtown Samarra and brought to the middle of the desert for twelve hours of questioning under the burning sun.

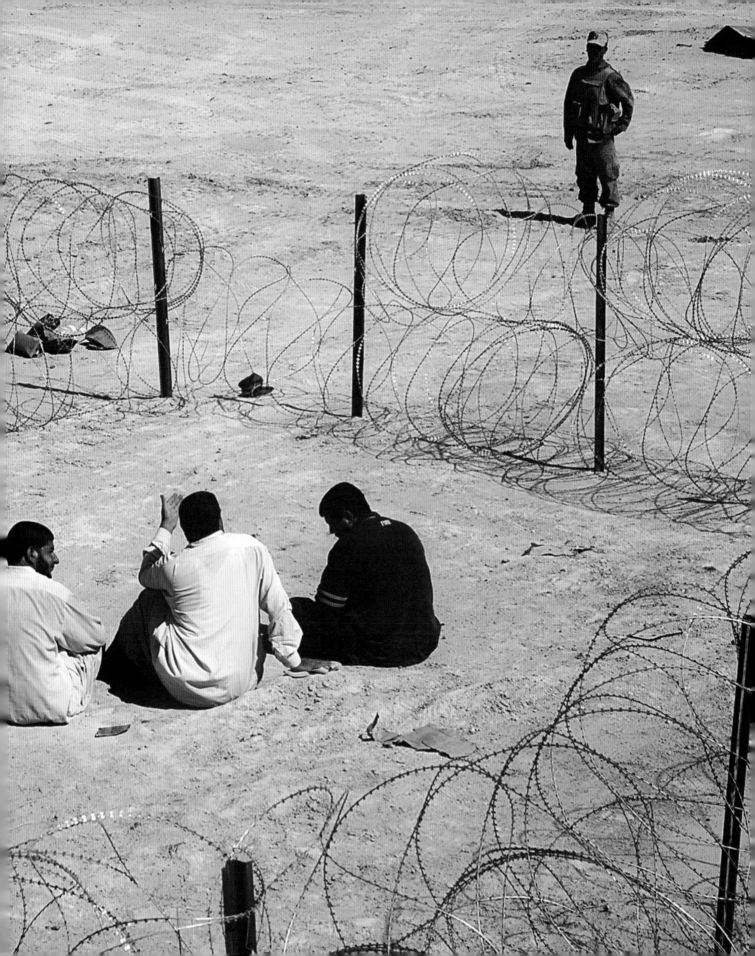

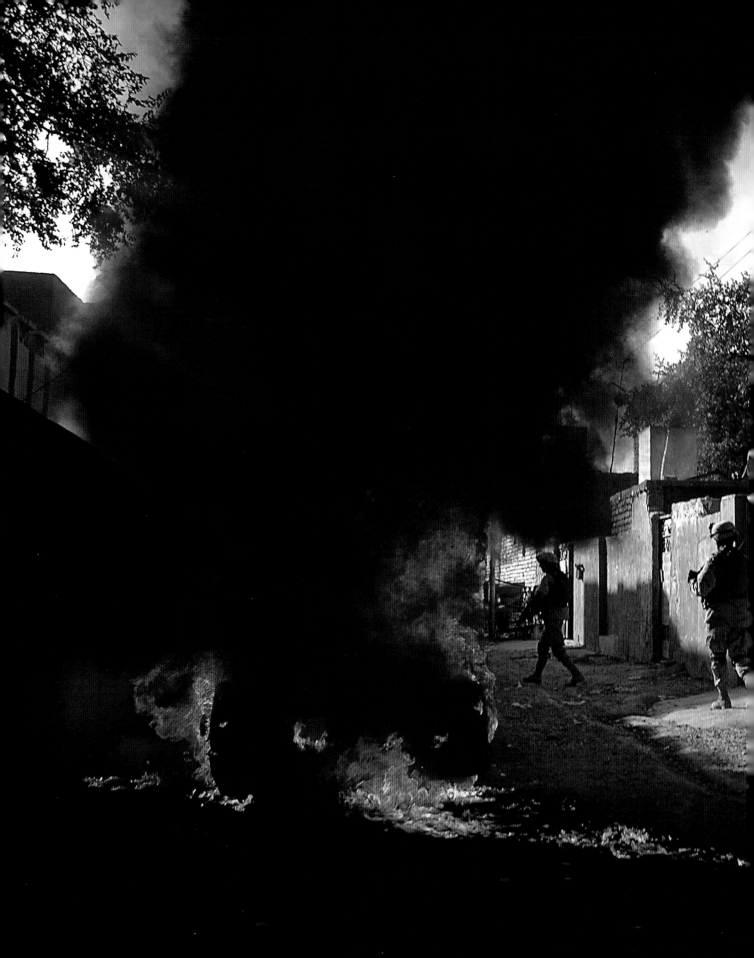

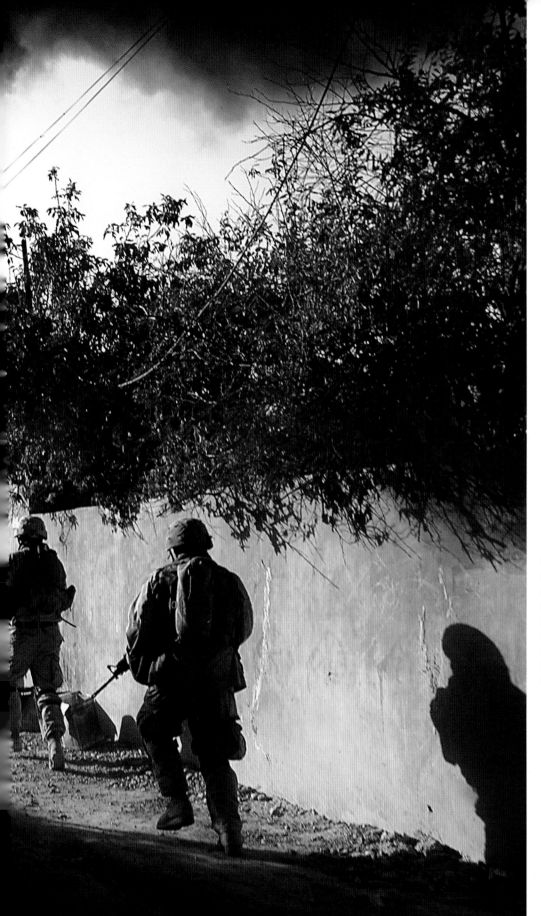

GIs shot up every car they saw—they were all potential car bombs. When troops from the New York National Guard saw this one, they really shot it up. It was sitting low to the ground, suggesting it might be laden with explosives. It wasn't. The only thing dangerous about the car was the troops' reaction to it.

161

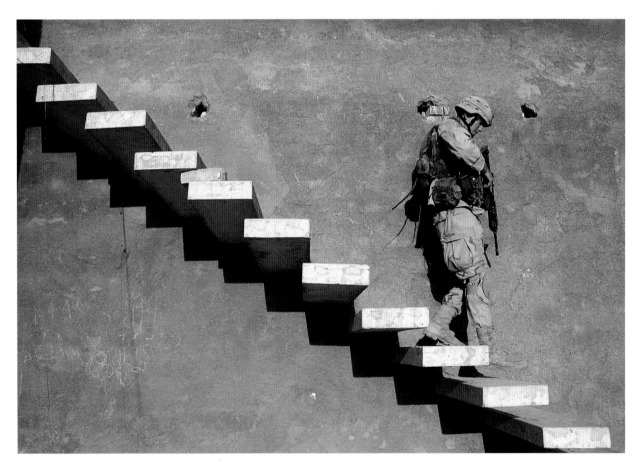

The military did in fact make an effort to compensate some of Samarra's residents for the damage to their homes. The New York National Guard returned to this house three days after they had fired a rocket through its door, just missing the owner who was inside. The platoon attempted to give him the opportunity to apply for compensation, but the owner wasn't home. They left him a note.

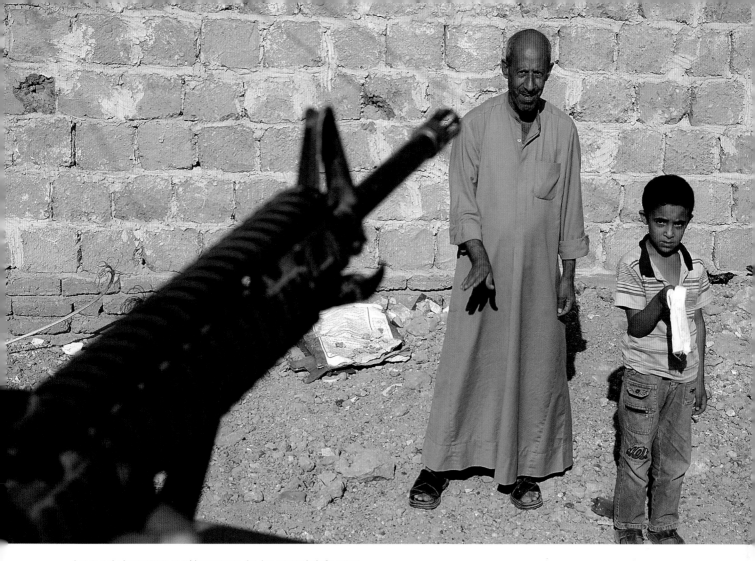

A man and a boy venture outside to assess the damage to their Samarra neighborhood. The boy carries a white flag to show that he is a noncombatant. Most residents carried flags like this, but that didn't stop U.S. soldiers from aiming weapons at them.

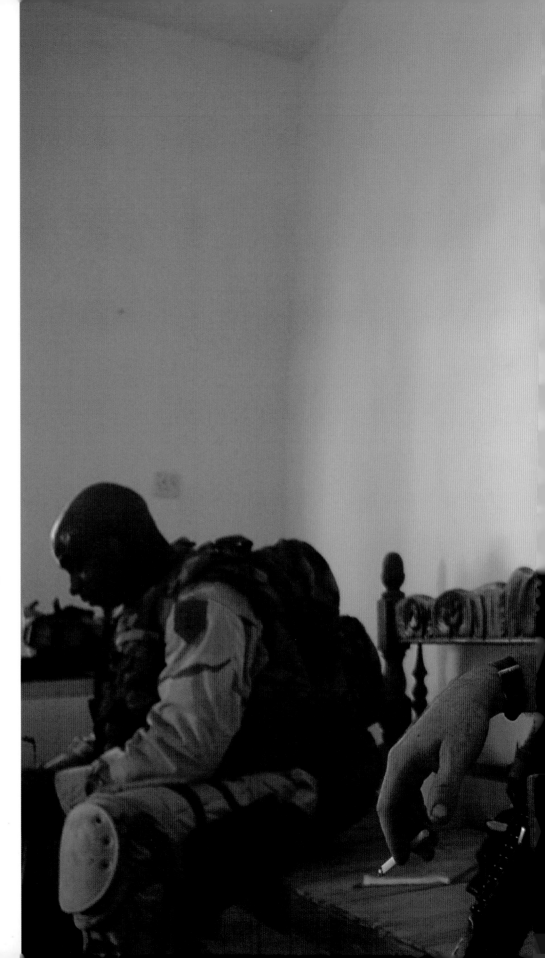

A soldier takes his first short break in thirty-six hours inside an Iraqi home. He and his squad had just searched more than 1,000 homes in southern Samarra.

164

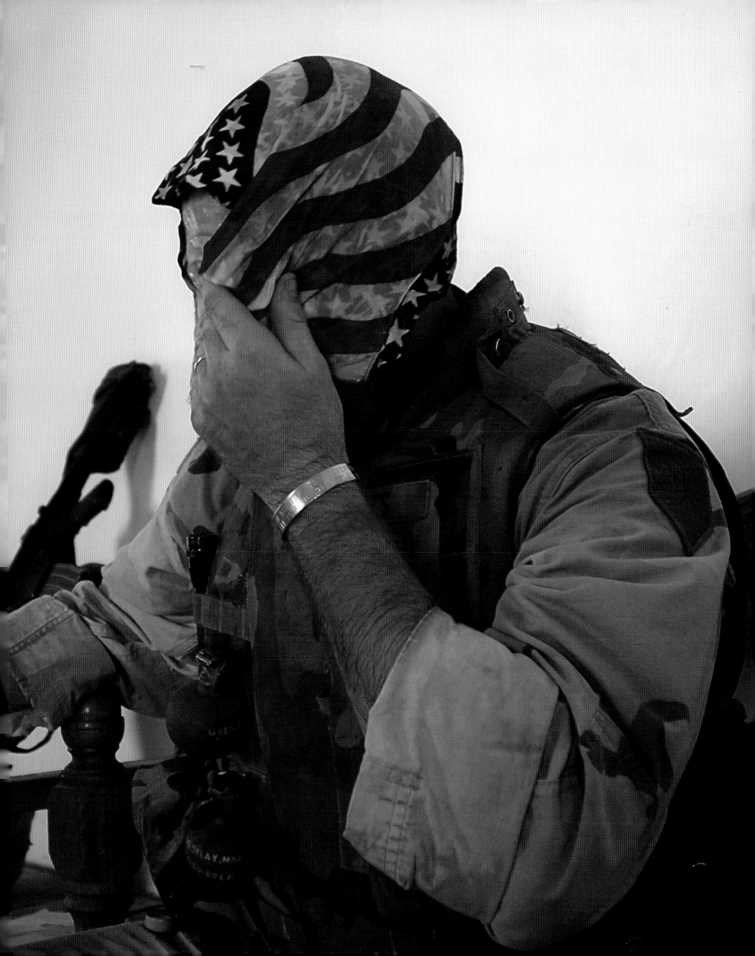

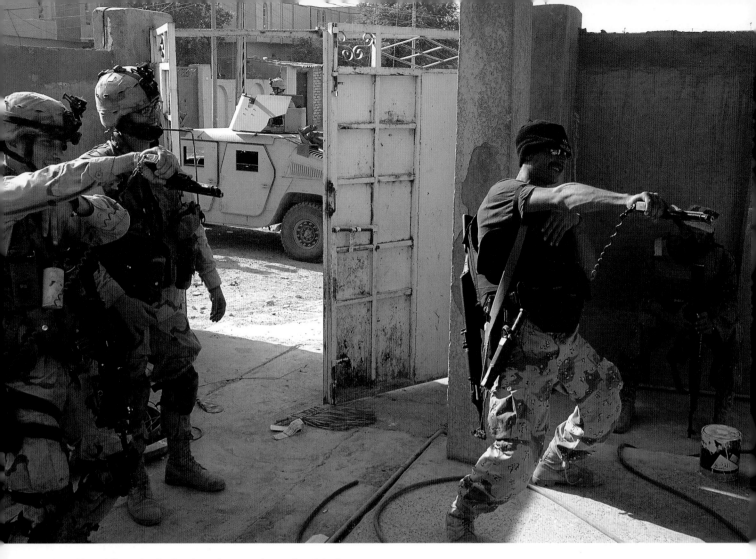

Money Mike, an Iraqi national guardsman serving as a translator for the Americans, learns to shoot gangsta style from Lieutenant Shawn Tabankin of the New York National Guard.

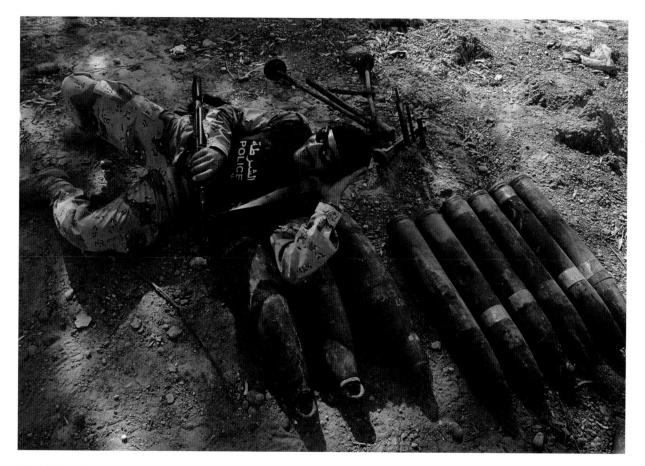

Money Mike strikes a pose.

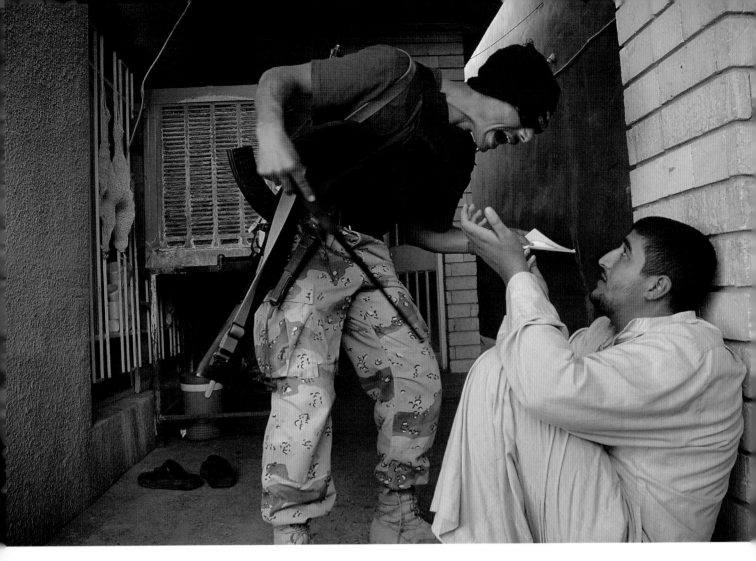

Mike violently interrogates a suspect. I had to send this frame to the
Times after I realized I hadn't photographed him threatening the suspect
with a knife.

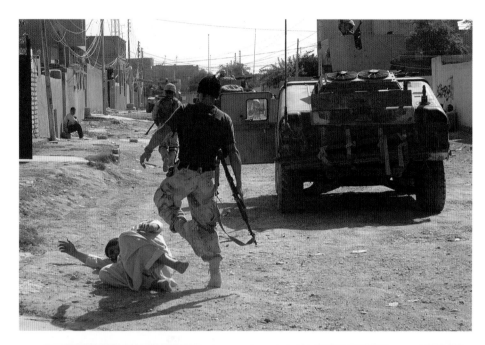

Satisfied with the interrogation, Money Mike makes a show of assaulting the suspect.

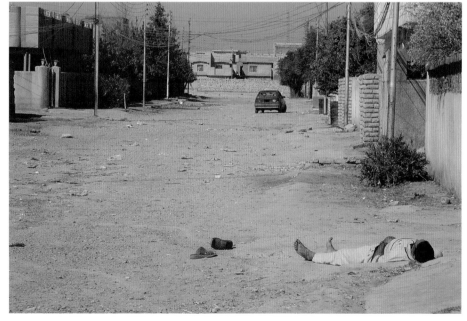

The suspect after his ordeal. I don't know how badly Mike hurt him, but he was better off getting kicked onto the street than killed by people who thought he had cooperated with the GIs.

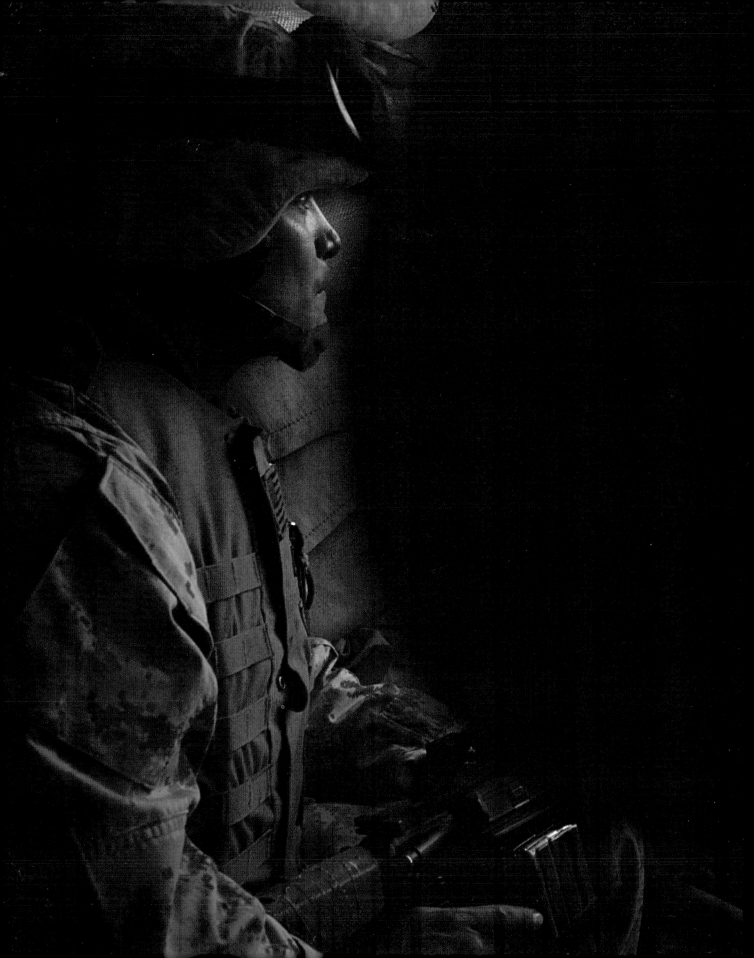

Iraqis go about their routines in front of the embattled Government Center in Ramadi. The marines in Ramadi had little contact with locals they were not shooting or arresting. Corporal John Rios does twenty-four-hour shifts defending the building from attacks by insurgents.

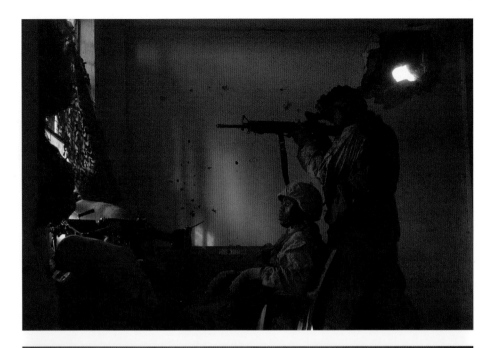

One of the marines' objectives in Ramadi was to keep open a road they called Route Michigan for twice-daily convoys. Lance Corporal Dwight Bibbins and Sergeant Nathanial Henderson cover the Suicide Train's trip down Michigan.

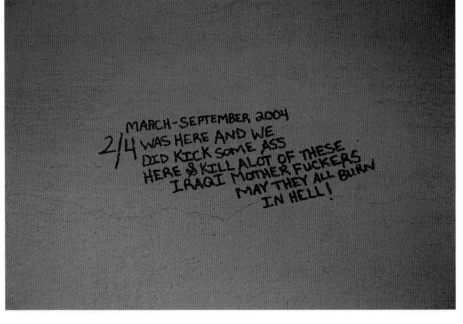

MARCH—SEPTEMBER 2004
2/4 WAS HERE AND WE
DID KICK SOME ASS
HERE & KILL ALOT OF THESE
IRAQI MOTHER FUCKERS
MAY THEY ALL BURN
IN HELL!

Marines who lost twelve comrades in a single firefight on April 6, 2004, left this message on a wall in the Ramadi Government Center.

OPPOSITE

Marines and Army units had overlapping rotations in Ramadi, and rivalry between them was common. A marine designed a version of Bingo mocking the Army's competence in Iraq.

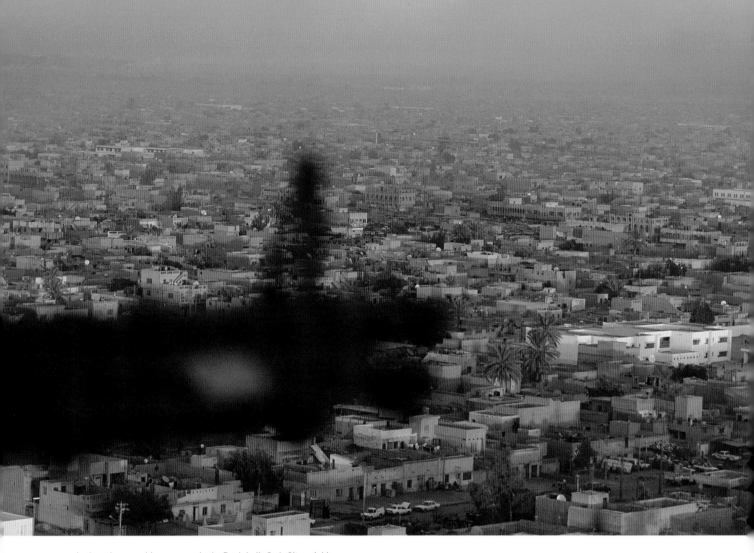

An American machine gun overlooks Baghdad's Sadr City neighbor-
hood, the stronghold of Muqtada al-Sadr's Mahdi Army. During the 2004
offensives in Samarra and Ramadi, the capital had become increasingly
violent. Insurgents stepped up attacks on Americans and each other's
communities. Still, Sadr City was one of the few places a photographer
could work relatively freely.

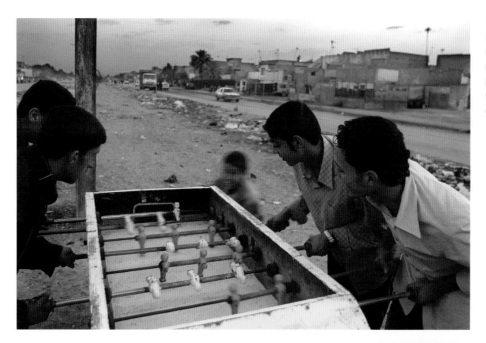

Iraqi boys play foosball on a table brought out from one of their homes. Houses are small in Sadr City, and while there may have been just enough room to store the table, it's unlikely there was enough to play on it.

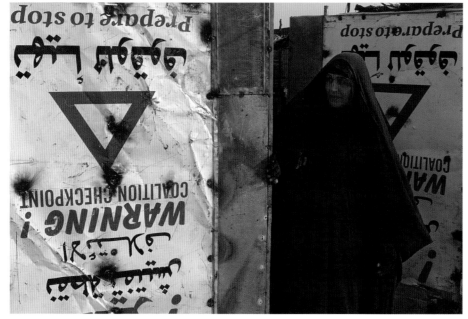

A woman watches a military convoy pass before her front gate. Sadr City is an extremely poor area, and many houses are thrown together with found objects. Hers is gated with discarded American checkpoint signs.

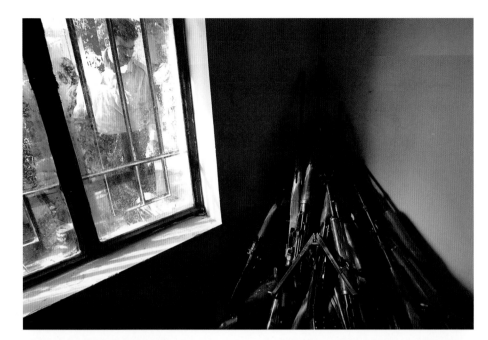

AK-47 rifles turned over by the Mahdi Army are stored in a police station in Sadr City. The U.S. military initiated a buyback program in an attempt to disarm the militia. Mahdi fighters turned over mostly rusted and unusable weapons, and the Americans paid twice market value for them. Any enterprising businessman trying to make a quick buck had only to drive to a nearby arms bazaar, buy a gun, and take it to the Americans to double his money instantly.

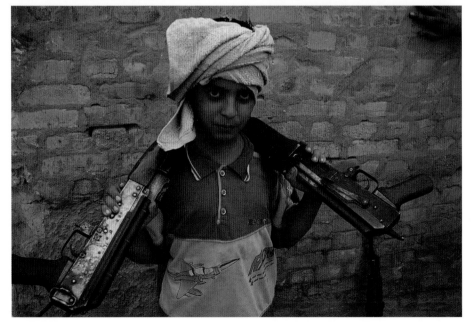

A young boy carries a set of well-used rifles for his father to sell in the Americans' buyback program. Several years before, the *New York Times* unwittingly ran a staged photograph of an Arab child playing with a toy gun. While the paper has no specific policy against photos of Arab kids holding real or toy weapons, I was told by my photo editor that it was unlikely the picture would be published because suspicions about such images still lingered at the paper. The picture did not see print.

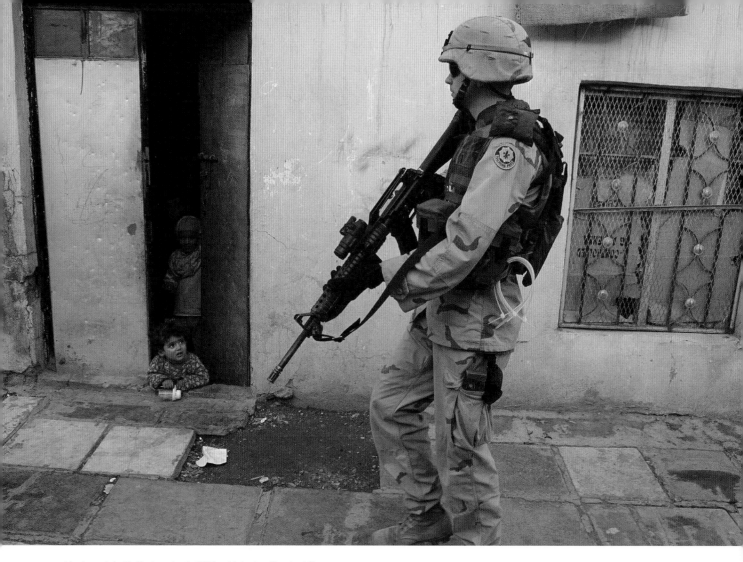

Lieutenant Justin Forkner leads 600 freshly trained Iraqi soldiers on a
raid of a Sadr City marketplace suspected to contain weapons. The raid
was not especially successful. The Iraqis netted two magazines—one for
an AK-47 rifle, the other, a copy of *Cosmopolitan* that the Iraqi soldiers
confiscated, claiming it was pornography.

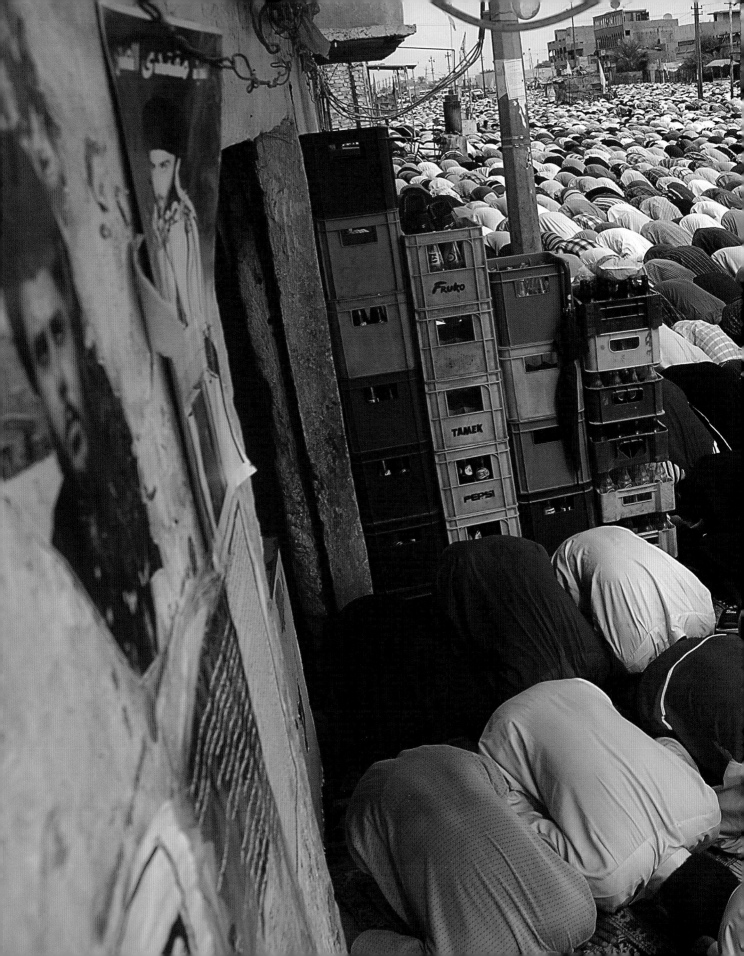

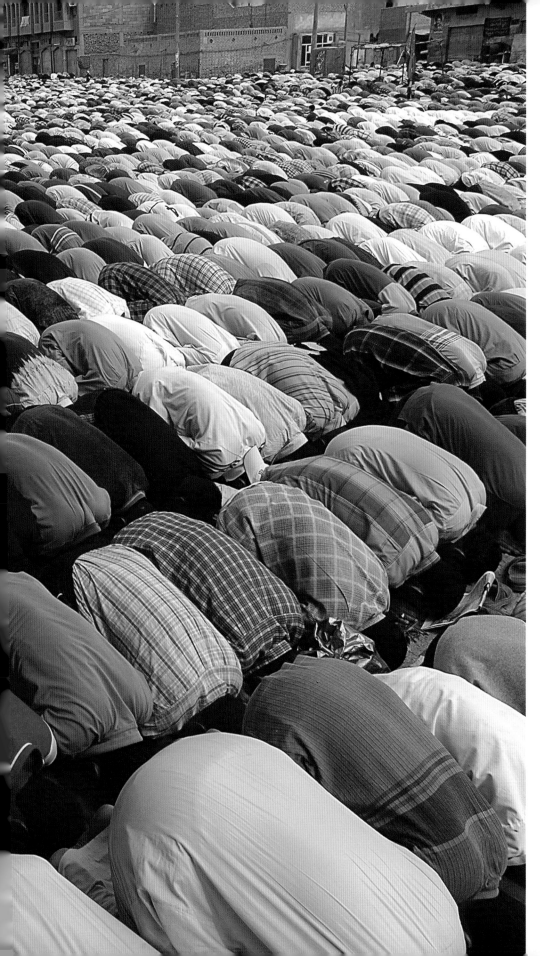

Friday prayers in Sadr City were a favorite for photographers. The slum was still relatively safe for us to work in, and Fridays were often quiet in Baghdad—the odd car bomb, maybe a firefight here or there. The pictures were often the same as the week before: kids dressed like Mahdi Army fighters, black-masked with model RPGs, or the thousands of Shia worshippers praying in the street. Their loyalty, after Allah, is to cleric Muqtada al-Sadr. His face is on a poster on the left side of this photograph.

FOUR

DANGER CLOSE
FALLUJA, NOVEMBER 2004

In March 2004, four American contractors were ambushed in the center of Falluja, a city forty-three miles west of Baghdad. They were dragged from their cars, beaten, and their bodies burnt. Their charred remains were strung up from a bridge leading out of town, amid cheering residents and insurgents. Photographs of the scene were beamed around the world, incensing politicians and civilians, and sparking the inevitable debate over the depiction of graphic violence in the media. Many networks and papers would not carry the images.

Back in Iraq, furious Marine generals who were supposedly in control of Falluja promised swift vengeance and on April 4 attacked the city with everything they had. Hundreds of Iraqis were killed in a week of intense urban combat. Concerned about America's image in the Muslim world, the Bush administration suspended the offensive, withdrew the Marines, and hastily assembled an Iraqi brigade to clean up the city. The plan failed miserably, and Falluja quickly became the center of the insurgency, both tactically and symbolically. It was known as the City of

Mosques in the Middle East, and its population of 350,000 was fervently Islamic, often adhering to the extreme sect of Salafism. Songs were written about the April battle praising the mujahedeen's victory against the "great Satan" and the "martyrs" who died fighting. Rumors circulated that the bodies of jihadists killed by the Americans smelled of roses.

Sunni fighters moved freely on the streets; they amassed weapons and coordinated attacks with little to disturb them. Occasionally an F-16 would drop bombs on what the U.S. military thought were rebel safe houses. Due to bad intelligence or just incorrect targeting, they often flattened civilian homes and businesses—among them Haji Hussein's, the best kebab joint in the country.

Twenty miles outside the city, the Marines plotted their revenge and gathered the strength to exact it. By October, the press started hearing rumors of a new offensive code named Operation Phantom Fury. Television personalities from around the globe started descending on Iraq, eager to get high-profile embeds for the campaign.

There were lengthy discussions at the *New York Times* bureau in Baghdad over who should be sent to cover the battle. Photographer Shawn Baldwin and I decided that he would take one of the two slots we had been allocated; he needed combat in his portfolio and I already had Karbala and Samarra. To Shawn's surprise, he and reporter Richard A. Oppel Jr. were flown to Ramadi to accompany a propaganda unit that would take the hospital on the eastern edge of Falluja but would not actually set foot in the city.

My rotation had finished and I was at the bureau packing to leave the country when a scramble ensued to get someone from the paper to cover the battle from the frontlines. *Times* higher-ups contacted generals and politicians, and eventually we were given two more slots, one of them mine. Joanna had been expecting to see me in Paris two days later. She was unhappy, but she understood that photographing the battle was an opportunity I couldn't let go. I repacked my bags, this time including body armor and equipment I needed to file my photos under battle conditions. A few hours later I boarded an aircraft bound for the dusty Camp Falluja five miles east of the city.

BRAVO 1/8

The night before I left, I attended a party at the nearby BBC compound where I polished off more than a dozen Falluja Flamers, some foul vodka-based cocktails one of the correspondents had invented for the occasion. I figured they were responsible for my less than average condition when I arrived on base, but three days later I was still sick as a dog. I had caught the flu.

I rested on a cot in the makeshift base. Eventually Captain Read Omohundro, the commander of Bravo Company of the First Battalion, Eighth Marine Regiment, came by. "You're going to get your ass out of bed and come and train with my marines," he said. "If you're going into Falluja with us, I want you to understand what we're doing and how we're doing it." I got the distinct impression that he didn't want to be dealing with a wounded or dead journalist on the battlefield, and that he doubted I was up to the task of running with the marines through the city.

Dexter Filkins, the *Times* reporter who got the other slot on our embed, was in shape. He had no problem keeping up with the marines and even less trouble gaining kudos from Omohundro. I was better suited to chatting with the grunts about Britney Spears and swapping "I was so drunk . . ." stories.

The company gunnery sergeant trained Dexter and me to use M-16s, AK-47s, and M-9s—just in case we were the last people standing, he explained. He fitted us out with gas masks to use if insurgents attacked with chemicals, as they had in recent operations. We ran about all day with the marines. At night, we rested while the marines played baseball, or screwed around smoking cigars, telling jokes and showing off the drilling skills some of them had learned to perform on the lawns of the White House.

One evening I accompanied the captain for a flu shot—not the most ingenious idea when you are already sick. The next day I was sicker than before. A medic came to my cot and gave me Motrin, which Joanna laughingly informed me that night is the medicine women often use to treat menstrual cramps. It's also what the marines take for anything from a gunshot wound to a headache. The pills worked, and my leftovers later proved useful when medics on the battlefield ran out.

On the Sunday before the battle, with less than twenty-four hours before the offensive kicked off, everybody was nervous. The correspondents gathered to watch Lieutenant General John Sattler, the commander of the First Marine Expeditionary Force, give a pep talk to a company of infantry marines. For the first time we had a detailed picture of the marines' plan. It was brutal. Some reporters who had begged for "tip of the spear" positions thought again and opted to stay in the camp instead of trying to keep up with the marines and dodge bullets in the city. "I didn't need to see marines knife-fighting insurgents," said one later on.

CNN cameraman Karl Penhaul had covered the April offensive in Falluja and was still pretty shaken from the experience. He approached Patrick J. McDonnell, a hard-nosed Irishman from the Bronx who worked for the *Los Angeles Times*, and asked, "What are you going to do?" Patrick said that he had come to cover the battle and would of course go in. "Well," Karl replied, "I'm not going to push your wheelchair." Patrick was speechless. Correspondents are a superstitious bunch, and Karl's quip was the conflict-zone equivalent of telling an actor "Good luck" when he's about to go on stage. Had Patrick not renounced violence after being bashed a few times as a kid, he probably would have laid Karl out.

Operation Phantom Fury kicked off on November 8, 2004.

Just after 02h00, First Sergeant Ron Whittington, a burly African American, shouted the roll call to Bravo Company in the freezing rain. Marines answered with cries of "here!" or "Ooo-rah!" as vapor trailed their words in the cold. I don't think it had rained for years in Falluja, let alone dropped below desert temperatures. When Whittington called out Dexter's name, there was no reply. The sergeant shouted Dexter's name over and over again, but none came from the dark rows of men. It reminded me of the roll calls at memorials for men killed in combat, when the fallens' names are called but never answered. I stood there in the formation as the rain fell—some of us would surely die. But I had no idea how brutal the battle would prove to be.

Dexter eventually emerged from a conference with Captain Omohundro and joined us in our two-mile march through the mud to the vehicles. Everyone, including us, was humping eighty-pound packs, and the marines had their weapons to carry as well. We loaded into amtracs, amphibious vehicles designed in the Second World War and still being used by the Marines today. A few hours later, the hatches dropped and we were in the desert outside of Falluja, the skyline clearly visible. Jets were dropping bombs all over the city. Gunfire and rockets flew through

the eerie blue light that precedes sunrise. You could be forgiven for thinking that the apocalypse had arrived.

The grunts who were not keeping watch on the perimeter would get some rest in foxholes dug out to provide cover from rocket attacks. The captains and colonels grouped the small gang of press attached to three companies of marines and gave us a rundown of what we were doing that day and night. On a computer that rested on the bonnet of a humvee, we watched live aerial video of insurgents grouping around mosques and safe houses, and driving around the city in pickups mounted with huge machine guns.

When night fell again, the marines loaded into the amtracs and drove to the outskirts of the city. The trac Dexter and I rode in broke down, and for some reason it could not be towed. We climbed out and loaded into another one, pushing and falling over one another. Another hour cramped in there raised everyone's fatigue and aggression: "Get that fucking rocket out of my back!" one marine said to another.

We were dropped near a train line, designated the breach point. A contraption called a line charge—350 feet of C-4 explosive—was fired down a road to clear land mines and roadside bombs planted there by insurgents. The explosions were enormous, and the concussion pounded us as we took cover.

The marines launched the offensive in single file, Dexter following right behind me in the string of forty soldiers. We ran down a hill flanked front and back by marines, taking cover with them against walls of houses that sat on the edge of the city. Bullets whizzed everywhere, RPGs whooshed by. That night, it was as though the city were having a violent allergic reaction to the marines, vomiting up all the deadly munitions it held.

From up ahead, I heard a call to arms blaring through the city on the scratchy speakers through which Falluja's mosques usually call prayers. From behind, a Psyops truck made its rounds, slowly fading in AC/DC's "Hells Bells" until the song blasted at full concert-hall volume, then fading out again. A spooky submarine ping later replaced AC/DC. I don't know what the idea was behind the eerie sonar tone, but the Psyops teams claimed they play AC/DC because the insurgents don't like rock and roll. I think those guys just liked "Hells Bells."

Dexter and I moved with Bravo Company into the city. The marines were met with fierce resistance all night long. It was pitch black—I could not make a single exposure. All I could do was move through the wet alleyways and streets with the marines, and wait for the dawn light. At one point that first night, the marines were pinned down by snipers. They were at an impasse, unable to locate the enemy's position. Navy Seals mysteriously slipped in from the darkness to confer with Captain Omohundro. They left as quickly and deftly as they arrived. The sniper fire ended moments later.

Just before dawn, the marines arrived at 40th Street, or phase line Cathy, as the marines called it, a main east-west road close to their first objective, an Islamic cultural center. Immediately, Bravo Company was met by a ferocious hail of insurgent fire. I remember thinking to myself: I'm with the lead squad, this is it. That turned out to be the first of many times those thoughts entered my head. The squad returned fire, calmly shot a rocket down the street, and retreated to join the rest of the company.

A nearby company mistook Bravo for a band of insurgents when it had regrouped around a column of tanks. Soon, white phosphorus artillery rounds started falling on us. No one was hurt, but a chunk of phosphorus burned right through Dexter's backpack. It was horrible

taking cover on the ground face up; to lie there face down would have meant that I couldn't dodge the pieces dropping from the sky.

My memory of the battle from that point on was hazy for a long time. Some events still are. I don't know how I photographed the marines running through the phosphorus, or what I was thinking when I moved through Falluja's alleys trying to keep in line with the marines, photograph them, and not get killed. I can't recall entire scenarios even while looking at the pictures I took of them. I can't remember some conversations I had with marines moments before they were killed. Now that enough time has passed, I recall things I sometimes wish I could forget. The seven days of combat come back as one long nightmare.

CROSSING CATHY

Captain Omohundro led the marines through the small streets and alleyways, ducking into cover wherever they could. The company finally massed in a small house at the end of a road. From the roof the marines could see the Islamic cultural center, a large building that was still under construction and thought to be a staging area for the insurgents. The marines were separated from this first objective by a six-lane road.

The marines started running across the road, their heavy packs shifting awkwardly. The inky morning light made it hard to see, and soon the marines were under fire from three angles they could not cover. Marines answered the fire from roof positions established in cover houses, giving the gunfight a fourth layer of sound and deadliness. Dexter and I shouted to one another over the din as we sat on a swinging chair we shared on the lawn of a house the marines had taken. Someone yelled, "Third Platoon, GO!" and forty men gathered in a tiny covered doorway leading out of the yard, then set out across the street. When the

second to last man began the dash, I turned to Dex, "I don't wanna go, I really don't wanna go." The last man gave me a look. I got up and started running with him.

I'm completely unprepared for what I see when I run out that gate. I immediately think I should turn back, but I am one lane into the street already. Everything unfolds in slow motion. I watch bullets kick up under the heels and soles of my boots as I run, I watch the bullets miss marines in front of me by inches. I see men hit. I see men fall. Other men grab and drag casualties from the street, leaving trails of blood behind them.

Three lanes down, three to go. The noise of shooting is deafening, so loud that I think it can't possibly grow any louder, so loud that I can't think about anything but making the sound stop. This racket and the terror of being on the open street is the first hell of Falluja. In times like this you think quickly, and time slows.

Two lanes. I see the low wall between the cultural center and the rest of the street, across a gutter and a dusty sidewalk. The marines are running to a small opening in the wall, but that entrance is now blocked by men carrying the dead and wounded. Nothing I can think of is worse than stopping in that fucking road.

One lane. With a strange clarity I think, I'm running faster than I have ever run before, which is a miracle since I am wearing cowboy boots, jeans, have cameras dangling from my shoulders, and an eighty-pound pack on my back.

The wall. I realize I'm looking at nothing but the wall. Dust rises from the sidewalk as bullets hit the pavement. I lift my feet, instinctively knowing there is a gutter to jump. I hit the dust, take two steps, and dive over the wall.

Beyond the wall, I see more dust and concrete kicking

around me. An insurgent is shooting at me from a direction I don't expect. I get up again and run as fast as I can to a wall of the cultural center.

While running I see Sergeant Ryan Shane being carried by a half dozen marines. My finger falls on the shutter. I hit the wall of the building with force and fold to the ground, trying to hide behind a column. I lie there looking up at the bullets ricocheting off the wall, trying to find me. A marine is suddenly in my face shouting, "You didn't take a picture of the Sarge did you?! Did you?!" Somehow I stutter that it's impossible, but even if I had, the *Times* wouldn't run it. I have no idea what he would do if I tell the truth. It ran the next day.

Navy Seals and Force Recon lined the entrances and windows inside the cultural center, some of them bandaged up. As the marines filed in, they fell against walls away from windows and doorways. Many were now completely oblivious to the heavy fire coming into and going out of the building. Around me marines slumped against walls, unable to speak, occasionally crying, staring into nothing. They looked into a void: the thousand-mile stare. I didn't really notice it at first. I was in the same headspace as they were, in a daze thinking, that was the most fucking dangerous thing I have ever done.

In what might have been hours or just minutes later, Dexter came up to me, aghast. He looked me over and moved on after seeing I was all right. Dex had stayed back with another platoon before crossing the street under slightly less dangerous conditions. Months later, over dinner in New York, he said, "I'll always know you as the guy who ran." Coming from the man who I thought exemplified bravado, the guy who would drive around in unarmored cars during the worst of times, who would say "If I stop traveling and reporting, then they've won," the remark shocked me.

The building started to shake with concussions as though a giant were rocking the ground below us. I emerged from my stupor. I had no idea what was going on but I guessed insurgents were using some type of cannon to level our position. I cowered into a corner of the building and watched the marines scurry around me, their faces suggesting they were as confused as I was. People shouted all around. I wondered if I should reconsider being an atheist.

As suddenly as they started, the explosions stopped. U.S. artillery had been called in on a position less than forty yards away to destroy a minaret where a sniper had been hiding. There were mujahedeen inside the adjacent mosque, and the artillery had hit that, too. This was my second experience of what the military call danger close, when bombs or heavy fire come too near to friendly forces. Friendlies are supposed to be well outside the danger close area, but in this style of urban fighting, it was impossible to have a more comfortable distance between us and the targets.

I went to the roof of the building. There, marines shot grenades onto insurgent positions below while bullets rained back in toward them. I set up the satellite link and started to file photos.

I stumbled around the cultural center to find the captain and Dexter. I came upon the captain and his first sergeant upstairs. Omohundro led me to a window and pointed, saying with a smirk, "There's your reporter." And there was Dexter, on the street, running toward a destroyed car outside the mosque. I watched him open the charred hood, fumble around inside. I realized he was looking for a battery—any sort of power to charge our computer and phones. He looked ridiculous out there, the only person moving anywhere in the vicinity, and in open view to anyone who cared to look. But he was right—what was

the point of being in this hell if we couldn't file back to New York? He tested the battery. When it didn't work, he scrambled back into the center. "Of course it wasn't going to work!" he said later in New York. "The car had been fucking bombed!"

DANGER CLOSE

Dexter and I left the cultural center with the marines before sunrise, heading toward their last objective, the Iraqi National Guard compound in the middle of town. After a couple of hours of hard fighting, Bravo Company's progress was halted by a sniper who had taken up residence in a large building overlooking the government center. Shot after shot rang out as marines launched grenades into various windows of the building. Others fired their rifles and machine guns, and artillery and jets were called in. All to thwart one sniper.

After all those bombs, projectiles, explosions, the sniper's single shots still pierced the air. For half a day, one sniper stalled a company of U.S. marines in the center of Falluja, effectively shutting down the company's advance.

The riflemen couldn't do much to help out, so some of them settled inside the house. Lying on couches and the floor, they rested and chatted. Sometimes their conversations—the guy they whacked, the college basketball scores, some chick back home—would be punctuated by the whistle of a bomb flying over our heads and into the building where the sniper lay in wait. A marine who was sound asleep when one of the bombs came in woke up as the whistle grew from a light whine to an unbearable death-scream. He woke up seconds before the bomb exploded and saw everyone covering their ears. Another danger close. He went ass-up onto the couch and covered his head. Some of the marines laughed, but their laughter sounded like madmen's in a loony bin.

The sniper only stopped firing after a squad ventured into the building to clear it. The sniper had vanished, leaving his rifle and box of ammunition.

The marines found the Iraqi National Guard compound mostly destroyed when they took it. It looked as though the insurgents had gone through the building throwing grenades into every room, wrecking anything and everything they could find. I had been in the building a year before, just after insurgents had killed the mayor and overrun the place. Then, it looked like a new hotel. Now, where walls were still intact, anti-American graffiti and religious slogans were scrawled in green spray paint. Rubble lay everywhere. Hundreds of Iraqi uniforms had been strewn around—ample evidence the mujahedeen had raided the National Guard's stash to blend in with friendly forces.

It was dark by the time we entered. I remember tripping over the rubble as people explored the building trying to find a room to rest, while sentries guarded the perimeter from windows blacked out by tables, cabinets, and any other flat objects they could find. It was behind one of those tables where I got ready to prepare my photos for transmission. I had to cover my whole body and the computer under my sleeping bag; any light emanating from the room would have given the marines away. It was hot already, but sitting under that bag made the temperature more extreme. I waited and waited in that bag of heat for my satellite phone to catch a signal.

Once the photos were sent to the desk in New York, I went downstairs to rest between two solid concrete walls. All my batteries—phone, cameras, laptop—were running low. I had no idea how to charge them, and I couldn't sleep from worrying about it. Dex was still awake, too, and we got to talking. Our conversation stopped though, when an enormous explosion tore through the corridor.

We jumped up, and in came another. Then another and another. We realized it was mortar fire, but not the 60 mm types I was used to, the ones Iraqis call pimples. These mortars were big ones, 120 mm, and they were coming closer very quickly.

Mortars aren't the most precise ways to bomb something, but they definitely get the job done. Soldiers drop projectiles into a long tube so they arc over a battlefield and explode on impact. To hit their target, the mortar team "walks in"—they go a little to the left, a little to the right, and BOOM. Dead. This team was walking in for a while, and the place was going nuts. Marines ran everywhere trying to find cover.

The captain ran to a window. Was he crazy? He shouted into his radio, "Find that fucking mortar tube and take it out! Someone!" That was the only time I saw the captain lose his composure. Dexter, who I think had invested all his cool in Omohundro, freaked out. He started cowering on the floor. Until then, mortars had never worried me. I knew you only die when a round actually hits very, very close to you. The next boom, though, I freaked out too. Those were huge bombs.

Then, strangely, the mortars stopped. So had my worrying about batteries.

THE CITY OF MOSQUES

I woke up the next morning in Falluja to the sounds of firing from up on the roof. In a small room at the top of the stairs, marines hid behind the doorframe before running like hell to a neck-high ledge on the rooftop. Apparently they were already under sniper fire.

Sensing a picture, I waited until the marine in front of me had made it to the ledge for my turn to follow. He hadn't

been fired on, so I guessed it was safe to make my own way out there. As soon as I ran out the door, bullets started cracking past my face. The marines started laughing between shouts of "run!" and I hit the wall.

Dexter was next. I turned to warn him that the sniper was active again, but he ran anyway. No shots. Another marine ran. No shots again. I looked in bewilderment at a nearby marine. "He got a bead on you," he said. Snipers pick a target—in this case, me—and wait for the kill.

I spent a long time on that rooftop behind the protection of the walls. I finally took a chance and popped my head up. No shots rang as I watched an RPG shot from an alleyway hit an amtrac. I cursed myself for missing the photo, and decided to pop my head up again. I didn't want to miss any more photos. This time, shots cracked around my ears. The sniper had a bead on me. From then on I kept very low. After a few hours passed, I watched men run back to the door without being shot at. When I ran . . . CRACK CRACK CRACK! He missed.

I made it downstairs to find somewhere to file photos, suddenly realizing my plane ticket from Amman to Paris had to be rebooked. Wasn't I supposed to fly today? I couldn't remember.

The next day, the captain told us that the National Guard compound was no longer Bravo Company's final objective: the new order was to push all the way to the southernmost part of the city, where the foreign jihadists were rumored to be holding out. Omohundro pointed his K-Bar at coordinates on a large satellite map, showing his lieutenants the plan for the offensive. Meanwhile, his men packed their bags and got ready to move.

The smoldering building across the street was the first

southern building the marines would take. I ran into it with the first wave and watched as they went through the hallways and staircases, then the rooms. It didn't matter that the building was empty. The marines carefully checked every room for weapons or bombs before clearing it for the rest of the company. I thought of the people who lived in these homes, and the outrage they would feel when they returned and saw the destruction these men wrought when they cleared a house. The place seemed haunted by the living ghosts of its owners, as if they were keeping their eyes on the marines razing their city.

Dex and I climbed to the roof of the house. From up there, the broader destruction was plain. The City of Mosques, once known for its towering minarets, had been practically flattened. From our vantage, only one minaret stood amid so many others' smoking remains. I said to Dex, "That one's still standing." That minaret was bombed the next day, after a sniper hiding in it killed a marine.

When the sun finally set that day and we were holed up in another house, I asked someone to suggest a place for me to file without making my computer's glow attract sniper or rocket fire. Someone pointed me toward a toilet. Like most toilets in the Middle East, the ones in Iraq are holes in a concrete floor. The marines' marksmanship with rifles did not extend to these toilets. And even though MREs are formulated to prevent the marines from having to make frequent pit stops, the place was a sickening mess. I closed the door, dry-retched at the stench, covered my body and computer with my sleeping bag, and worked.

The battle had taken a turn for the worse. The marines were up against hardcore jihadists who weren't from Falluja but who had come to Iraq to die fighting. The insurgents had been pushed into a corner. They would do anything to kill an American before they died. Or an Australian photojournalist. Anyone who wasn't on their side. I was exhausted.

As night fell, the marines moved on. Every now and then they fell into a house to plan and regroup. The odd RPG whizzed down the street but hit no one, and no one saw any insurgents despite consistent reports that they were close. A car stood at the end of one street completely engulfed in flames. The marines slid silently by as the car seats popped and hissed like fireplace logs.

Combat is strange: you're with 160 men, or 40 if you spend time with one platoon, but you feel so alone. If you're under fire, you're allowed talk but can barely hear yourself think; if there's a lull, you're not allowed to talk because any sound might give up your location. You have to find a space inside and discipline yourself, make yourself small and quiet—as invisible as possible. It helps to stay behind a guy with a big gun, or just behind a big guy.

I stayed back as the point platoon advanced into the darkness. Up ahead, gunfire rang out. The radio informed us that insurgents disguised as friendly Iraqi forces might try to ambush. I waited while the rest of the company stalled. I had no idea why, but it became pretty clear when I dropped out of my spot in the formation and moved ahead. Insurgents wearing Iraqi Intervention Force uniforms had been waiting for the point platoon on a street corner. The uniforms were adorned with bands marking their associations with the U.S. military, and before the marines noticed anything suspicious, the insurgents opened on them at point-blank range. They killed one marine on the spot and wounded two more.

The marines grew quiet as the news of the ambush filtered through the company. Across a clearing on my right, a line of houses were set low along the dark horizon. The

night was clear enough for me to see all their architectural details, the back doors, the roofs. From which house, I wondered, would an RPG or a bullet find me? When it's silent and still in combat you have time to think. You become very scared, very quickly.

The lieutenant in charge of the point platoon was walking around in circles. He wasn't crying. He was beyond tears. While he paced, clearly freaking out, his men started to lose it as well. The machine was falling to pieces. For the first time, I appreciated how much these units depended on leadership. When the head fails, the body follows. And that's the crux of what Captain Omohundro told the lieutenant as he grabbed him and tried to talk sense into him. I felt guilty listening, like I was hearing something I shouldn't. The lieutenant pulled himself together. His men followed. And the fight went on.

The marines had received reports that insurgents were grouping at their next target, the Grand Mosque, and as they squeezed the insurgents tighter and tighter into a box, the mosque and its surrounds grew more heavily trafficked.

The company found a house opposite the mosque to prepare for their attack the next morning. While a squad of men entered the house to clear it, the rest of us waited in the pitch black on the street. More time to think. I looked at the houses around me. These ones were larger, two and three stories. This seemed to be a wealthier street. I hid behind a burnt-out car until a fence on my left spooked me. I hid in front of a wall, until a wall on the other side of the road spooked me. I was running to a new hiding spot when an explosion ripped through the night, followed by screaming, "My face, my face!" Then another man started screaming too. I looked up. The house had caught fire.

The squad had tried to make their way to the second floor when an insurgent started rolling grenades down the stairs. Men stumbled out, one holding his face, another holding his leg. The rest of the company fled into the front yard of the house, firing into the upstairs windows and massing on the grass out front. It was some of the only grass we found in that city, strangely comfortable, even as gunfire blasted around me.

The fire grew, and a marine rushed from the house, this time talking to one of the nearby sergeants. Word went around quickly that the house had been rigged with explosives, and the fire would probably blow it. For what seemed like hours but was surely only minutes, I sat on the soft grass, enjoying its familiarity, until the marines started filing into a house at the next corner.

The whole time, I couldn't shoot a frame: it was too dark. Nighttime was fine for Dexter, but not for me. I needed to show this stuff in pictures. I was taking phenomenal risks, but at night I couldn't even take pictures to justify them. I was embedded, and I had no choice but to be there, a lame photographer.

Dexter woke me after a few hours of sleep in the corner house. We moved with the platoon across the street to a tall house near the mosque where the captain and his men could assess how many insurgents were congregating. It was still dark, and we kept low on the rooftop, crouching behind its chest-high ledges. The sky turned a rich blue as the sun began to rise, and the air officer attached to Bravo Company heard from Basher, the call sign of the AC-130 gunship, circling above us at five thousand feet. The pilots reported they could see forty insurgents on the roof of the mosque and wanted to know if they should destroy the target using their 105 mm cannon. Omohundro looked over the ledge, two floors above

the mosque's roof. He couldn't see any insurgents, but he knew they could be hiding behind the dome. He also knew he was about to send his marines into the mosque. He OK'd the air strike.

After a few minutes, Basher radioed to say it was prepared to fire on the insurgents. We could hear the drone of Basher's rotors coming closer, and the captain looked over the mosque once more. He still couldn't see anyone, and he turned back to look at the roof dotted with his forty marines. He lit an infrared strobe light to identify their position to Basher, and immediately the crew radioed that the insurgents had acquired an infrared strobe. Omohundro shouted at his men to evacuate the building, radioing Basher to cancel the strike at the same time.

Once inside the mosque, the marines took up defensive positions at windows on both floors, taking shots as a black-clad insurgent ran through the grounds. I went to the second floor and spoke to a sniper team, Corporal Nicholas Ziolkowski—known as Ski—and his spotter. With his eye ever-pressed to the scope of his rifle, Ski explained that he was hunting a certain sniper, a sniper who had been hunting him. He told me that during the April offensive, the insurgents in Falluja had learned how deadly the marine snipers were, and made them priority targets during this operation. Two days later, while Ski was again behind his rifle and scanning the horizon, his personal enemy put a bullet through Ski's head. Ski hadn't been wearing his helmet, but it wouldn't have made any difference. "The type of round that killed him would have penetrated his helmet like it was a paper hat," Omohundro said later.

THE CIVILIANS
There was a flurry of movement downstairs and some mention of civilians. I headed down and gathered with

a couple of marines and some of the few Iraqi forces allowed to remain after the disguise ambush. We made our way outside the mosque's grounds, into Falluja's badlands. The marines turned a corner, and I watched as an RPG whooshed through their ranks, missing all of them. I learned in Karbala that when an RPG is close, you feel the fire burning your skin as it passes. This was one of those times. The men peered down the street, hearing gunfire from the other end. A machine gun firing from another direction soon silenced it.

As we moved quickly down the street, a man wearing a bloodied dishdasha stumbled around the corner, carrying a blood-covered rag. His face was covered in blood too. Through the marines' translator, the man said there were civilians in a car around the corner who had been shot at while trying to escape the fighting. A precisely cut semicircle showed where a bullet had grazed the man's cheekbone. He frantically begged the marines for help. The Iraqi troops stepped forward and said in Arabic, "Just kill him!" but no one translated that to the marines.

They went around the corner and found a car torn to pieces by bullets. There appeared to be two women inside it. Protruding from a driveway by the car, next to a machine gun, a dead insurgent lay awkwardly, his body horribly contorted, whipped by bullets. The Iraqis started screaming for anyone in the adjoining houses to come out. Two men, both wounded, emerged with their hands held high. One of them was crying. The marines ordered the men to lie on the ground. They were searched, then violently herded by the Iraqi troops toward the mosque for first aid. The man who had been crying had raw fear in his eyes, more so than in any human being I have ever seen.

They still had to deal with the car. The lieutenant with us cautiously approached it and found the two women. One of

them was young, crying hysterically, utterly confused. The other was an old woman who sat in the car seat motionless, soundless, her chest still. The translator opened the car door and started escorting the young woman to the man in the bloody dishdasha. The lieutenant checked the pulse of the old woman. "She's dead," he said flatly, and moved back toward the mosque.

It took a long time to help the civilians navigate the streets. Rocks and dust and pieces of peoples' houses were everywhere, strewn by bombs and by the tanks the marines had used to gain entry through the mosque's walls.

Times reporter Ed Wong later tracked down the young woman who had received treatment inside the mosque, locating her at a Baghdad hospital. She told him that when the marines found her, even though they had shot at her family, she appreciated their help. But once she was being treated and saw what they had done to the Grand Mosque, she was disgusted and only wanted to get away from them. She also asked Ed what had happened to the old woman, who was her mother. The marines had not told her they had killed the old woman. Ed didn't have the heart to tell her, either.

I settled into the mosque to file my photographs while I had the chance. Again, I was pointed to the darkest room there. It was the room where the Korans were kept, along with the Imam's other items. Now it was being used as a toilet.

I crouched between boxes that had been used to transport rations, poetically refilled with digested MREs. I put my satellite phone outside between two shit-filled boxes, my sleeping bag over my head, and while my photos evaporated into the ether on their way to New York, I e-mailed the desk to say that they shouldn't expect anything from me for the next twelve hours, because the marines were rumored to be resting up at the mosque that night. I didn't write that I hoped the rumor was true.

Back inside the mosque's main room I found more than one hundred marines layed out across the floor in perfect ranks, trying to get some rest. Their adrenaline was still running high, though, and the men were restless. One of the marines had found an old battery-operated radio, and he started going through the dial, trying to find a station broadcasting in English, "to hear what they're saying about us out there," he claimed.

The radio was full of static, and between the barking Arabic channels he kept passing, a grating hiss penetrated the room. No one said a word, but they seemed happy to hear a familiar sound, like I felt sitting in the familiar grass by the house over the road. Then came a faint sound of music, and the marine found a tune: that sappy theme song from the movie *Titanic*. A marine in the corner of the mosque started singing along, and then another on the other side of the mosque. Soon a choir formed from among the toughest men in the American military, singing along to Celine Dion from a destroyed mosque in downtown Falluja.

"DON'T PISS YOURSELF"
I awoke to the other radio, the one that delivered orders from command back at Camp Falluja. We were to move forward under the cover of darkness. With their night vision, they like to say, the marines control the night. They moved house to house through relative quiet. The captain eventually settled on a house overlooking a large clearing that faced the southern side of Falluja. It was reportedly in the city's most dangerous area.

The marines settled in, hammering holes in the walls for their snipers to peer through, setting up sentries on each wall to look through their night vision scopes, the rest of them bedding down inside. I was completely exhausted and fell asleep outside by the feet of one of the marine sentries overlooking the clearing. Sleeping there was dangerous—the place was exposed to snipers and mortar attacks. But I could no longer bear the little rooms packed with men sleeping so closely. Omohundro was lying down outside too, keeping an eye on things. He never really slept, just lay down with one of his eyes open taking everything in, like a dragon. "It's really dangerous out here," he said. I fell asleep.

A few hours later I felt something burning my neck and face. I could see through my eyelids that the sun was up and could hear shooting coming from right above me. I opened my eyes to see the sentry firing over the ledge. Shell casings poured down on me, and I rolled to get out of the way. I lit my first cigarette of the day and asked the marine how long he'd been shooting. "About fifteen minutes," he said.

Dex and I are caffeine junkies, and every morning we would collect the discarded instant coffee packs that come with the MREs. The marines didn't usually use them because there was no hot water, and because the coffee was repulsive—dehydrated Taster's Choice. The ritual went like this: after finding as many sachets we could, we'd open one, carefully pour in a packet of sugar, then slide the combination into our mouths, take a gulp of water, swish everything around, and swallow. As disgusting as it was, I looked forward to the ceremony every morning. I began to slither out of my bag to start my rounds. I felt something wet around my crotch. You've gotta be kidding me, I thought.

Yes, it was true. I stayed in the bag to evaluate the situation. How could I hide this? Could I do the rest of the battle in boxer shorts? Should I pretend to spill water all over myself when I find some water for my coffee packets? Where is the water? I can't ask that guy, he's trying to kill someone! Maybe there was a pair of pants in this house somewhere? But how could I find them without giving myself away? It was ridiculous that with everything going on, I would worry about losing face with a bunch of twenty-year-old marines. But I did.

I had no choice. I just pretended it hadn't happened. No one said anything, though I saw some eyes drop below my belt for a second or two.

The marines brought in a few wounded fighters who had surrendered. The insurgents told the marines they were university students who got stuck in the area. "Yeah, right, University of Jihad, motherfucker," one of the marines said as he looked down at the blindfolded and cuffed man. The marines covered their gunshot wounds with ninety-mile-an-hour tape and waited for an amtrac to come and pick up the detainees. It was dawn, and the light was perfect. Long shadows dappled a wall above one of the detainees. While the wet patch on my jeans dried, I waited for the guard to cast a silhouette over the Iraqi. Meanwhile, marines wandered up sporadically to study their elusive enemy.

Later that afternoon, I stood on a roof as the marines sent rockets and bullets into the houses and mosques south of us. A section of the Army was coming in, Omohundro said, to clear a path that his men couldn't. I watched as a few Bradleys drove down the streets, letting loose their 30 mm cannons into every house they passed. The destruction was astonishing. Entire streets that had been

relatively livable were flattened into heaps of dust. "That's why we don't travel with the Army," the captain told me, "they shoot at anything."

All of my equipment's batteries were running low again. I'd heard an amtrac was dropping off ammo and picking up captured weapons, so I went downstairs to meet it. The amtracs had proven to be our best power supply during the battle. Dex had brought an AC/DC power inverter, which I connected to the battery of the amtrac and started charging everything, one by one. It was a grueling and tedious process.

Hours later, I lay out on a rooftop to sleep, this time next to Dexter. I thought he was asleep, but just when I got comfortable in the rubble, he said, "Night dude, don't piss yourself."

THE LAST MAN
The company's final objective in the battle of Falluja was to get to the southernmost point of the city. Along the way, the marines passed through houses, not through doors now, but through holes they had blown in the walls with their rockets. They found huge piles of mines, surface to air missiles, ammunition. Other units found car bomb factories, insurgent propaganda offices containing computers used to edit beheading videos, torture rooms, and tiny dark prisons with shackles and chains and wheelchairs used to strap down kidnapped hostages.

I photographed the men while they pushed south, encountering more heavy fighting. I was so tired, but I hadn't lost friends I'd had since childhood, nor was I carrying as much weight as these guys. I don't know how they kept it up. I just wanted it to stop. I would've done anything to make it stop.

One night, I talked to the marines in a pitch-black room about what they wanted to do when they left the service. Private security contractor, policeman, and so on. It was strange, sitting there in the anonymity of darkness, hearing their plans, their dreams. The question then occurred to me, what would I do when I got out? I didn't know the answer until long after the battle ended.

The company secured three houses at the southern end of Falluja on November 15. Their last objective had been met, but the battle continued. During a lull, one of the marines told me that he had seen a dead insurgent in a minaret the company had cleared earlier that day after firing a tank shell into it. I told Dex about it, and he agreed that we should go and see it.

We went to the captain to ask him to alert his men that we were going, to tell them on the radio not to shoot. He didn't want to let us go at first—it was too dangerous. But then he changed his mind. No one but the marines really understood how dirty the war was in Falluja, that insurgents were using mosques as command posts and minarets as firing stations. My photo could change that. He radioed his men to tell them not to fire at us and insisted on sending us out with a squad for protection.

The minaret was only 130 yards away, and I didn't want an escort. I wanted to adhere to my policy of noninterference, of not altering the natural flow of events. I explained this to the captain and also told him I didn't want the responsibility of being a burden to his men, but he told me that if we were going, a squad was going too. I wanted the photo so badly, and Dexter wanted the story. We gave in.

We ran to the house where the escort squad was located. They seemed surprised that they were going out there to

protect us, as though they didn't want to go. Under their captain's order, they kitted up. I ran behind them toward the minaret thinking, I shouldn't be doing this, I'm crossing the line.

When we got to the mosque, it seemed empty. Two marines went in to clear the building. I knew what I needed and went directly to the base of the minaret. I was about to start climbing the stairs when I felt a hand on my back. It was Lance Corporal Christian Dominguez. "We need to go first to make sure it's clear," he said.

I argued with him that I should go first, but there was no point. Dominguez's friend, Lance Corporal William Miller, started up the sharply turning stairwell, with Dominguez close behind. I followed them up at least three flights of stairs, all dark and covered in rubble left by the tank shell fired at the insurgent sniper I wanted to photograph. Our boots crunched on the steps as we climbed.

The sun began to light our path up the stairwell. Being able to see better gave me hope that we'd be out of there soon. But then a shot rang out. And another, and another, and another, and another.

Dominguez pushed me, knocking off my helmet, shouting something like, "Run! run! run!" as we fell down backwards into the dark. Somehow, I managed to get my helmet back on as we tumbled down the stairs. I was covered with something warm and wet. My face, my jeans, my cameras, everything. I thought, or hoped, that it was water, set loose from a camel back pierced by one of the shots. When I stopped falling, I knew it was blood, and I started crying, and running, and mourning.

Not a day goes by that I don't think of that minaret and Miller's crumpled, bloodied body.

A battle finishes when the last shot is fired, when the last man falls. In the case of Falluja, the battle will never finish, not really, not for me. Many others fell after that day, but for me, Miller was the last. While combat has a beginning and an end, those who experience it dwell on what happens between those two points. We wonder what would have happened if we had done things differently, made different choices. We wonder whose lives could have—and should have—been spared. I still wonder.

Marines play baseball after a
day of training at Camp Falluja.
The men prepared relentlessly
for their assault on Falluja, and
rarely had time to relax.

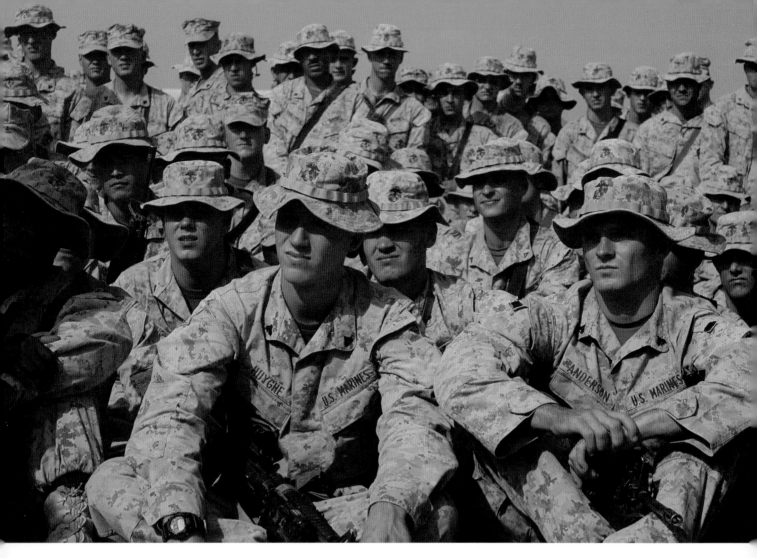

Corporal Nathan R. Anderson (front right) listens to Lieutenant General
John Sattler's pep talk the afternoon before Operation Phantom Fury
commenced. Five days later, Anderson was shot by an insurgent
disguised as a member of the Iraqi Army. He died immediately.

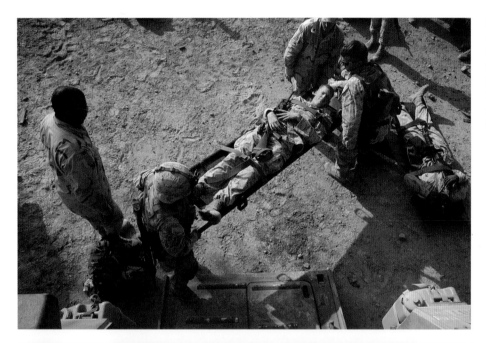

Lance Corporal William L. Miller
volunteers for medivac training
before battle, playing the part of a
wounded marine. Ten days later,
Miller was shot point-blank by an
insurgent hiding in a darkened
minaret. He died en route to the
field hospital.

Lance Corporal Demarkus
D. Brown (right) was another
volunteer as the marines practiced
loading stretchers into their
vehicles. He too was later killed
in Falluja.

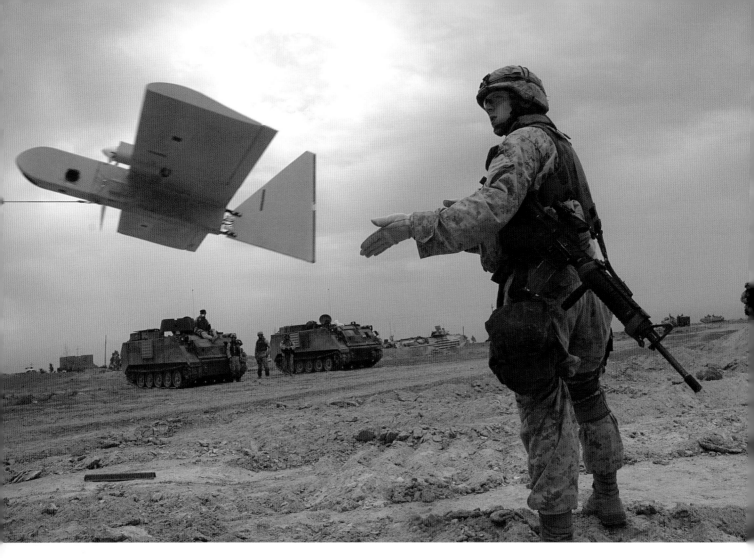

A marine releases a Dragon Eye surveillance drone on the outskirts of Falluja. These low-flying aircraft are equipped with cameras that transmit live images, helping the marines plan their attacks. Hearing the drones' high, irritating buzz during the battle meant the shooting had stopped for a few minutes.

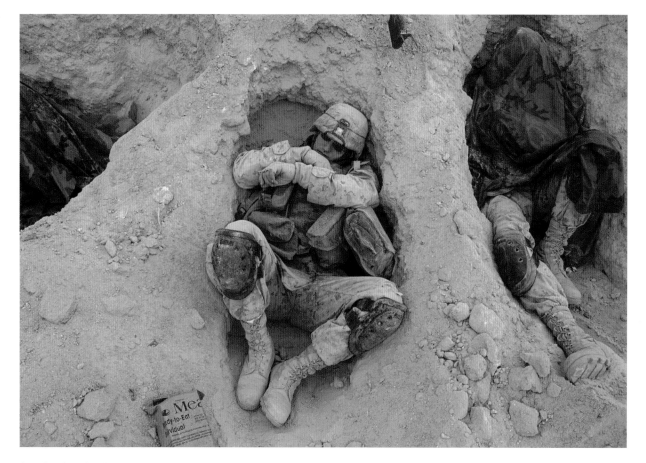

A marine sleeps in a foxhole before the battle to protect himself from rocket and mortar fire.

As the battle for Falluja begins, marines of Bravo Company, First Battalion, Eighth Marines, run for cover after white phosphorus is accidentally fired at them by another company.

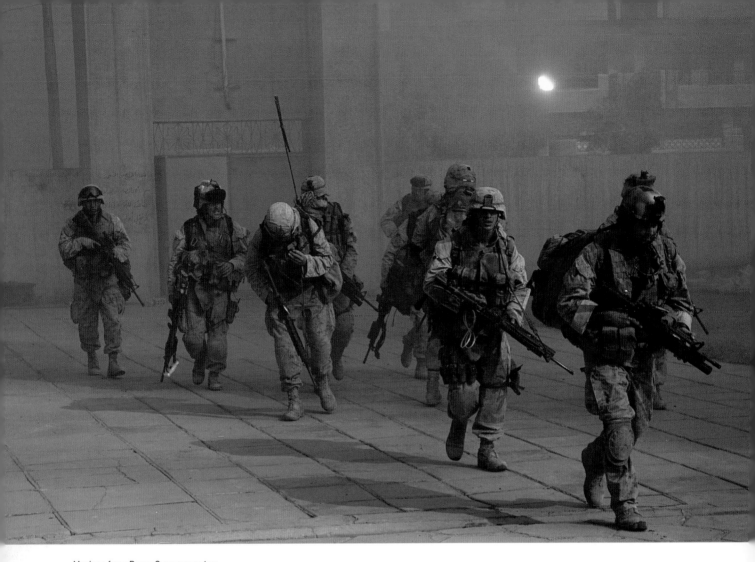

Marines from Bravo Company enter
a mosque from which a sniper
had been firing at them. Corporal
Gentian Marku (second from right)
was killed Thanksgiving Day after
he entered the courtyard of a house
and was ambushed by insurgents.

OPPOSITE

Marines file past one of the four
insurgents they killed near the
highway to the cultural center.
Some insurgents were wearing
suicide vests that they detonated
after marines gave chase. To
prevent the vests from being
used again, Captain Omohundro
ordered plastic explosives to be
put on the bodies and they were
blown up minutes later.

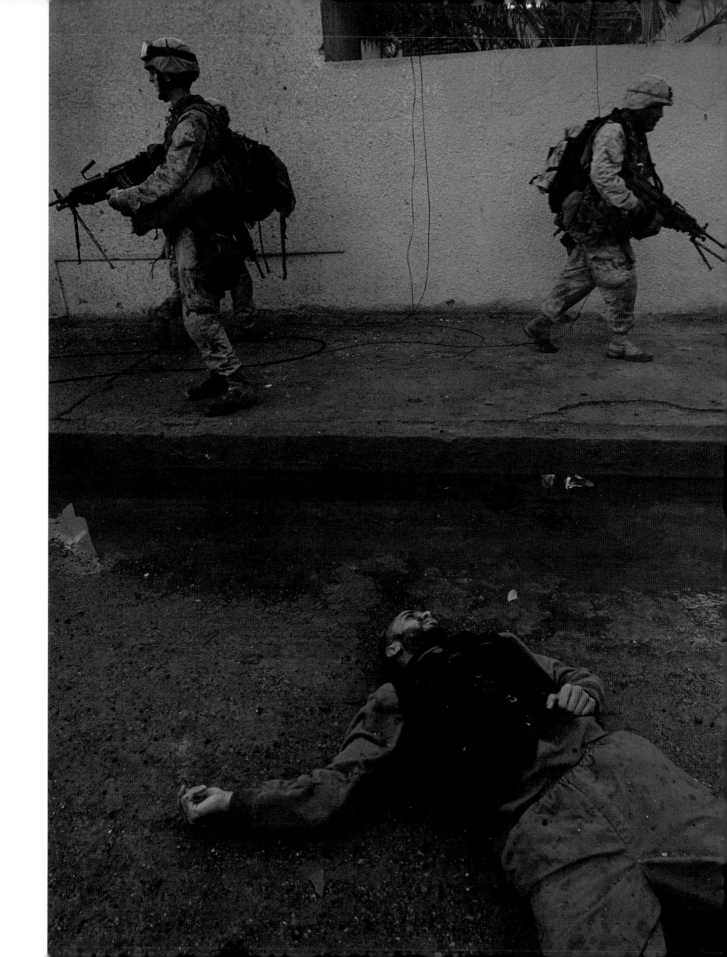

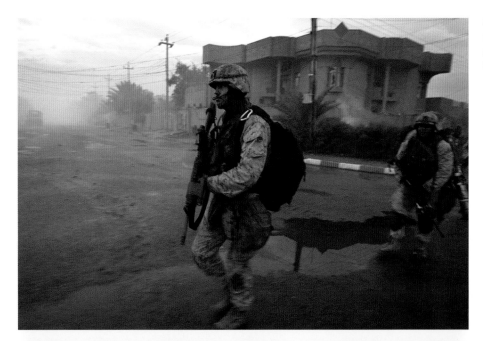

Sergeant Lonny Wells, minutes before making the run across 40th Street, where he was shot in the leg. He bled to death.

Marines carry Sergeant Ryan Shane to the cultural center after he was shot trying to save Sergeant Lonny Wells.

OPPOSITE

A member of the Marines' elite Force Recon shouts from just inside the cultural center after being wounded by insurgents.

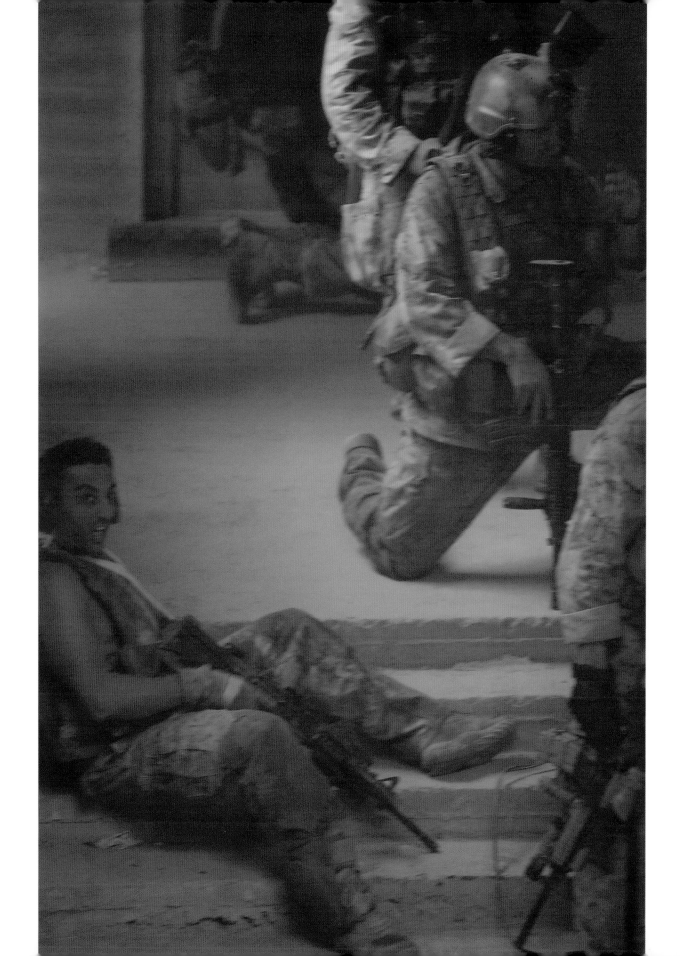

A marine fires a grenade at insurgent positions outside the cultural center. Once the marines occupied the center, their enemy constantly attacked them from every side of the building.

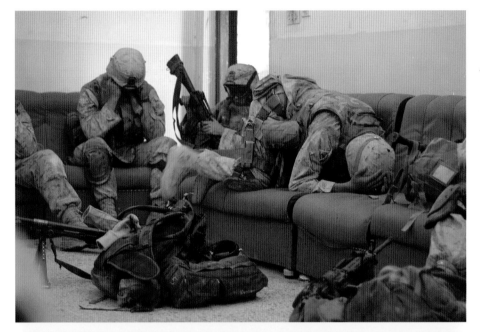

Marines take cover while a jet drops a bomb into a very nearby building.

"Danger close!" they shouted, right before the explosion sucked the air from our lungs.

A marine files out of the cultural center.

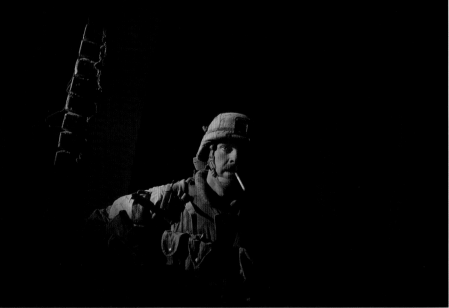

A squad rests in the Iraqi National Guard compound's remains. Initially, the compound was Bravo Company's final objective in the center of Falluja, but within hours of taking the building they were ordered to push south into the most dangerous area of the city.

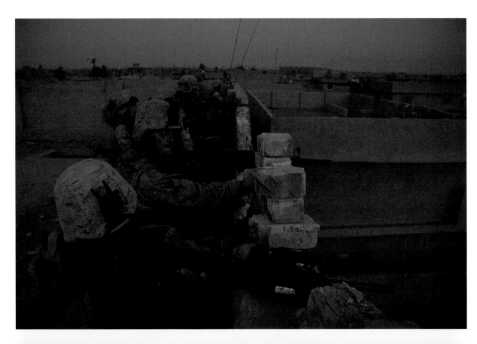

Corporal Kirk J. Bosselmann
returns enemy fire from the
roof of a house. An insurgent
killed Bosselmann two weeks
later when Bravo Company,
having reached the southern
edge of Falluja, was sweeping
back north through the city.

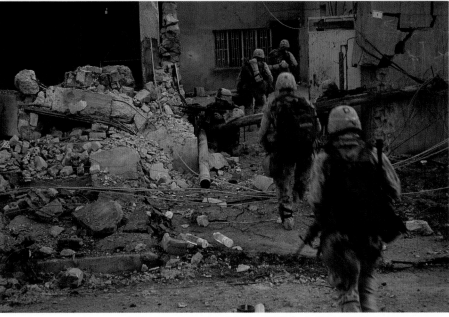

Marines run into a house
after a tank rammed the wall
and part of the house next
door to make an entrance.

Captain Omohundro (left) explains
the new plan to push into the south-
ern part of Falluja to his lieutenants
inside the Iraqi National Guard com-
pound as *New York Times* reporter
Dexter Filkins (below) takes notes.
To Dexter's left, the captain's Jamai-
can interpreter translates the plans
to the Iraqi Intervention Forces who
were sometimes attached to Bravo
Company.

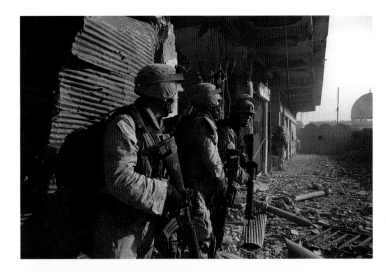

Lieutenant Andy Eckert's First Platoon leads the attack south. Hundreds of jihadists from Iraq and abroad awaited them and the rest of Bravo Company in Falluja's suburbs.

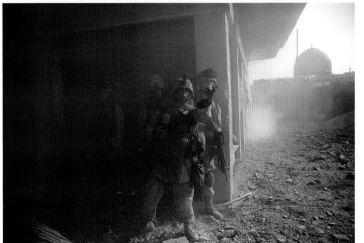

OPPOSITE

Marines run past a mosque American jets destroyed after insurgents used it to attack them. Unlike the technologically advanced communications Americans used to plan and group soldiers, insurgents raised black flags above houses and water towers to call their comrades into the fight.

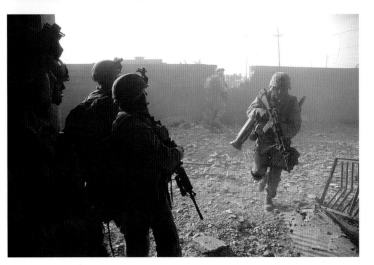

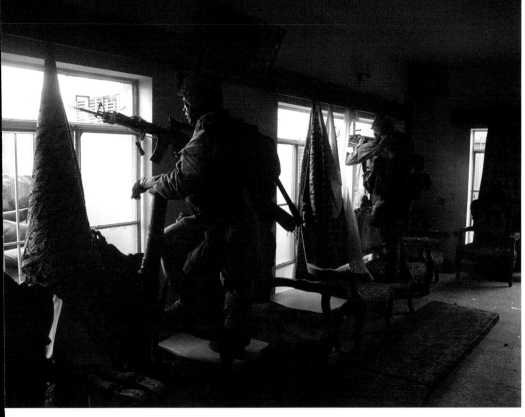

Bravo Company assumes defensive positions inside an abandoned house after receiving radio reports that a large group of insurgents was heading in their direction.

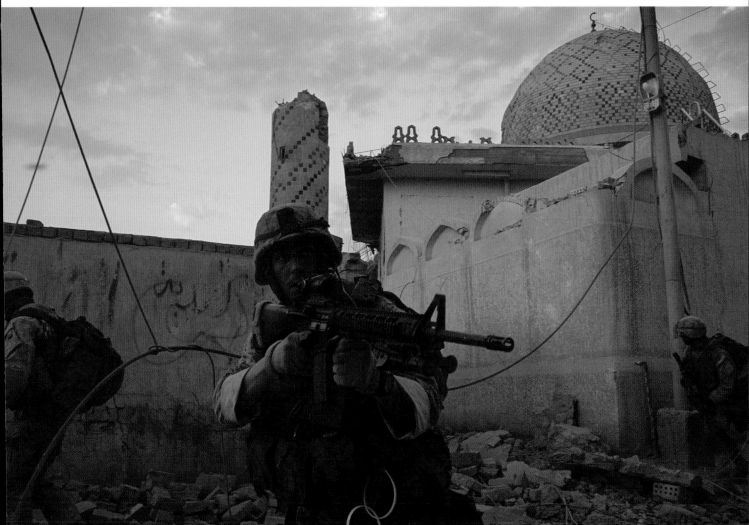

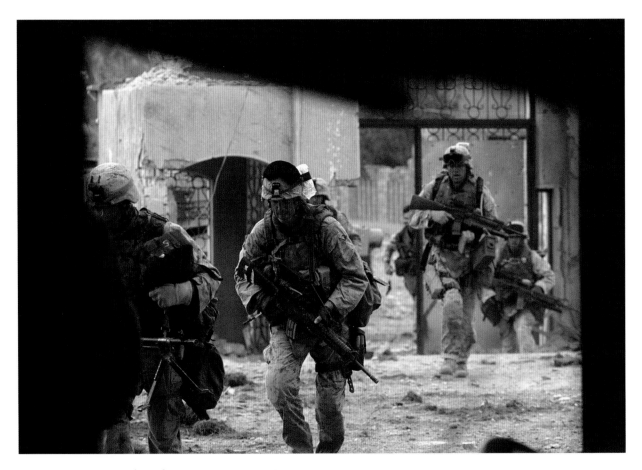

Lance Corporal David Houck (center) storms the Grand Mosque. Two
weeks later, Houck was killed trying to rescue injured marines from a
house full of insurgents.

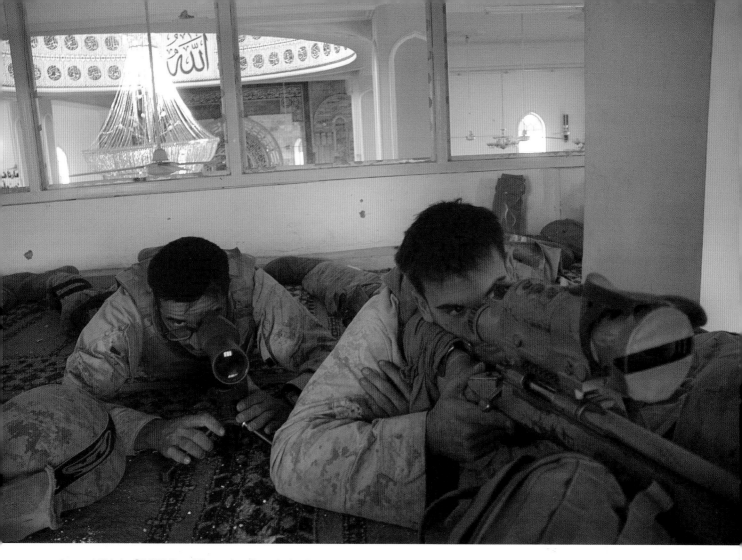

Corporal Nicholas "Ski" Ziolkowski hunts the sniper who has been hunting him since the beginning of the battle. As usual, Ski wasn't wearing a helmet; he said it interfered with his ability to see through his rifle's scope. Only two days later Ski's sniper shot and killed him.

Corporal Joel Chaverri (top), Lance Corporal Hector Orantia (bottom), and
Lance Corporal Michael Oliver Ray (opposite) during a break in combat.

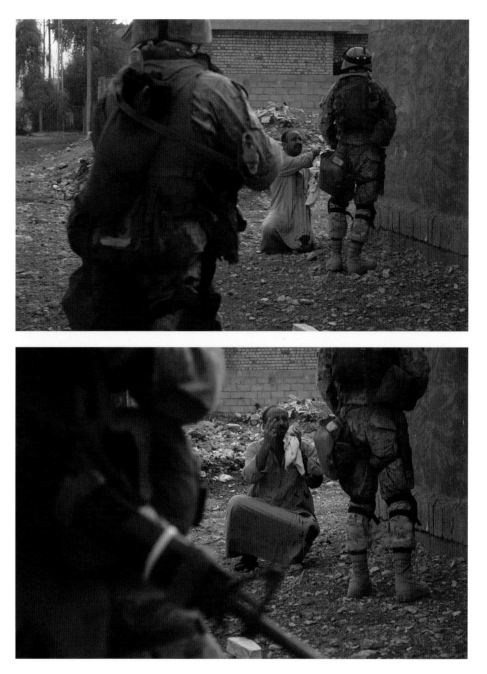

A wounded man emerges on a Falluja street to ask the marines for help. Some Falluja residents refused to evacuate their city despite grave warnings. This man feared his house would be looted and decided to stay. When the battle came closer to his house, he tried to flee in a car with his family. A marine machine gunner shot at them from the roof of a nearby mosque.

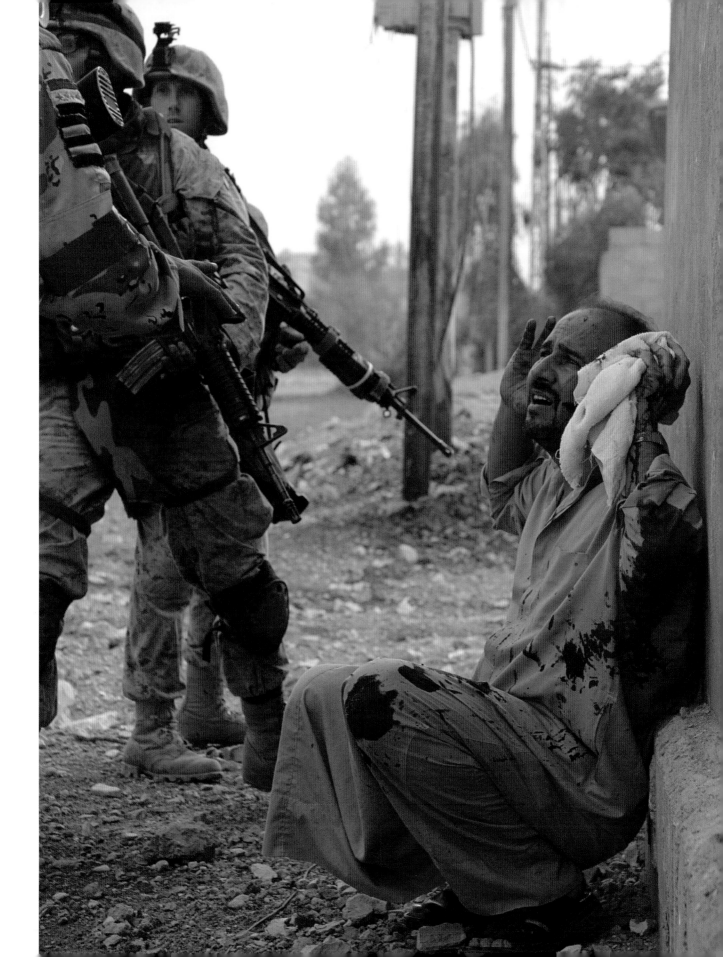

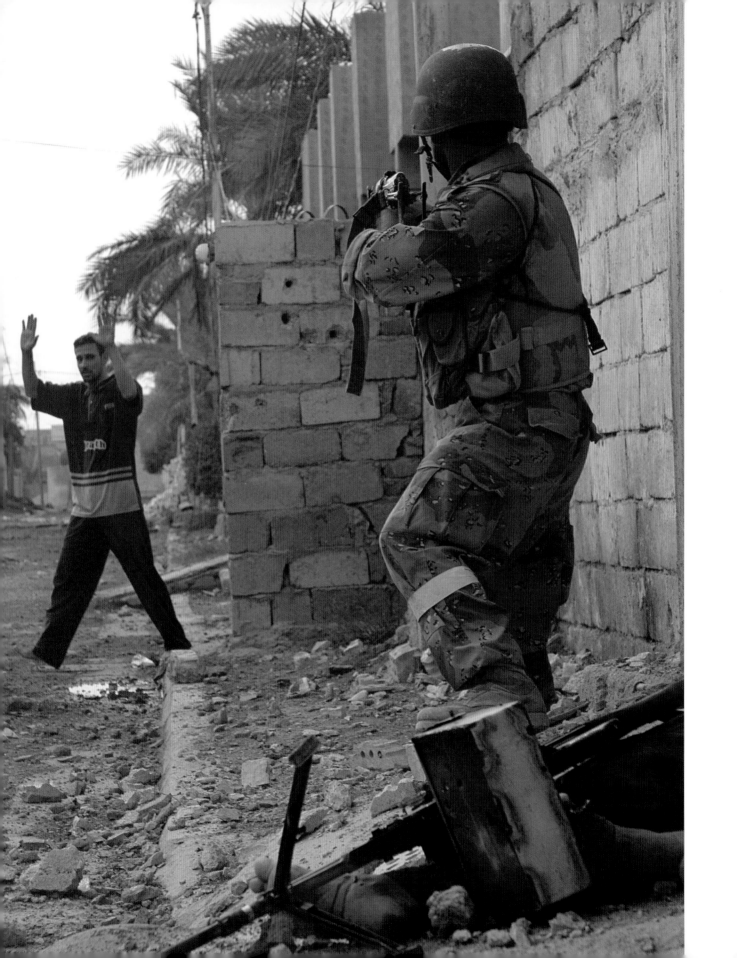

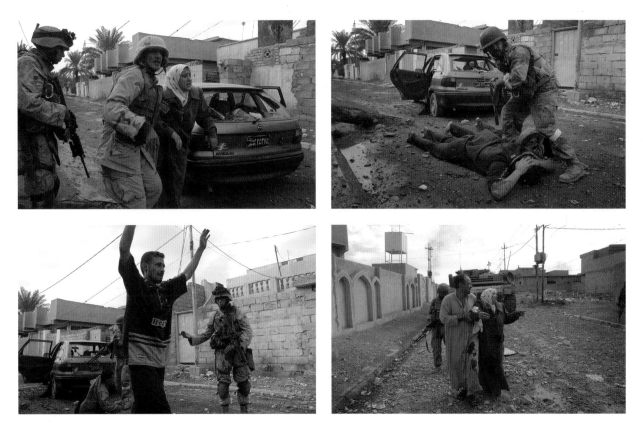

Marines and Iraqi Intervention Force troops approach the carload of
civilians who had been mistaken for insurgents while two wounded men
emerge from a nearby building with their hands high. A dead insurgent
lies in the foreground with his weapon. Inside the car, the marines find a
young woman, wounded, and her mother, dead.

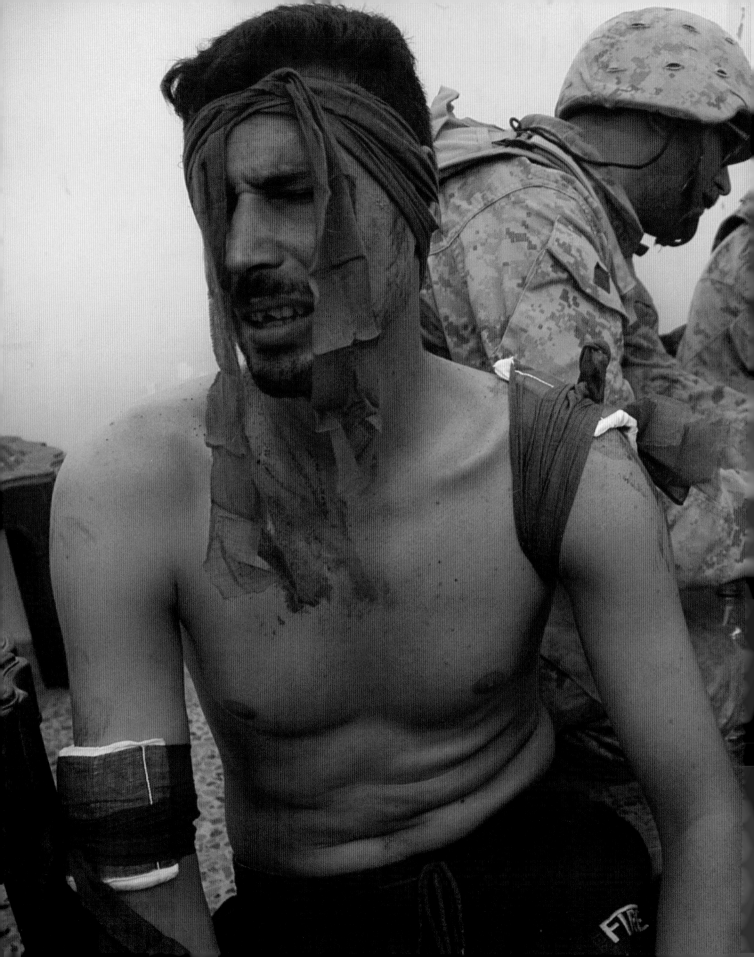

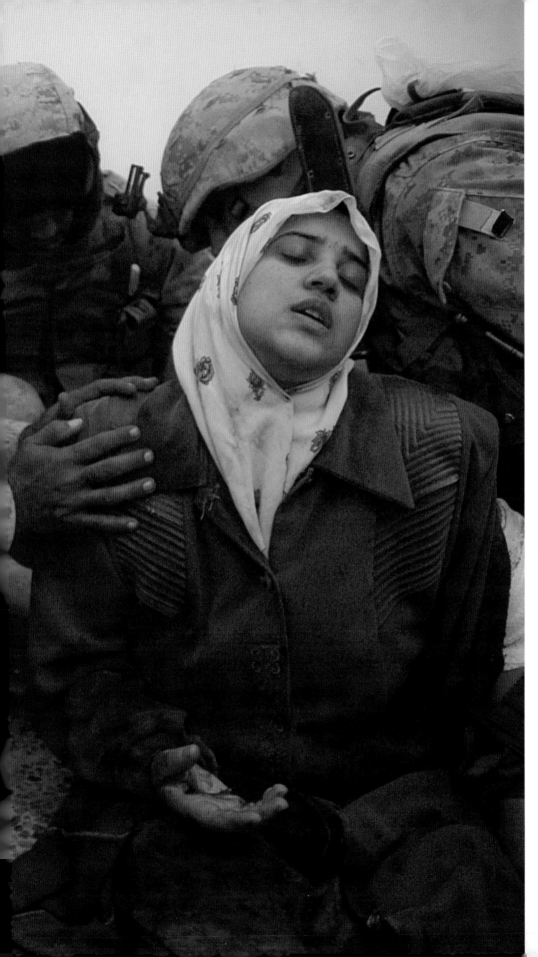

Inside the Grand Mosque, marines
treat the young woman injured in
the attack on her family's car.

225

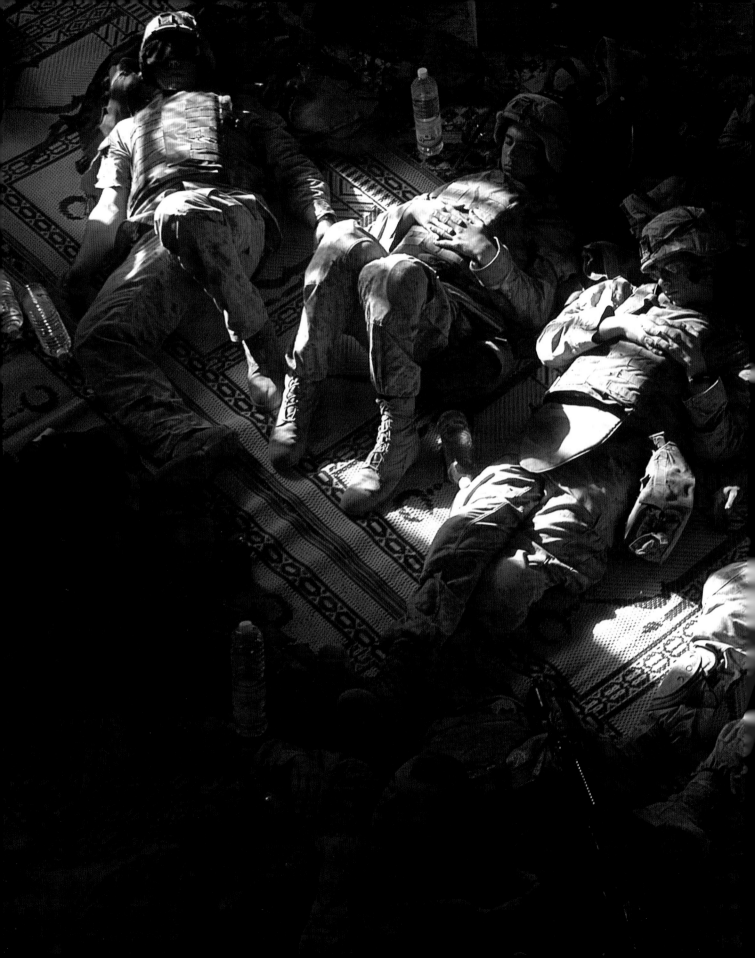

Marines rest in the Grand Mosque after a night of house-to-house fighting. At far right are Lance Corporals Demarkus D. Brown and William L. Miller.

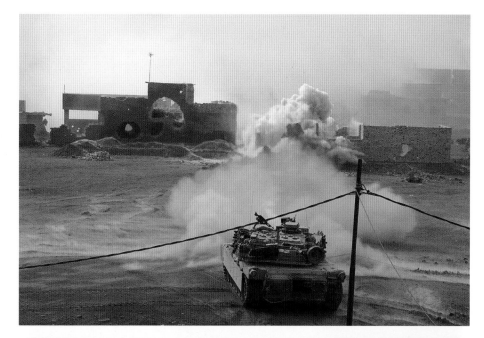

Tanks pulverize buildings containing insurgents.

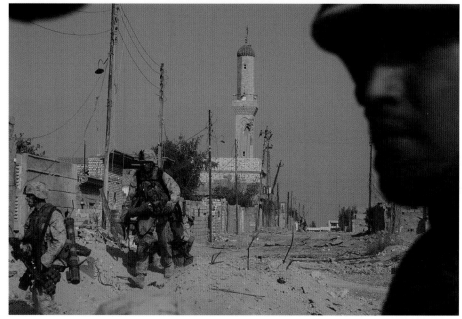

Marines file back through a ravaged street from a mosque to their base at the southern end of Falluja. Lance Corporal William L. Miller was killed by an insurgent hiding in the mosque's minaret. The marines later leveled it with a 500-pound bomb.

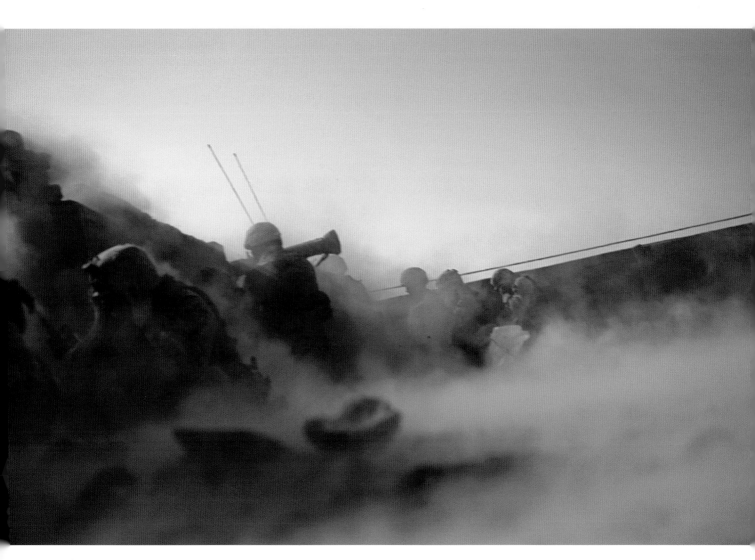

Bravo Company marines take cover while firing a rocket at insurgents.

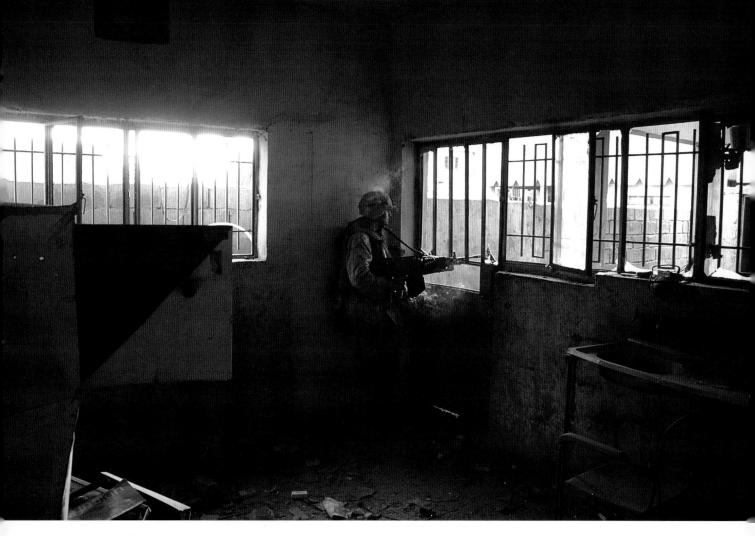

A marine provides cover for his comrades searching houses. He's smoking what they called a "liberated" cigarette, which meant it was stolen.

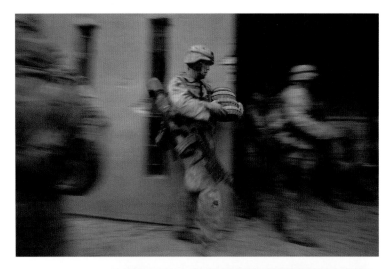

A marine removes land mines from a mujahedeen safe house (above). Dexter files a story from the safety of a makeshift toilet (center). Marines size up a wounded insurgent (below).

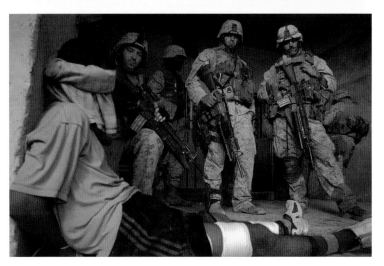

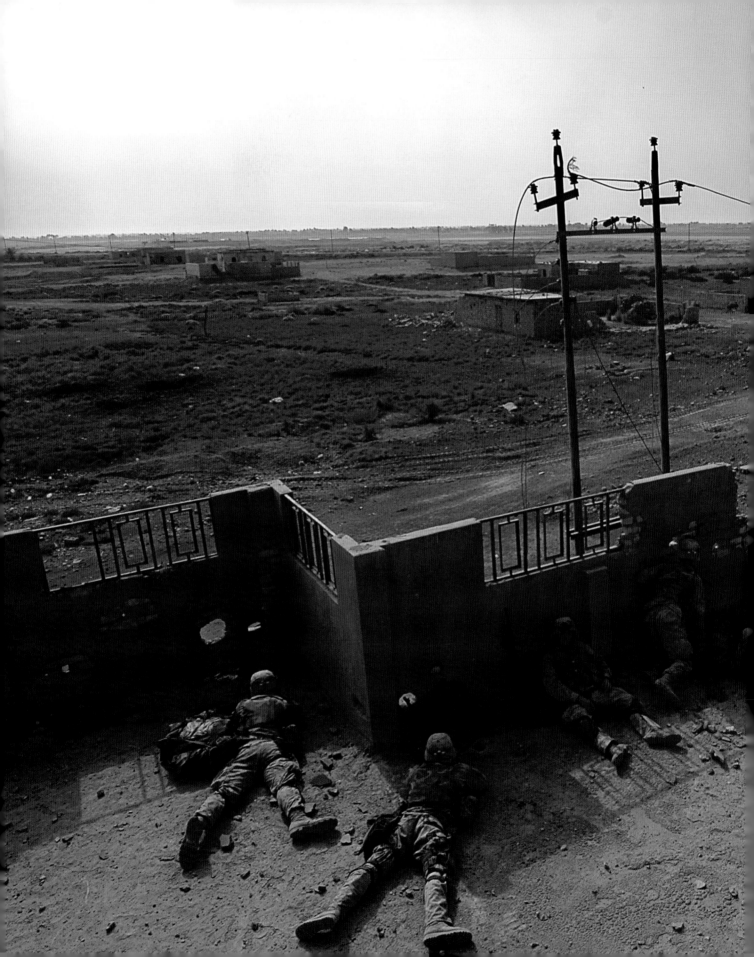

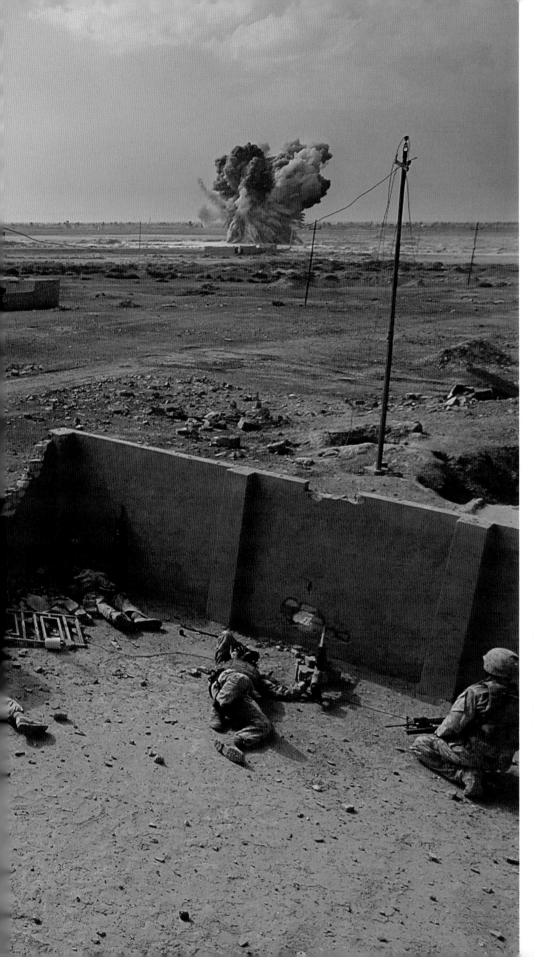

Marines take cover while in the distance a 500-pound bomb destroys an insurgent bunker complex. Exhausted, the marines had reached the southern city limits after a week of solid combat. After the bomb detonated, a sniper kept these marines awake for another hour until a tank blew him up. The second the marines saw the dead sniper's body roll into view, almost every one of them fell asleep on the spot. That would have made a great picture, but I fell asleep too.

During a pause in the fighting,
I asked Lance Corporal Alex
Saxby what he got for his birthday.
"Two dead friends," he said.

OPPOSITE

The captured fighter claimed to
be a student who had gotten stuck
in Falluja. A marine responded,
"Yeah, right, University of Jihad,
motherfucker."

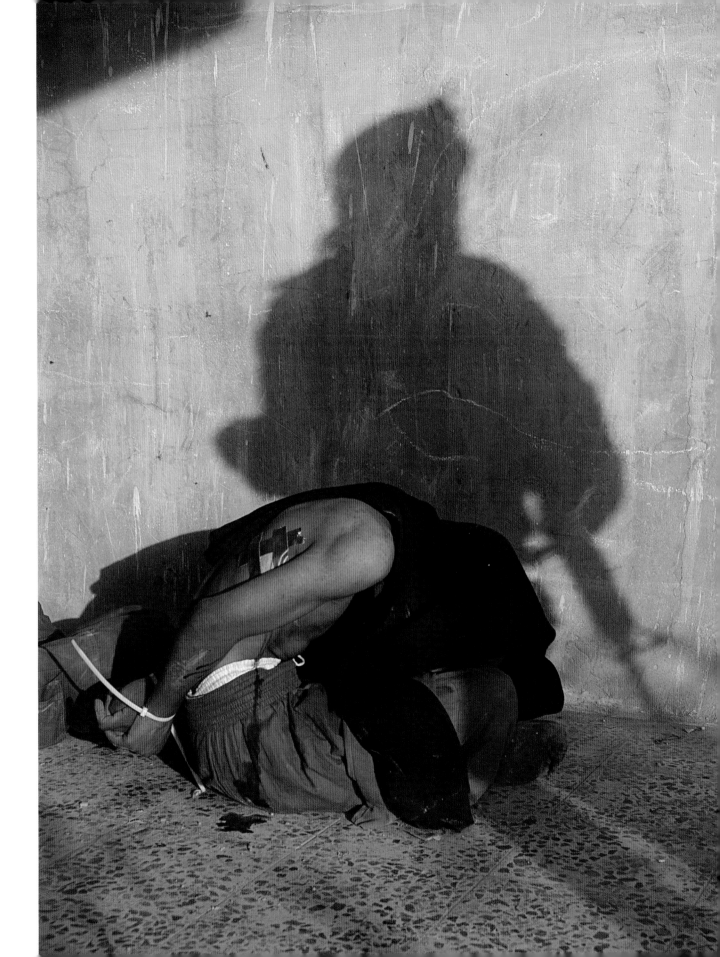

FIVE

DESCENDING INTO DEMOCRACY

YES, I HAD POST-TRAUMATIC STRESS SYNDROME

After Miller died, I had to leave Iraq. My picture editor at the paper, Beth Flynn, gave me permission, and so did Omohundro.

The next morning I hopped into an amtrac that had come down to the southern edge of Falluja to drop off supplies to Bravo Company. We sped back to the middle of town, where the marines had established a firm base in the Governor's Center. Several hours later, I was back at Camp Falluja waiting with dozens of other correspondents, all of us begging the marines for a spot on a bird going back to Baghdad. No one could get out. All of the flights were full, and the public affairs officer was giving us estimates of up to seven days. I was so desperate I considered asking the bureau to send someone to Falluja to pick me up. But then the Marines' public affairs officer told me there was a spot for me on a convoy heading to the capital if I wanted it. Sitting in the open back of a humvee was a ridiculous risk to take after having pushed my luck for a solid week under fire, but I took it all the same.

I spent a few days totally hammered in the bureau before

trying to go home. No matter how much beer I put away, I couldn't stop thinking about Miller. After he'd been medivaced, I'd run away from the mosque under a downpour of insurgent machine gunfire, wishing one of the slugs would tear through my torso and kill me. Back in Baghdad, I no longer wanted to die, but I had no idea how I could continue to live knowing I was responsible for a man's death.

The drive to the Baghdad International Airport required two cars loaded with weapons, five armed Iraqi guards, and the bureau's security advisor. It was virtually another military operation. This time, just five minutes into the trip, we were forced to turn back when a roadside bomb hit a humvee on the bridge leading over the Tigris to the airport. I didn't even stop to take pictures. I just wanted to get the fuck out of the country. We tried a couple of hours later only to turn back again, this time because a gun fight had broken out between a private security outfit and insurgents on the airport road. On the third try, we made it, but just when I was about to board, airport officials said there was no room on the flight. I bribed them with fifty bucks. Fifty bucks was nothing compared to what I would have given to get on that flight.

When I got back to New York at the end of November 2004, the *Times* offered to set me up with a shrink. I'd never seen a therapist before; I thought they were a useless bunch, that I could work out any problem I had myself. I learned pretty quickly that the *Times* was set on making me their first guinea pig in a program they were developing to help correspondents returning from conflict zones readjust to life back home. In the paper's typical way, they found a therapist who'd written the book about traumatized war correspondents. Problem was, he was in Toronto. For the next month I spent an hour a week on the

phone with this guy, pacing about my apartment, chainsmoking, downing shots of vodka, and trying to explain why I was blaming myself for Miller's death.

The therapy wasn't working. I had nightmares every other night, though I often wouldn't remember them because I usually got to sleep by drinking until I passed out. Every morning I'd wake up and read any article about Iraq I could find. I tried to read other news stories, but if they weren't about Iraq, I could rarely get past the first paragraphs. I was scared to get on a plane, afraid that it would drop me off in the center of Falluja. I'd pick fights with Joanna when she was trying to be supportive, and with strangers for just looking at me. I wasn't interested in discussing anything except Iraq, but if anyone who hadn't been there wanted to talk about it, I wouldn't give them the time of day. They didn't know jack shit about the place. No one did unless they'd been there.

My shrink in Toronto recommended one of his colleagues in New York. This guy had also worked with journalists returning from war zones, as well as with refugees—he got my respect for that. I went to see him. Over the next few months, I learned that my benchmark for normality had become Iraq. I had come to see any other way of life as a waste of time, to believe that being happy in New York when Iraqis were miserable was arrogant and wrong. In those two months I started to snap out of it. I realized it was unfair—both to myself and to the Iraqis—to see life in Iraq as normal. Getting shot at isn't normal. Car bombs going off every day isn't normal. Celebrating by firing AK-47s into the sky isn't normal. Seeing people suffer and die every day isn't normal.

On July 14, I asked Joanna to marry me. She thought I was joking. I asked her again, and she said yes, even though

she still thought I was joking. When I told my shrink the news a couple of days later, he sat back in his chair and told me that for the time being, I didn't need to see him.

GETTING BACK ON THE HORSE

The minaret attack on Miller, Dominguez, and me forced me to confront a truth I knew before but had never experienced with such intensity: war is death. But innocence, if you can call it that, wasn't all that I lost after that battle. It seemed to me that in Falluja, the Americans taught Iraqis a symbolic lesson: they were no longer interested in playing ball politically or culturally. Any hope I still had that America's involvement in Iraq could end positively was destroyed along with Falluja.

I had worked in Iraq almost continuously for the better part of three years, and even between rotations I was still immersed in the story. A year after Falluja, I came to partial terms with my cynicism and I was ready to go back. The landscape had changed somewhat; Iraqis had nominal power over their own destiny. I needed to find out how they wielded that power. The *Times* gave me another two-month contract. I was to arrive at the beginning of December, ahead of the national elections that had been scheduled for that month, and travel north to Kirkuk after a couple of days preparing my press credentials in Baghdad. My trip wasn't just getting back on the horse—it was my final attempt at rekindling the hope I had once had for Iraq's future.

What I found in Iraq that winter extinguished whatever optimism I'd regained while I'd been away. Politicians bickered in central Baghdad's fortified bubble, disconnected from their constituents and the uncontrollable strife on the streets outside. The Iraqis were experiencing less freedom than ever before, even after they risked their lives to vote. American generals and politicians were claiming the country wasn't in a civil war, but what else can you call it when police find fifty tortured and mutilated bodies on the streets of the capital every day?

Covering Iraq had grown far more difficult after spending a year in New York. Iraq changes into a new world every day, always worse, more dangerous, and less hopeful. When I returned after two months away, I was always surprised at how horrible things had become in a brief absence. Returning after a year presented not just a new world but a new planet in an alternate reality.

The 2005 general elections went as planned. The only surprise I experienced was how I reacted to covering it. Earlier in the year, watching coverage of the National Assembly elections, I had been disgusted by the TV news analysis of the vote. Images of Kurds dancing in the streets didn't mean it was a step forward. From six thousand miles away it had been easier for me to see the big picture—that in effect the vote meant nothing and the war would continue regardless of the political games taking place. But I witnessed this round for myself and was moved. Human beings love voting. For decades Iraqis had been denied the right, and finally they had a chance to feel involved in the future of their own country. But elections couldn't change the reality they were up against. The euphoria didn't last.

CIVIL WAR

The war in Iraq was still of massive importance to the *Times*, but gaining access was becoming more difficult. At best, a story involved behind-the-scenes political reporting, which did not lend itself to strong photography. At worst, it was about violence between the Sunni and Shia, which was impossible to photograph. So while the writ-

ers would often have stories above the fold on A1, I was told over and over again a variation of "I'm working on this story, but there's no chance you could take pictures for it." On my previous rotation I'd had about thirty front-page photos in the *New York Times* and *International Herald Tribune*. On this rotation I had only one, from a story about Shi'ite militias in the Sunni hamlet of Salman Pak.

Salman Pak is one of Baghdad's satellite towns, where the Americans had recently turned security over to Iraqi authorities. The town had now been shut down by Sunni insurgents who were furious at the presence of the Public Order Brigade (POB), a Shi'ite paramilitary force that had been torturing and killing the town's Sunni residents. The insurgents hoped to starve the paramilitary out of Salman Pak, and successfully kept stores closed for a while by threatening to kill shopkeepers who opened for business. But closed shops meant that the town's Sunni residents could not buy food, either. To solve the crisis, American troops trucked in thousands of MREs for the police to distribute in the center of town. The *Times*' Sabrina Tavernise and I tagged along with an American advisory team on the trip from Baghdad and arrived at the police headquarters in the evening. To welcome our convoy, the general of the police brigade presented us with a chicken dinner and birthday cake.

While preparing to leave the headquarters, I laughed with the Iraqi policemen who were dancing and shouting in unison—usual behavior before a mission, I was told. They broke into chants of "Muqtada! Muqtada!" and loaded into their pickup trucks. I shouted to one truckload, "Mahdi Army or police?" They all shouted back "Mahdi!" It was no secret where their allegiances lay; they went so far as to affix photos of their leader to their guns and trucks. As members of the Public Order Brigade, they were paid and equipped by the Ministry of Interior, but they fought for their militia.

The POB was supposed to be equipped exclusively through Iraqi channels, but occasionally the American support teams broke protocol and gave them boxes of ammo. One morning I stood around a humvee with a platoon of Americans and eavesdropped on their mission brief. Their commander ordered them to stop giving out bullets. "A stiff turned up on a road outside of town and they found American brass at the scene," he told his men, referring to the spent shell casings investigators found near the dead Sunni. It couldn't have been much clearer that Salman Pak's police also acted as the town's judge, jury, and executioners.

The prison was a dilapidated little building behind the police station. The Americans had caught the police there torturing suspected insurgents, hanging them upside down, pulling fingernails, even shooting people dead. I asked one night before a raid if I could take a look inside, and my American guide, Sergeant Travis Fisher, told me it might be better if I hung around headquarters. He was going to interrogate a man the Iraqis suspected to be an al-Qaeda fighter based on a tip from a cab driver who ratted him out for ditching a five-dollar ride.

I waited, sipping cup after cup of tea until my bladder got the better of me. I excused myself and was just through the door to the hallway when I jumped. There stood an Arab, bound and blindfolded, positioned by his captors in a corner. He was enormous. His well-washed hands looked like they could crush my skull effortlessly, his shoulders were twice the width of mine, and he was built like a brick shithouse. I was terrified just to be in his presence.

Sergeant Fisher went through the items his men found in the suspect's pockets—two expired Egyptian passports, a cell phone, and a list of cars he said he was intending to buy or sell. The Americans' eyebrows were raised when they saw a Daewoo "Prince" on the list, a model often

used in making car bombs. The suspect's cell phone, which had tested positive for TNT residue, contained the most interesting information: among his phone numbers were contacts in Egypt and Saudi Arabia, two police commissioners in Baghdad, an engineer from the Iraq mobile phone provider Iraqna, some highly ranked Iraqi National Guardsmen, and a man on the Ministry of Interior's most wanted list.

Most of the text messages were ordinary, except for one, this shining example of al-Qaeda humor: "There were two monkeys. One of them was eating a banana, the other is reading this message."

The next morning 450 Iraqi police and 300 Americans conducted a raid in Salman Pak. The Iraqis were supposed to lead the operation, but as usual, the Americans spearheaded the action. In the gray predawn light, they kicked in doors and took all military-aged men from their houses, turning them over to the Iraqis to guard. It was relatively peaceful as far as raids go. The only weapon that discharged was an Iraqi policeman's misfired gun. An American later told me that there were usually more accidents like that one, many of which ended in injuries. The Iraqis, he said, were learning.

Together, police and the Americans detained close to fifty members of the Dulaimi tribe, a powerful Sunni family with strong ties to the insurgency. They were herded together and seated, facing a wall. Three hours later, the detainees were further humiliated when their children saw them as they walked by on their way to school.

After covering Salman Pak, I sat inside the *Times* bureau in Baghdad for almost a week without doing anything significant. When I could go out, I'd drive around, trying to get a sense of what was happening. I found a tailor who made custom shirts. When we weren't talking about how

he couldn't get cotton or why he kept placing the shirts' pockets too high, I'd chat with him about Iraq. Anything to get an idea of life outside our bureau. He grew nervous after a few visits, though, afraid that a foreigner visiting his shop too regularly would result in reprisals from the insurgents. I had to send a driver to get the shirts when they were finished. He eventually got the pockets right.

I did what I could to highlight the country's problems, to bring the reality of what I saw to the pages of the *Times*. I even tried to do a couple of "good news" stories. The picture I took of a captain practicing his golf stroke in the Green Zone while some American-sponsored militia— a.k.a. the Iraqi Army—geared up to hit the streets was among those; it ran in the paper on New Year's Day.

I left Iraq in January of 2006 convinced that the country will never put itself together again, whether under American or Iraqi administrators. America invaded Iraq, and it stood aside as the country plunged into chaos. The occupation steadily inflamed the insurgency and turned Iraq into the number one destination for jihadists across the world. America armed militias on all sides, and then shrugged as civil war broke out, proclaiming it to be an Iraqi issue.

The Americans lost the war, and in losing it, turned Iraq's people against each other with greater fury than what had been exacted on them for the last four years. They broke Iraq apart, and its people are devouring the pieces— and themselves.

A 2006 study by researchers at Johns Hopkins, Columbia, and Baghdad's Al-Mustansiriya universities found that 600,000 Iraqi civilians have been violently killed since 2003. That's more people than the population of Washington, D.C.

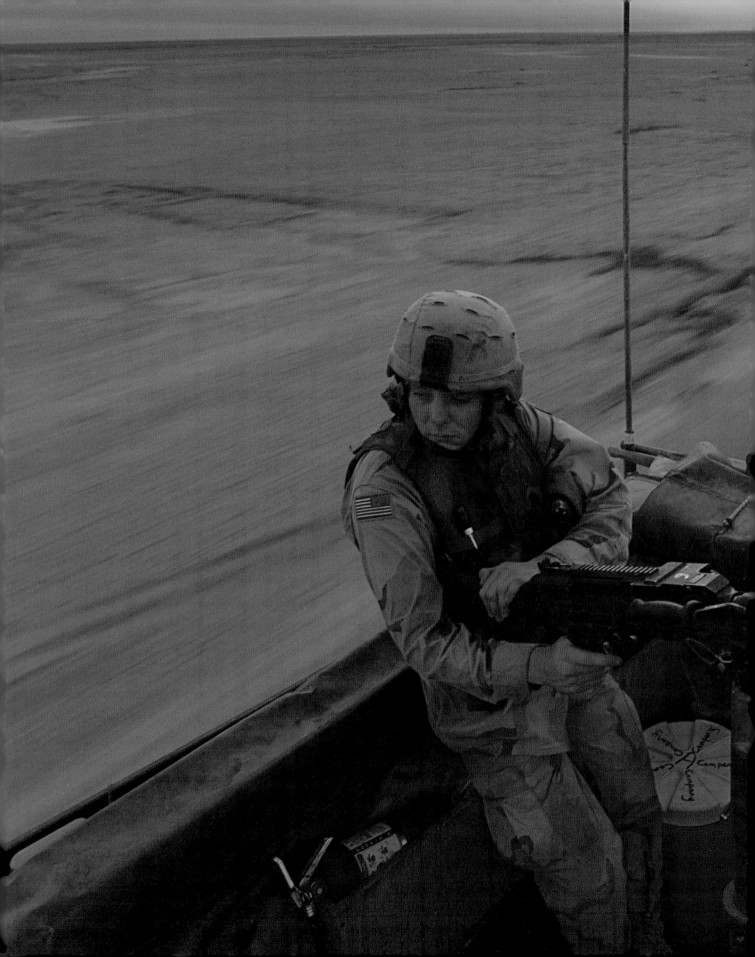

Sergeant Chris Shamblin patrols
the Iranian border for arms
smugglers and pilgrims. In 2004,
Shamblin was one of only thirty-
two American soldiers responsible
for guarding the thirty-seven miles
of "approximate" line dividing Iran
from Iraq. One night the soldiers
stopped their humvees on a dirt
track and walked across a small
hump in the path. I thought they
were checking for bombs. One of
them started to urinate: "It's
impossible to say exactly, but right
now I think I'm pissing in Iran."

243

Two off-duty Iraqi policemen watch Saddam's trial on television.

National Guard soldiers sleep before catching a flight from Baghdad to Qatar for two weeks of R&R.

An infantryman fills his tank with gas on an American military base in Kirkuk. He was bothered by the fact that while he faced mortal danger daily, a fellow serviceman was a gas station attendant. "Imagine," he said, "you come all the way here and work in a gas station. What's that guy going to tell the girls back home?"

Wire photographers pose a soldier to photograph his ink-stained finger,
signifying that he had voted in the December 2005 national elections.
The habitual practice of setting up pictures annoyed me, but when I saw
a photographer climb a high post and direct hundreds of soldiers into a
more dynamic composition, I was shocked.

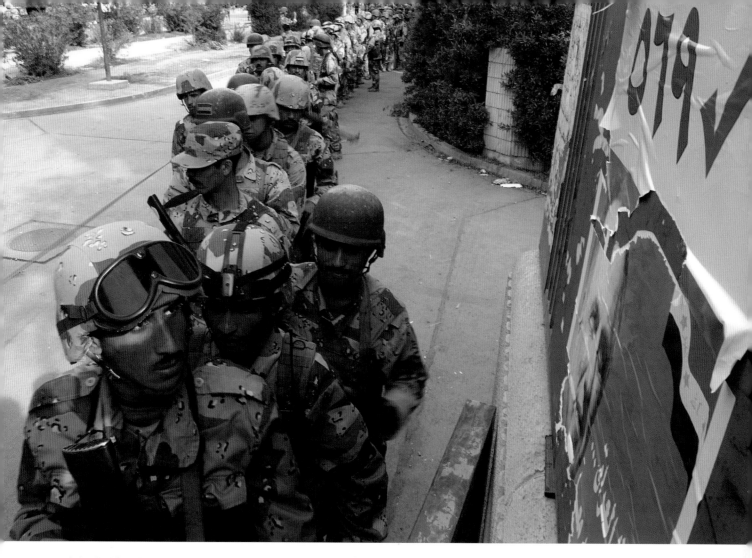

As Iraqi soldiers lined up to vote in Baghdad, they had to pass hundreds of campaign posters depicting CIA favorite Ahmed Chalabi, who was hated inside Iraq. Chalabi's images became more and more defaced as election day went on.

Men and women form separate lines to vote in Kirkuk.

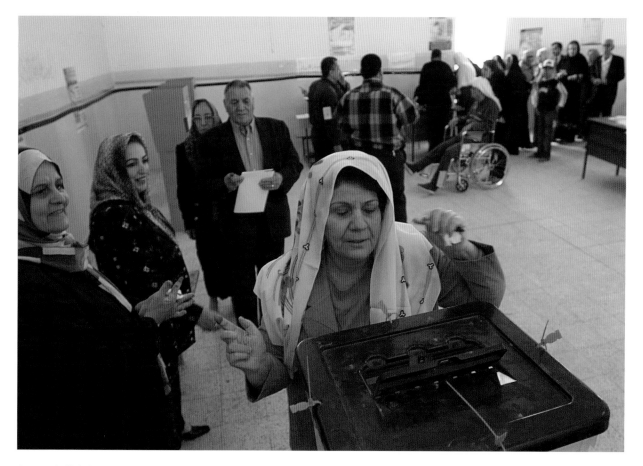

A woman in Kirkuk casts her vote inside a girls' secondary school. I was trying to file an image in time to make the last edition of the *Times*. After I took this picture, I ran outside and frantically began transmitting by sat phone, which is always slow. I missed the deadline by twelve minutes.

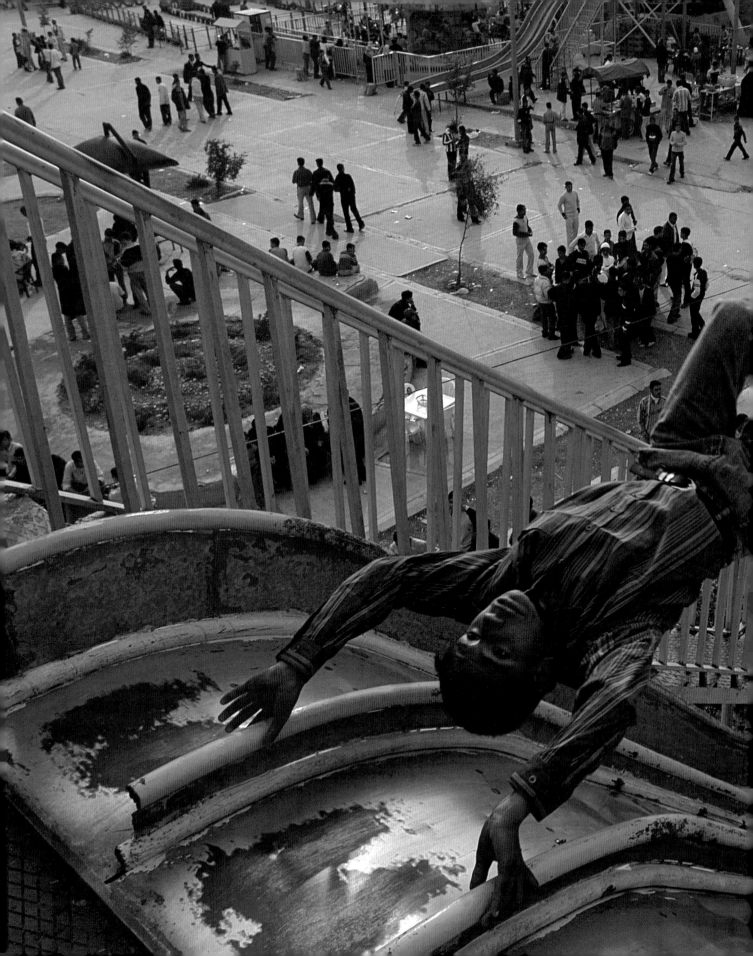

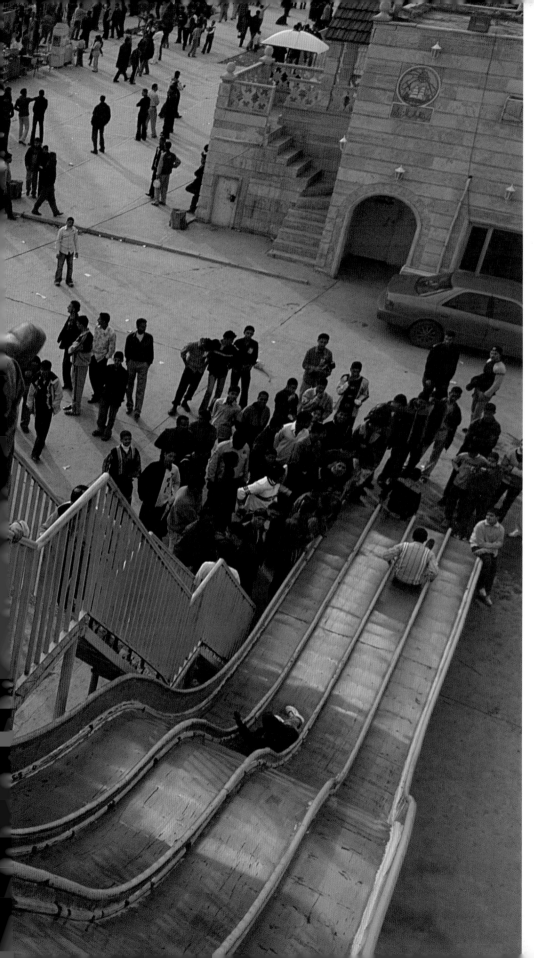

Kids celebrate the first day of
Eid al-Adha at al-Zawraa park in
Baghdad. It was January 2006, and
every person entering the crowded
park, including children as young
as five, was searched for weapons
and suicide vests.

251

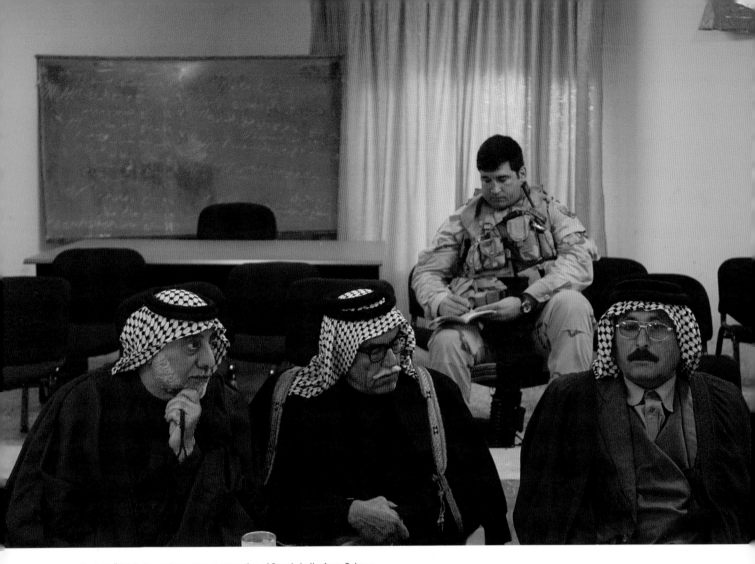

Captain "JP" Pelkey takes notes at a meeting of Sunni sheiks from Salman
Pak, a town twelve miles southeast of Baghdad. With the United States
encouraging Iraqis to assume responsibility for policing, the Shi'ite-
controlled Public Order Brigade (POB) took control of this largely Sunni
town, torturing and killing its residents. Many members of the police
force were in fact militiamen from Muqtada al-Sadr's Mahdi Army. Sunni
insurgents responded by shutting down Salman Pak, and the sheiks were
now demanding that the POB leave immediately. After the meeting, an
American officer told me he was frustrated; he was certain that some of
the sheiks were insurgent leaders.

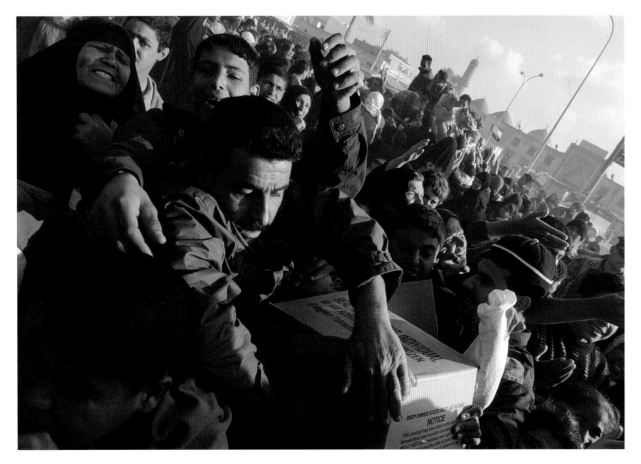

Hungry Salman Pak residents scramble for American rations after Sunni
insurgents circulated fliers forcing storeowners to close. As soon as the
food ran out, the residents began cursing the police and the Americans.
The shops would not reopen until the POB and the Americans abandoned
the town.

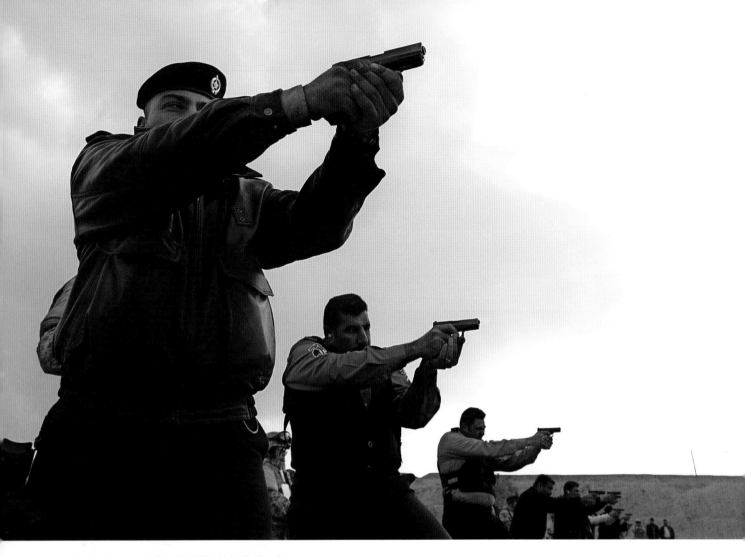

Iraqi police practice firing their Glock pistols. Americans oversee two
weeks of training before the POB begin their policing. An American
advisor told me to stay well away from the Iraqis during target practice.
"They shoot wildly," he said, adding that he didn't even feel safe standing
behind them.

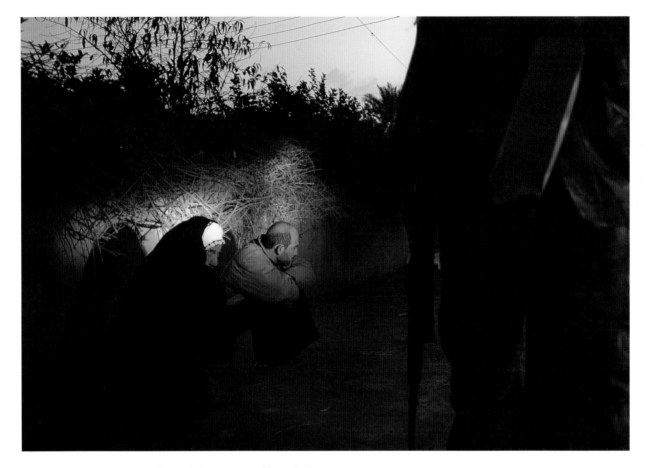

Sunni detainees cower in the headlights of a humvee on a cold morning in
Salman Pak. Twenty-eight men, all belonging to the Dulaimi tribe, were
detained as suspected insurgents.

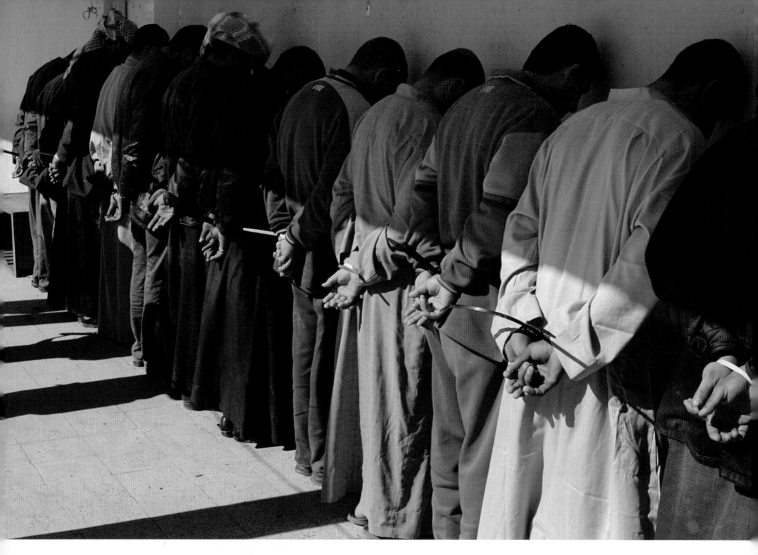

Suspects cleared by the Americans stand facing a wall at the behest of
the Iraqi general in charge of the POB. Two of the men in the lineup tested
positive for recent exposure to explosives. The Iraqis detained the other
nine because the general suspected they were "planning or pushing
people to do things."

OPPOSITE

A POB officer casts his shadow over
a man who collapsed to the ground,
terrified that he would be detained
for a third time. The American and
Iraqi officers surrounding him
laughed because he had reacted
the same way the last time they
captured him. The Americans
ultimately decided he didn't pose a
threat but the Iraqi police disagreed
and detained him. He fainted twice
while the Iraqis questioned him,
violently hitting his head when he
fell to the ground.

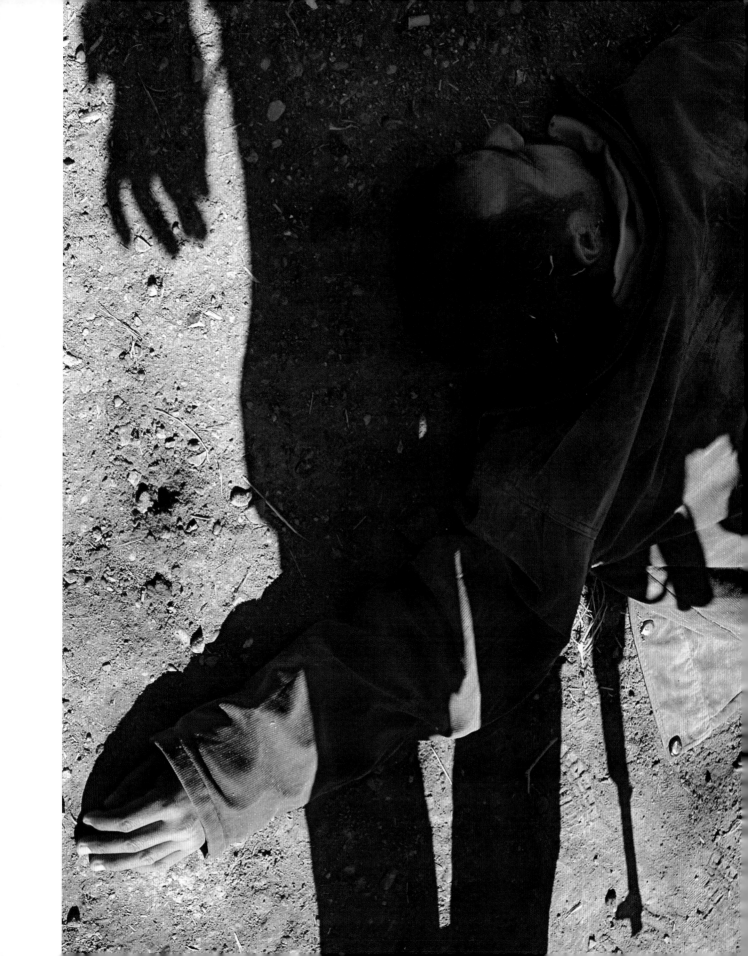

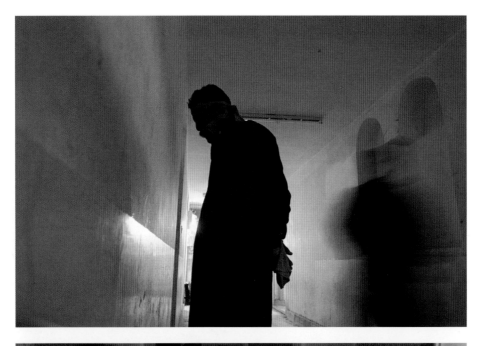

An Egyptian man suspected to be a member of al-Qaeda awaits interrogation in Salman Pak's POB headquarters. Sergeant First Class Travis Fisher tests the suspect's hands for explosives. They tested negative but the man's cell phone showed traces of TNT.

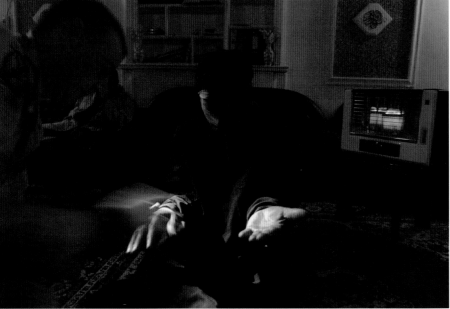

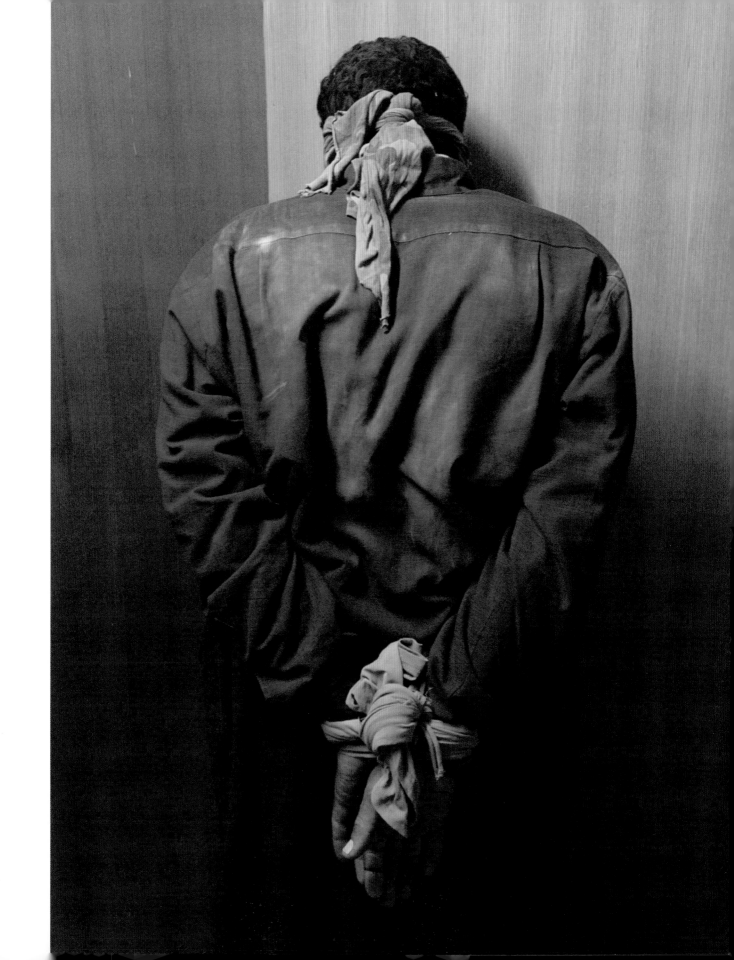

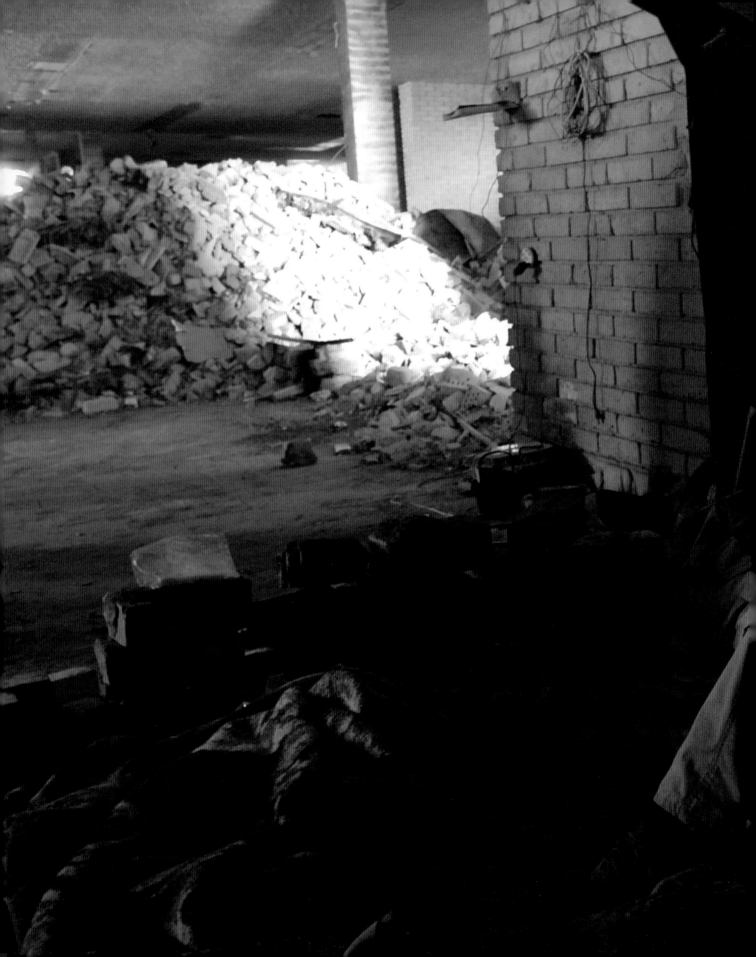

A member of the POB sits in front of a poster depicting Muqtada al-Sadr. He is paid and armed by the Iraqi and American governments: his allegiance lies with al-Sadr and the Mahdi Army.

ACKNOWLEDGMENTS

Throughout my years learning the ropes, my family has supported me despite the crazy situations I put myself in. Thank you to my parents Wendy and Peter, my brother Jamie, and my aunt Fiona Barber. Thank you Paul Bernstein, and the rest of my new family.

Timothy Grucza, you're in the book, so how much more do I need to write, except thanks for bankrolling me in the beginning. I would also like to thank Warzer Jaff, for always having my back; Franco Pagetti, for teaching me how to make gnocchi in a war zone; Johan Spanner, for somehow always managing to lighten the mood in the bureau; Shawn Baldwin, for being so goddamned easygoing; Stephan Zaklin for not; and Joao Silva, for providing me with some sense of normalcy in a completely abnormal environment.

To my original mentors, Emmanuel Santos and Masao Endo, your integrity will always inspire and teach me. José Azel from Aurora, Flip Shulke, and Jennifer Lyons, thanks for having faith in photojournalism and in me. I am especially indebted to my editor, Alan Thomas, whose

unwavering dedication to this book humbled me. Also at
the press, Mara Naselli and Isaac Tobin, for their hard
work in the manuscript editing, design, and production of
this book.

There are so many members of the press who have helped
my pictures see the light of day. Nonetheless I have to
thank Beth Flynn, Jessie Dewitt, and Michele McNal-
ly from the *New York Times* and Cecilia Bohan from the
International Herald Tribune for both getting the best pic-
tures out of me and getting me home.

The *New York Times'* Baghdad bureau is a remarkable
place. It requires innumerable people to run safely and
smoothly, all under the seemingly effortless guidance of
Jane Scott-Long and John F. Burns. In addition to running
the bureau, John is one of the most brilliant writers I was
privileged to have worked alongside in Iraq. Dexter Filkins
is another. This book might only have three parts without
him. Without Edward Wong, two. Without Ian Fisher, Rich
Oppel, Robert Worth, and Jim Glanz . . . you do the math. I
treasure my friendships with all of you.

This book would obviously be impossible without the
American military. A lot of you guys saved my ass while I
was doing my job. You know who you are. Still, there are
two particular outfits that I'll never forget. Sergeant David
Garcias and the men of Black Sheep platoon and Captain
Read Omohundro and the entire 1/8 Bravo Company.

Lastly, I would like to thank the people of Iraq who let me
document this violent period of your history and for giving
me access to some of the most painful, and occasionally
joyous, times in your lives.